ABOUT PRINTS

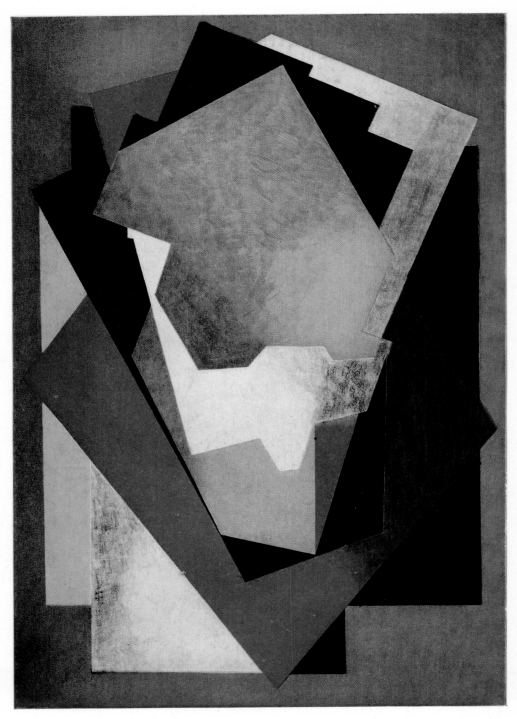

1. JACQUES VILLON. Composition. 1921. Colour aquatint $19\frac{1}{4}'' \times 13\frac{1}{4}''$

ABOUT PRINTS

S. W. HAYTER

To see a World in a Grain of Sand,
And a Heaven in a Wild Flower,
Hold Infinity in the palm of your hand,
And Eternity in an hour.

BLAKE: *Auguries of Innocence*

LONDON
OXFORD UNIVERSITY PRESS
NEW YORK TORONTO
1962

Oxford University Press, Amen House, London E.C.4

GLASGOW NEW YORK TORONTO MELBOURNE WELLINGTON
BOMBAY CALCUTTA MADRAS KARACHI LAHORE DACCA
CAPE TOWN SALISBURY NAIROBI IBADAN ACCRA
KUALA LUMPUR HONG KONG

PRINTED IN GREAT BRITAIN

FOREWORD

It is usual to have a harbinger to go before the writer of such a book as this with a trumpet: my friend Herbert Read did this office magnificently for the last book I wrote on prints. However, it is the opinion of my publisher that by now I am capable of blowing my own.

In this work it was not my intention to offer a cook-book, nor to compete with the do-it-yourself kits that have added another menace to life in our time. This book is addressed to the intelligent layman and technical matters are discussed only as they affect a print *per se* and not as they seem in the hands of a print-maker. I will admit that as a working painter and print-maker I may have been betrayed into discursions beyond this programme, but this was the intent.

In the selection of material to present I attempt to give a sampling of contemporary prints including some extreme experiments, with the intention of indicating the enormous variety in this field, rather than to offer a cross-section. It was clearly impossible to show the great number of fine prints of this time, so prints which would be provocative and little known were often chosen.

The definition of the orders of originality in prints might be thought to be in the domain of curators and dealers, just as many artists would leave questions of the mechanics of perception to psychologists. From this book it will be clear that in the writer's view both these matters interest the artist, because they have to do with his relation to his world. So it seemed that the fun of investigating variants and anomalies could also be permitted to the simple collector and not restricted to the expert.

For permission to reproduce prints I wish to thank Madame M. Lacourière, Messrs. Berggruen, Gheerbrandt of Galerie La Hune, Kahnweiler of the Galerie Louise Leiris, Jaeger of Galerie Jeanne Bucher, Aimé Maeght, and the Chalcographie du Louvre: all of

Paris. Further I wish to thank Mr. Sylvan Cole of the Associated American Artists Gallery and Mr. William Lieberman of the Museum of Modern Art, New York; Messrs. Nesto Jacometti of L'Œuvre Gravée, Zurich, and Eberhard Kornfeld of the Gallery Klipstein & Kornfeld for prints and plates they contributed. I also thank Mr. Timothy Simon and the Curwen Press, the Hon. Robert Erskine of St. George's Gallery Prints, Mr. Rex Nan Kivell of the Redfern Gallery, Mr. A. Zwemmer of the Zwemmer Gallery in London for plates and permission to reproduce prints, and Mr. Roger Prior for permission to reproduce the Chagall print.

For information, aid, and sympathy I am indebted to Messrs. Edmond and Jacques Desjobert, Frélaut, Raymond Haasen, Leblanc, les Frères Mourlot: all of Paris, and to Juichi Saito of Tokyo.

My friends Anthony Gross and Lynton Lamb read the manuscript and contributed valuable suggestions; the Hon. Robert Erskine supplied me with information and compiled the bibliography, Arthur Deshaies advised me on the use of plastics, Monsieur René Laraignou of Lorilleux, Paris, on the properties of pigments. Mr. Bernard Karpel, librarian of the Museum of Modern Art, New York, provided me with invaluable advice and my son William helped me with editing and the preparation of the index.

In conclusion I acknowledge my debt to the artists who gave permission for the reproduction of their works and the very large body of my past and present associates in the Atelier 17 who are still teaching me a great deal about prints.

<div align="right">S. W. HAYTER</div>

Paris, 1959–61

CONTENTS

PART III. QUALITY AND VALUE IN THE PRINT

ILLUSTRATIONS

PART I

The Print Itself

I

INTRODUCTION

The origins of the print ★ *Paper*

THE deliberate making of images is one of the attributes of man: one of those functions that distinguish his species from those of the beasts. And it seems to have begun very early in his development: not, if we can believe the anthropologists, as early as his use of fire, nor as early as his use or his making of tools. But that he made these images to show to his fellows, a sort of interchange of experience, a gesture shared with others, seems evident. He seems to have been aware in a sense other animals were not, or at least to have been aware to a different degree. Perhaps his acuity of recognition and comparison was in some way more intense, and some peculiarity of his mind focused the faculty on the results of his own action. He was the self-conscious beast, conscious of his own identity, and the action of recording things past is witnessed in human artefact from very remote times.

In the special field of making prints that we are considering, it is probable that the first print observed by man was his own foot-print or hand-print, together with the trace of the beast he hunted, like other predators. But as his own foot- or hand-print was more specially his own, it was thus connected with his identity and under his control. Although the deliberate making of such prints is known from early Palaeolithic times, even from 50,000 years before our era, undoubtedly an even greater lapse of time separated this deliberate action from the first conscious observation of such a print. As soon as the involuntary print had been followed by an intentional imprint, the possibility must have been realized of its use as a sign, an

indication, somewhat of the order of a gipsy patrin. These signs would constitute for man the record of things known, and perhaps suggest the form of action to be taken. Comparison with the use of sign of the few Palaeolithic societies still surviving leads to the conclusion that such action will ultimately be developed in a magical sense, to obtain power over those forces which otherwise appear beyond the personal control of the individual or group, and thus help to situate man in his own existence and add to his power of survival as a species. This magic sense could be understood as a ritual, or very much more simply as a direct action intended to produce a certain result. If we agree with Frankfort and others that the frame of reference of pre-historic man was a continuum in which no distinction was made between man himself and the world around him—his world within, as without, was seen as one uninterrupted system—then his action, ritual or other, would be intended to produce a direct result. Thus if he pours water from a vessel, as he feels himself to be a part of the rain and the force that makes rain, he is causing it to rain. So his magic is a sort of pre-science rather than an appeal to an external personified force. The importance in view of his survival was perhaps less what his action produced on his surroundings than the effect it had on him: the action taken in common with other individuals bound the com-munity together and defended them from fear. In any case, we have here a definite use of image for the purpose of communication between men.

If, as we have suggested, an enormous lapse of time intervened between the first observation of an image and its deliberate formation, a lesser but still very considerable interval must have passed before the repetition of an image having power and significance to man would have been deliberately undertaken. Fundamentally this image was just as much a gesture endued with permanence as it was the copy of a thing seen, and as these two different views of an image will have great importance in our later discussion of contemporary prints, we will explain them further. The view of any trace as the record of a gesture suggests that our principal interest is in the action of the person who made it, even to the extent of compelling us to follow or

imitate his action, so that we are made to participate in the making of this image somewhat as a group takes part in a ritual. The other way of considering an image consists of recognition of that object, already known to the observer, which it resembles. The actual making of this image has relatively less importance and its appeal is to a different order of thinking from the previous one. These are not absolute categories: the recognizable image may involve us to some extent in the human action of the person who made it, and the participation in the action of making an image does not exclude comparison and recognition. The importance of this point is that it determines the attitude of the observer relative to the seen image.

A mere five thousand years ago the first device leading to the production of identical copies of an object is found in the first recognizable writing, known as cuneiform from the wedge-shaped, or more exactly arrow-shaped, elements in the ideograms. Sometimes carved in stone, these texts were more generally impressed into slabs of wet clay with two tools, one large and one small, having ends of this arrowhead shape. I think, without unduly straining the argument, that we have here all the conditions of what has become printing, a method capable of producing an indefinite number of similar signs. Perhaps one might expect that the first image reproduced in this way would not only be an extremely elementary symbol but be in fact no more than a component of a far more complex arrangement of signs, possessing in itself no other distinction than size and direction. The people who exhibited the extraordinary intelligence to have perfected such a means of communication and of record were also the people to have used, if not to have invented, an extremely accurate means of reproducing a much more complex image. This image was in effect a sculpture in relief on a small scale, and it was formed by carving into stone hollows which formed a mould or matrix into which clay or other plastic material could be pressed to form a relief in half-round. Not only did these very brilliant people make use of the principle of casting from a mould, but these moulds were made in cylindrical form, so that when rolled out on to a slab of wet clay a series of images was produced in relief in the form of a frieze. Here we

have an operation which could be called printing. And furthermore, it is printing from the rotating surface of a cylinder. Now one of the most modern and rapid systems of printing, 'Rotogravure', employs great revolving cylinders carrying ink in their crevices. It is curious to reflect that it has this principle in common with the Sumerian's cylinder seals.

It is interesting to speculate on the reasons why, when all the conditions for true printing apparently existed, some five thousand years passed before man found need for a trace on a flat surface which could be easily multiplied. Probably, as with most of the exhibitions of human ingenuity, there was insufficient general recognition of this need; for whenever in the history of man such need has been widely felt, the means to satisfy it have been devised. The origins of true printing are variously attributed according to what the authority in question considers to be a true print. It seems very likely that certain stones with forms in relief carved on a flat surface, which are known from the Han period in China (200 B.C. to A.D. 400), were used at that time, as they are definitely known to have been used at a later period, to produce decorative images on woven tissue. The way this was done was very ingenious and very simple. The material was stretched over the stone and the surface rubbed with a lump of solid pigment, just as today we make rubbings with black-lead on paper stretched over engraved brasses. Of course such prints do not have absolute definition, but the image on the fabric is in the same direction as that on the original block and not the reversed image as in a mirror, as it is with most other methods of printing since devised; the one exception is offset printing (described later), in which the image is reversed twice, ending in the original direction. This very early date for the invention of printing is quite speculative, no example of such tissue indisputably of this time being known; the presumption is based on the same use of similar stones some centuries later.

Otherwise the invention of true printing awaited the production of paper—that convenient and readily available sheet on which an impression could be made. After the walls of caverns, the incised surfaces of horn or bone or rock, the skins of animals prepared as

parchment, the skins of sheep, deer, or bovines, bark of trees, and woven tissues were all used to carry images. The enormous advantage of paper over these materials was its ease of production from readily available material. Fundamentally paper is a sort of felted layer of some animal or vegetable fibre frequently bound and strengthened by some sort of glue, gum, or paste. The combination of these materials was found in the two most obvious natural sources in different hemispheres. A stout reed which grew and still does grow on the banks of the Nile, when soaked in water for a while could be flattened out on a stone with a wooden paddle and allowed to dry in the sun, when the sheet of papyrus (from which paper is named) could be peeled off. It was a happy accident that this particular reed contains matted fibre and sufficient sticky material to hold it together, and when protected from rot, damp, and fire such sheets have endured over two thousand years.

Another more cloth-like sheet, the Polynesian Tapa, is made from the outer fibrous coating of a species of palm; again flattened and pounded in water like the papyrus reed, a sheet is produced on which an image can be made, also of almost indefinite preservation. From a very early date in China woollen felt was made by a primitive but very effective method. A rectangle of turf was cut away from a level surface and into the hollow so formed wool was spread, soaked with water, and trodden down flat. When the water had soaked away into the ground and the matted fibre been allowed to dry in the sun, a sheet of felt was formed. As we know that a similar method using vegetable fibre instead of the wool was later used for making paper, some authorities have suggested that paper-making originated in this way. In later times the fibre used was the matted underbark of a species of mulberry tree (known for this reason as the paper mulberry) which could be reduced to a sort of pulp by beating in water, and very soon the primitive hollow in the earth was replaced for smaller sheets by a tray of woven strips of bamboo cane and later metal wires. These, when covered with a film of the pulp, would allow the water to drain away and leave a sheet of paper which when dry had sufficient strength to be handled. Such paper was made as early as the eighth century A.D. (T'ang Dynasty) in

China and with its appearance the first true printing became possible. As we shall see later (Chapter 12), in Japan and in Europe such paper is still made; in fact all paper was made by such methods, requiring fibre of very fine quality, until the invention of pulping and paper-making machines in the nineteenth century permitted the making of bad paper from wood pulp and other inferior material.

These first true prints, without taking into account the rubbed decorative prints on fabric previously mentioned, were made from incised blocks of stone and wood, which latter was no doubt found to be a far more convenient material for the purpose. Here inking was done by laying pigments on what remained of the original surface of the block, the hollows remaining uninked, just as type is inked to this day. The sheet of paper was then placed over the block and pressure applied to the back of it by rubbing with some instrument, probably similar to the Japanese 'Baren' which is still in use today.

Both the making of paper and the art of printing reached Europe in the late fourteenth century. The earliest actual prints known date from about 1418; they were on paper and apparently made by some simple press—that is to say not rubbed from the back. The screw press using a wooden screw, possibly derived from the winepress used to crush grapes, was definitely in use from the fifteenth century. The principal centre for printing books and images, all from cuts on wood, was Mainz, and it was not until the sack of this city that the art of printing spread to Italy, to France, and to the Netherlands.

In these earliest European prints a drawing was transferred to the wood block, if not actually made on it, and the background then cut away, so that very little concession was made to the mechanical diffi-culties of cutting; and yet the crudity of workmanship sometimes gives these blocks a quality of direct expression which is not seen again until the revival of woodcut in the twentieth century. There is considerable evidence that the originator of the design did not actually cut the blocks; furthermore that the hand that cut them was very little respected. Consequently the manner in which the work itself might modify the image through direct contact with the medium is only very exceptionally seen.

At almost the same time, in fact within the same century, the other typical method of printing appears, known as 'intaglio' from the fact that the printing ink is carried in the incisions of the plate, generally of metal, and its surface is wiped clean. At the beginning there was no collaboration between the draughtsman and the engraver: the engraver was a goldsmith or worker in precious metals, practising one of the most ancient graphic crafts. A device used by the gold-smith to see more clearly how his design on precious metal was pro-gressing may have been the origin of this type of printing. Impressions on clay and even casts made by melting sulphur on to plates, which were clearly intended for decoration and not for printing, are to be found in the British Museum. Another practice still sometimes used by working engravers is to rub in an oily black to fill the cracks in the work, to lay a wet paper over it, and to rub off the back with a burn-isher (a tool which they would have at hand). A few prints are known from the fifteenth century which look as if they had been made in this manner. It is difficult to be sure from which source printing from the incised line originated, but already in the fifteenth century many artists, such as Pollaiuolo and Mantegna, were making original prints.

Both these artists were, as the Renaissance artist was so often expected to be, goldsmiths, sculptors, painters, and even architects. Thus all the skills needed for this order of print-making were at the disposition of such men. It is then to be expected that the plates they made would have been conceived as independent works for their own sake, and not merely derived from originals in other arts such as painting or sculpture. Within a century of its inception, however, the new art of engraving (together with etching, in which the grooves in the plate were bitten with acid instead of being carved by hand) had attracted many artists of the second order who were predominantly artisans. In their hands the art was rapidly converted into a method of disseminating numerous copies of the work of more famous artists, and by the sixteenth century had already acquired the character of a process of reproduction which it retained until its displacement by the more rapid and convenient method of photo-reproduction. We

can only suppose that the reasons for this change were to be found in
the preference of the public for the ideas of famous artists, even when
interpreted by another hand, to works originated in the medium by
less gifted artists. It is, however, a fact that throughout the subsequent
history of printing the vast majority of prints produced were inter-
pretations by skilled artisans of originals already existing as drawings
(sometimes the cartoons for projects of a master), paintings, or
sculptures, and the small number of prints produced for their own
sake by major artists represent an infinitesimal minority in the pro-
duction of those times.

Already in the sixteenth century the press which was used to print
engravings had reached the form which has hardly changed down to
the present time. It consisted essentially of two rollers having a flat
bed passing between them, one of the rollers being turned by means
of arms attached to its spindle. These rollers were supported on bear-
ings in a very heavy frame in such a fashion that by means of packing,
or later by screws, great pressure could be applied to the flat bed on
which the plate (covered by wet paper) could lie. Woollen blankets
were, and still are, used to distribute pressure and mould the damp
paper into the cracks in the plate containing ink. When the bars
attached to the upper roller are turned, the bed carrying the plates is
drawn through the press, subjecting the plate to a rolling pressure.
These presses, originally made from hard wood and later from cast
iron and steel, operated, if slowly, with such efficiency that they are
still completely adequate for the printing of engravings today. In
London in 1940 I used such a press, dating from the seventeenth
century, having rollers of ironwood, enormous bearings and frame of
oak, and the prints were as perfect as anything I could have obtained
on a modern press.

In these crude wood blocks cut by hand and these metal plates
painfully engraved and etched we have potentially most of the
modern photo-mechanical methods of making a printing surface. In
the two primitive types of press, equally, we have the progenitors of
the enormously complicated, rapid, and efficient machines used for
printing at the present time. In fact, with the sole exception of such

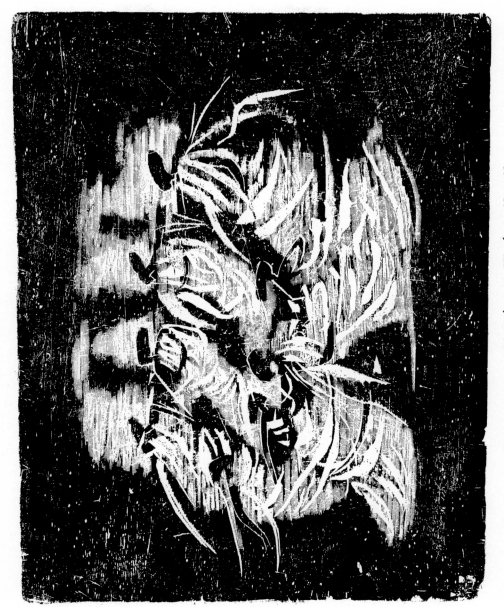

2. LIVIO ABRAMO. Macumba. 1957. Woodcut $10\frac{1}{2}'' \times 13\frac{1}{2}''$

3. TOSHI YOSHIDA. Ukiyo-e print. 1957. Woodcut $9\frac{3}{4}'' \times 14\frac{1}{2}''$

methods as offset, derived from the nineteenth-century invention of lithography, all the contemporary methods of printing are elaborations of these two simple methods; in typographic printing, whether from line-cut or the more elaborate half-tone where the printing surface may be curved on to the surface of a drum revolving at a very high speed, the principle involved is just the same as that in the primitive woodcut. In the high-speed printing method known as rotogravure the dots and hollows etched into the surface of the drum are filled with ink just as those of the etched or engraved plates of the fifteenth century were, except that in the modern mechanical version the ink is very liquid and the excess of ink is removed from the surface of the roller by a flexible steel blade instead of by gauze and the palm of the engraver's hand. But while printing's function of disseminating information to a great number of people in a more or less temporary form has been taken over by the camera and the high-speed press, the production of more precious and more permanent images by the primitive crafts, returned after many centuries to the hands of the artist, is still practised to provide limited but durable images for the solace of man.

2

RELIEF PRINTING

Woodcuts and wood engraving ★ Printing in black and colours from
relief blocks of wood, metal, or plastic

ALTHOUGH strictly one single and unique impression could well be
seen as a print, as in the category of 'monotypes' still made at this time,
the current use of the word print does really imply that a number of
identical examples of the image can be made or do actually exist.
That these should be known as 'copies' records the circumstance in
which hand-copying was the only feasible means of disseminating a
work. But the expression also indicates that somewhere something
existed before they came into existence, and that that process which
caused them to come into existence was the copying or repetition of
this presumed original.

The complete justification for this attitude is to be found in the
history of print-making in Europe and in Asia where the great
majority of prints produced over centuries were of course fairly
faithful imitations, in view of the limits of the mechanical techniques
employed, of a work which already existed as a drawing, a painting,
the study or 'cartoon' for a painting, a sculpture, &c. Thus these
prints were copies (or reproductions) of a copy: that plate, block, or,
later, stone, screen, or stencil being itself the first copy from which all
the other copies were derived. It is in reality only since the displace-
ment of autographic methods of reproduction by more rapid, if not
more efficient, photo-mechanical devices that the hitherto somewhat
rare species of print made for its own sake became predominant in
this field (see Chapter 11).

Although in this treatise I do not propose to repeat or to replace

already existent handbooks on the making of prints, to the amateur, the collector, or to the public interested in prints, some acquaintance with the quality of print produced by each of the different methods is valuable to enable them to be distinguished; and some interest may even be found in the action taken by the artist or artisan, in so far as this can modify the appearance of the print.

As was mentioned in the previous chapter, one of the first methods used seems to have been one in which a block of some material is cut away so that parts of the original flat surface can be coated with ink (the cut-away parts remaining clean) and this image transferred by pressure to paper. Typography is, of course, printing of this order and both letterpress (ideograms) and image were made by this means during the T'ang Dynasty (eighth century A.D.) in China, although it may well be that rubbed prints on fabric existed much earlier.

It has been said that wood offers itself as the most readily available and convenient material: one of the most ancient media, it is still employed for the making of prints. There are two main varieties of wood used for this purpose: the one (A) a plank, being cut parallel to the tree trunk, the other (B) end-grain, being cut at right angles to the length of the tree trunk. Quite different tools are used in the two cases and it is nearly always possible by the appearance of the print to distinguish which of the two has been employed in the particular instance. When the flat grain of the plank is used, the original grain of the wood can frequently be distinguished as differences of tone in the print itself, unless, as with some fruit woods as pear or other very close-grained woods, heavily inked, it has been concealed. The procedure for making a woodcut on a plank is, as already mentioned, to cut away what is to be white on the block and to leave parts of the original surface to carry black or colour. Already this involves two different ways of going about the work. In one, perhaps the earliest form of woodcut, the design is drawn on the block and that part of the wood not covered by the design cut away. It is clear that this is some sort of reproduction: the forms actually cut have no particular reference either to the wood itself or to the normal action of those tools used in cutting. In such cases also, the individual who cuts the

block is very often not the originator of the design, i.e. the artist. The result of the action of cutting on a block is to produce a white, so if the image is conceived in white lines or forms it is more closely connected with the direct action on the plank. Such prints are more

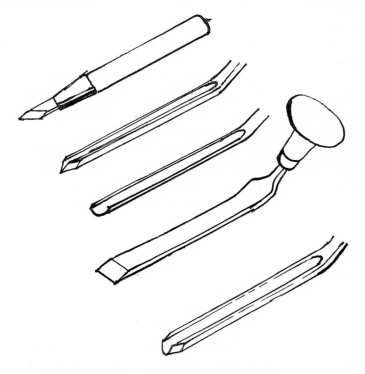

TOOLS FOR FLATGRAIN WOODCUT

likely to have been cut by the artist himself and to have been devised by the artist himself rather than transferred from a drawing.

The tools used for work on the plank are either knives, gouges, or both. To remove a line with a knife two cuts will have to be made, and in most Western examples the cut is made at an angle of forty-five degrees from the surface in two directions, so that a shaving of wood is removed between them. The same result could be produced by the use of a V-gouge (which in the case of work on the plank is

4. ROGER VIEILLARD. Fête marine. 1960. Burin line engraving 12″ × 16½″

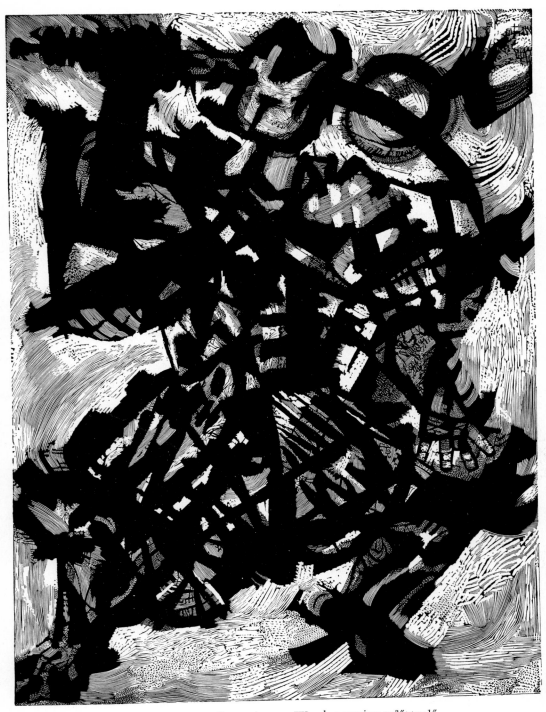

5. MISCH KOHN. Samurai. 1954. Wood engraving $19\frac{3}{4}'' \times 14\frac{1}{2}''$

open), but the white line made by this means is somewhat less flexible and precise than that produced by work with a knife. Careful examination with a glass of the surface of a woodcut print would enable a

ORIENTAL AND WESTERN TECHNIQUES OF WOODCUT

collector to determine with a fair degree of accuracy whether a knife or a gouge had been used in cutting a particular block. In the Oriental techniques of cutting on wood it has been very rarely that the artist who originated the design actually cut the blocks. Here the knife is held vertically to the surface of the block, controlled by one hand while being driven by the other, and as white line is very seldom used

the unwanted wood can be removed with a flat gouge. Here again
the amateur can determine the difference of quality in this sort of
cutting from that obtained by the method previously described. The
determining quality of the wood itself, to which we have already
referred, can also be detected in another way. A moment's experi-
ment will show that a knife can be drawn faster and with less effort
along the length of the grain than across it. Only in the category of
prints in which we have assumed direct action on the part of the
artist on the plank, and some degree of development of the idea during
actual cutting on the block, will this effect be evident in the result.
Woodcuts by Edvard Munch and by many of the German Expres-
sionists during the twenties show the influence of this varying
direction of the grain in the plank to such a degree that in some
cases we could imagine that a certain configuration of the grain of
the wood gave rise to the image, just as Palaeolithic man may have
found the configuration of his animals in the irregularities of the walls
of a cave.

Where wood has been replaced by such materials as linoleum,
masonite, or plastic, similar tools and a similar action is used to make
the block, but an absence of this quality caused by the grain in wood
will very often serve to identify and distinguish works on these
materials from true woodcut. It is a fact that the softer the material
the more perfectly sharp must the tools be to produce a clear result
without crumbling, tearing, or slipping.

What is more commonly known as wood engraving, the work
referred to in the original category B, is performed in a different way
and has a very different character from that carried out on a plank.
To cut into the end-grain wood burins are used, such as solid chisels,
full gouges, scorpers, and other solid tools, and as the vertical grain of
the wood frees the shaving it is not necessary to use a hollow gouge
(see p. 17). As there is no distinguishable difference between one
direction and another in cutting on the end-grain, a very much
greater freedom of line is possible. Again the most direct result of
cutting is a white line, although reproduction engravers of the late
nineteenth and early twentieth centuries not only arrived at the

isolation of a black line but also by the use of multiple gravers succeeded in translating the variation of tone in a wash drawing with more than photographic fidelity. As with the previous category of woodcut on the plank, a print which seems to have originated in

TOOLS FOR END-GRAIN WOOD.

white line or in which the direct feeling of the cut of the tool into the material is employed, is more likely to be a work originated by the artist in the material itself than a reproduction from a painting or drawing carried out by the most skilful artisan.

Printing from any of these blocks is carried out by depositing ink upon what remains of the original block-surfaces, often by gelatin rollers, so as to leave the hollows uninked, placing a sheet of paper over the block, and applying pressure. As a result careful examination

of the surface of any print made in this way will show some degree
of indentation of the printed form. Whether the pressure has been
applied by a printing press, a hand-worked screw press, a mechanical
typographic press, a lithographic press, or very crudely by rubbing
a smooth object on the back of the sheet, this indentation will be
seen. The example of wood engraving (Pl. 5) by Misch Kohn,
printed from a block of boxwood on a soft Chinese paper with
great pressure, shows the deliberate use by the artist of the embossed
whites of the paper between the deeply impressed blacks of the inked
block. The use of this white relief, possibly derived from such effects
used by Japanese woodcut artists in the nineteenth century, or from
the relief whites used in intaglio prints since 1930 by the members of
Atelier 17, has enabled this very original artist to extend the limits of
expression of wood engraving in a way that the writer would not have
considered possible.

There are obvious practical limits to the size of end-grain wood
blocks (generally of boxwood which grows so slowly that a 300-
year-old stem is about a foot across), the strain on the blocks when
sufficient pressure is used to provide these raised whites being of the
same order as that used for intaglio printing (see Chapter 5): about
three tons. This pressure to be effective has to be of a certain intensity
per inch; that is, the total pressure on the press must be greater with
bigger surfaces. With the desire of many print-makers, in America
particularly, to make bigger and bigger prints, one reaches the abso-
lute limit of possibility in wood; partly for this reason Arthur Deshaies
and others have replaced the wood by plastics such as plexiglass and
lucite. The general ignorance of this problem is shown by a recent
'cookbook' on the subject published in the United States in which the
author suggests a pressure of 100 lb. for this purpose, which would be
absurdly inadequate. Deshaies gives the following reasons for his
adoption of plexiglass: (1) to escape from the restriction of size in the
use of wood; (2) clear plastic enables him to use drawings taped under
the sheet; (3) ink can be rolled up on the surface, and with white
paper under the sheet the work will be apparent and the surface
can be cleaned with benzene if changes are needed; (4) far

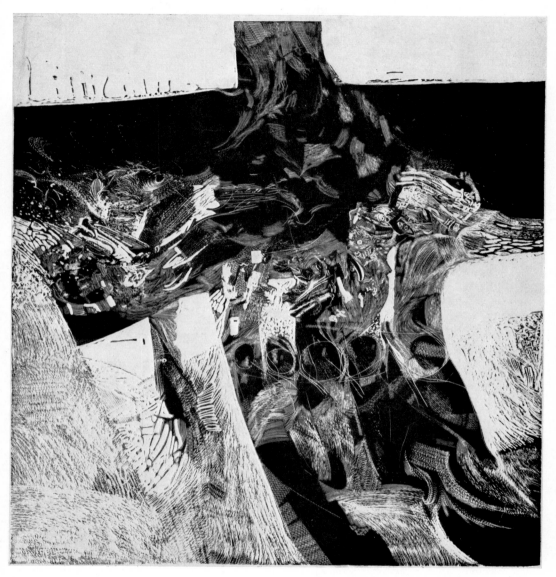

6. ARTHUR DESHAIES. A Cycle of a Small Sea: Elegy. 1959. Engraving on Lucite 24″ × 22½″

7. JOAN MIRÓ. Child Skipping. 1947. Relief print from etched and engraved plate 12″ × 9″

better control of inking on plastic without the absorption of wood surface, checked against the light before printing; (5) for intaglio printing white paper underneath shows the result before printing; (6) the variety of tools that can be used, including motor tools, drills, routing bits, as well as invented tools for scratching, rasping, filing, stamping, burnishing, burning, and even adding to the surface. As I try to make clear when dealing with intaglio techniques, I am not entirely convinced of the advantages of plastic for intaglio printing: the avoidance of certain difficulties by its use sacrifices some qualities which can work for the expression of idea, but once one accepts the need for extending the scale of relief blocks, the advantages of plastic become obvious. Misch Kohn's solution to this problem is very interesting. In many of his later prints, which are of enormous size (and, exceptionally in his case, justify the scale), he has used a technique similar to aquatint (see Chapter 3) to make prints from the surface of the plate, treating it like a wood or plastic block. Sufficient pressure is used to raise the white elements between the blacks which represent the original surface of the plate; the processes of etching, in area and in texture, give to the action of the artist a degree of freedom beyond anything possible even on plastic. However fine the results in his hands, let us not forget that ease and freedom of action in the operations of plate-making do not necessarily mean ease and freedom of expression in the mind of the artist.

The block intended for printing in this way may also be made of metal, and if it is cut in a similar way and with the same tools as those used in wood engraving, it is probable that a soft metal would be chosen, such as zinc, lead, or type-metal—although copper could also be used. The methods of etching with acid and indentation with punches or toothed tools can equally be applied to such plates, which when printed in the manner described above can give results very similar to wood engraving. Again careful examination of the quality of line or margin will show a character different from that which is cut into wood: a microscopic serration typical of the action of acid is often seen along the etched line. Such prints are known: the crude but vigorous cuts in type-metal of Posada (Mexico), for instance,

and in this case it is difficult to distinguish them from cuts in wood or
linoleum unless one has become sensitive to the quality of the
material and the way it influences the work of the engraver. Where
relief prints have also been made from etched plates (see Pl. 7), those
open parts not intended to print having been removed by the action
of acid, any conceivable degree of elaboration of texture and quality
can be executed with ease—the plate ultimately being set up as type
and printed in the same way.

Of all the methods used to produce a relief surface suitable for
printing, those already mentioned depend upon the principle of
cutting away from the surface which is to be the printing surface.
Most people are familiar with the 'line-cut' which is made by
etching away the background from a trace protected by a photo-
graphic light-sensitive coating. What is less known is that certain
artists and artisans have elaborated methods of making line-cuts by
hand without the use of photography, and it is only possible to
distinguish such prints from ordinary line-cuts by very careful
examination. Werner Schreib (Pl. 8) has made such prints by draw-
ing with a needle on a black coated glass, then employing this as a
positive and exposing a light-sensitive plate under it. The developed
metal plate is subsequently etched away to produce the actual cut
from which this illustration is printed. There exists also a method,
perfected for the making of plates from which maps are printed,
which results in the formation of an electrotype similar in all
respects to (but different in quality from) an ordinary line-cut. A thin
layer of wax about 2 mm. thick is formed on the surface of a copper
plate. The design is then drawn with a needle, or several needles of
varying thickness, into the wax, and copper is deposited by electro-
lysis on the wax surface prepared to make it conduct electricity.
Here again the final result is a copper plate with lines or forms
standing up in relief.

At the time when the Atelier 17 was first established in New York
I was working with some of my associates on a method by which
line-cuts were made which were really cut, that is, had the absolute
precision of the action of cutting, compared with the etched profile

of ordinary commercial line-cuts; and we had the curiosity to show some of the results to one of the leading publishers and the managing editor of one of the leading newspapers in New York. The reaction of both these people was much the same. What they said was, in effect, 'Why do you waste your time with improved processes when what we have is already far too good for the public to be able to distinguish differences in quality in its results?' The publisher furthermore pointed out that there was one very serious disadvantage to the application of such methods to 'commercial' art. The 'artists' would need to be qualified engravers and would consequently expect to be paid at higher rates than the thousands of hacks always to be found willing to execute what is known in these circles as 'art-work'. Both of them strongly if mistakenly counselled us to devote our attention to perfecting devices that would enable people to make money. Within recent years the American artist Brussell-Smith, while working with the Atelier in Paris, perfected a method of making direct etched plates for colour printing which could be used for commercial purposes and I understand this to have been extremely successful. It seems our two critics were wrong, and anybody who introduces a better mousetrap into the extremely competitive field of advertising can catch an awful lot of fingers in it.

The simplest method of printing from any of the plates produced by the various methods described is in black on white and generally with a uniform inking from the rollers. Certain wood blocks cut on the plank by Gauguin were printed with unequal inking; either by slightly lowering the level of certain parts of the block or by partially wiping away the ink from certain parts, a half-tone grey is produced between the black of the original surface and the white cuts. In recent times there has been, most particularly in America, a great development of woodcut in colour on blocks of very large scale. The print (Pl. 9) of Louis Schanker, who since the thirties has been one of the most active teachers in this technique, shows certain peculiarities of printing which are typical of this whole school. He headed a print-making project in W.P.A. (a relief scheme set up by Roosevelt during the depression), and from his example the great development of

colour woodcut in America chiefly stems. The cutting of a series of
blocks intended for colour has clearly to be undertaken systematically
so that the registration of colour is exact; in the classical Japanese
technique a 'key' block to be printed in black or grey would first be
cut. In the frame around the image notches fix the position of a sheet
of paper cut to size. Then if similar notches are cut in the frame of
each colour block to follow, an impression from the first key block
can be printed back (counter-proof) on to these new blocks, giving
the positions of elements of colour which will then fall at each
printing within the spaces defined by the first block. Another con-
venient device is to stick down on to each block a print of the key
block made on thin, almost transparent paper, which can then be
cut through in each case. In Western techniques of multiple block
printing by hand a frame or 'chase' holds the block, and the notches
or tabs that hold the sheet of paper are on this frame and not on the
block itself; but in all cases the object will be to register the position of
the image on the sheet of paper in a uniform fashion with as much
accuracy as possible.

By whatever means they are executed, prints from wood blocks in
colour fall into three definite categories according to the manner
in which the colour completes or amplifies the design. The simplest
is clearly that in which each block carries a single colour on a clearly
cut-out pattern, and the elements of another colour fill the spaces
between the elements of the first and so on; thus a mosaic of colour in
the simplest of terms is produced. Variations within this category
will show perhaps several tones of each colour obtained by hatching,
dotting, or otherwise texturing the surface of the block; but the
operative principle in this category is that no mixing or overprinting
of colours is intended. A second category is that in which over-
printing of one, two, or three colours will be designed to extend the
range of tones with secondary and tertiary colours. By this means
three printings give seven colours; four printings give thirteen, &c.
To design blocks successfully for this purpose obviously demands
a greater experience of printing and colour; also, if the former cate-
gory is typically printed in opaque colours, this overprinting method

8. WERNER SCHREIB. Creation. 1957. Needle etching $4\frac{1}{2}'' \times 5\frac{3}{4}''$

9. LOUIS SCHANKER. Circle Image. 1925. Colour woodcut $14\frac{1}{2}'' \times 18\frac{1}{2}''$

would call for the use of transparent or at least translucent colour, in order to make the most effective use of the two, three, or more layers of different colours. The third category of colour woodcut printing arises from the purpose for which the colour is employed. While one might imagine that the first and second categories could represent colour forms alone—coloured objects in which the hue has the greatest importance—in the third category, known as chiaroscuro, the variations of colour represent light and shade on objects or scenes and, more typically, in one or a few different hues, but with a wide range of value (as light and shade) within these hues. Very common in the eighteenth century, this category is less typical of the second half of the twentieth, though examples of it are still seen. Again, with its obvious applications to reproduction from drawing, painting, or water-colour originals, such prints are more likely to be the work of skilled artisans than to have originated with the artist himself; or to have made an image different from that which would arise from drawing or painting.

When in Majorca in the thirties I met a Catalan wood engraver of astonishing skill who was engaged in cutting a series of blocks to reproduce sepia water-colours by a fairly unexciting artist of the time. It was at this moment that I first realized that in the hands of a sufficiently adept craftsman this sort of chiaroscuro reproduction by wood engraving was more faithful to the original than the finest results of photo-reproduction. However, the work was being undertaken for a bibliophile society of a type which must have almost disappeared, to illustrate a book to be printed in an edition limited to the members of the society, and with, as far as I could see, the sole purpose of justifying the exorbitant price that copies would fetch in the market. As I may already have indicated, I was not convinced of the necessity of reproducing such drawings at all, or even of preserving them.

The normal procedure in printing colour from wood blocks involves a succession of operations in which the oil-base or, in the case of Japanese prints, the water-base colour is laid on the blocks by rollers or even with brushes and each printing allowed to dry before

the next colour is printed: with a glass the succession of operations can be followed on the print. It is clear that this has some importance in the result: a simple experiment will show that red printed over a blue has a different effect from the same blue printed over red. However, in the case of the print of Louis Schanker (Pl. 9), printing was carried out wet on wet: i.e. before one colour had time to dry another was printed so that some degree of mixing of the colours appears; and as very heavy inking was used at times, a sort of marbling due to the stickiness of the ink pulling away some of the previous colour is also apparent. The effect is of course similar to that of oil painting, from which the method is evidently derived. Somewhat similar effects are obtained in certain prints by means of serigraphy (described in Chapter 6), but careful examination will show a distinct difference in the quality of the surface. With a serigraph no trace is seen of the characteristic indentation which is always found to some extent in prints from blocks; the colour lies upon the undisturbed surface of the paper, and generally shows the texture of the screen itself.

There is one variety of print that can be made from a wood block, or a series of wood blocks, which does not present this characteristic indentation. These prints are very rare, in fact the only ones I know I have made myself or seen made in the Atelier 17. The print, which may be in colour or in black on white, may show the grain of the wood, so it is clearly derived from the cut surface of the block of wood and yet no indentation whatever is to be seen. An engraved block of wood of Indian origin, probably intended for printing fabric but having a very irregular surface, was brought to us in the New York Atelier by its owner who wished to have a print made of it. Owing to the irregularity of the surface no impression could be made on an ordinary press; nor would rubbing from the back give a perfect print. The method we devised at this time which produced a perfect print showing every pore in the wood was to print by means of offset. We inked the surface of the block with gelatin rollers soft enough to follow its irregular contours; a large clean gelatin roller of a circumference sufficient to develop the width of the block was then

IO. MICHAEL ROTHENSTEIN. Cock. 1958. Colour linocut $18\frac{3}{4}'' \times 28\frac{1}{2}''$

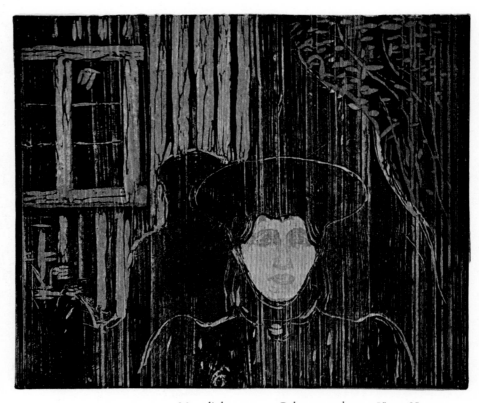

11. EDVARD MUNCH. Moonlight. *c.* 1903. Colour woodcut $15\frac{7}{8}'' \times 18\frac{3}{8}''$

passed over the surface, picking up on its surface all the detail of the block. This roller was then rolled out on a flat surface of paper on to which the print was offset. This method provided us with the means to print from any irregular surface, or from any material, such as the engraved slates of Raoul Ubac, too fragile or brittle to resist a press. Later the method was amplified to make three-colour prints from three cuts in wood. To make this operation clear I will describe how such a print was made for a greetings card quite recently. Near one end of a long plank one image was cut with knife and gouge, and

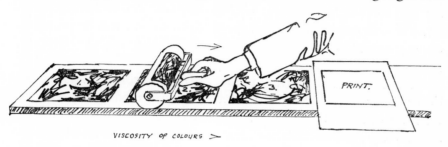

VISCOSITY OF COLOURS >

inked with a roller in the usual way. Another roller of sufficient size, which is to serve for the final printing, was passed regularly over this inked surface and rolled farther along the plank where it deposited three offsets of the first image at a distance from one another equal to the circumference of the roller. It was then very simple to cut within the first of these impressions the form to be printed in the second colour, and in the second that form to be printed in the third colour. The work having been completed, the three cut images were inked in the three intended colours in such a way that each successive colour was slightly more liquid than the one before. When the clean roller was passed evenly over the three inked surfaces the three impressions accumulated on the surface of the gelatin and as the roller continued were deposited all at once on a sheet of paper placed over the fourth position (see diagram). The result is of course a triple offset in which all the seven consequent colours will appear. However, if a different procedure had been followed in inking the blocks so that the first colour was the most liquid and the third the most sticky, a

mosaic of three pure colours only would have appeared on the sheet, since where the first colour was present the second colour could not adhere to the roller, nor the third adhere in the presence of the first two. The procedure described is rather slow and awkward and demands a certain amount of care to produce a uniform result as the roller used for the final printing has to be cleaned after each print. In practice the use of this method in the Atelier 17 is not quite so simple. If in the fourth position a plate worked in intaglio (see Chapter 3) is used, this plate having been already filled with ink and its surface wiped as for normal intaglio printing, after the operation of offsetting all this series of colours together with the intaglio colour will be present at the same time on the plate and one passage through the press will transfer the complete image on to paper.

Another method of getting a mosaic of colour from a single impression was used by Derain: a white line was used to separate the elements of flat colour on the surface of the block; then the different colours were inked through stencils and the whole transferred to paper in one operation. The effect is a mosaic of flat colour with each element separated from the next by a white line. Another method of printing which produces a multiple colour image of very similar effect involves cutting the block apart with a saw, inking the pieces separately in different colours and reassembling them in a sort of frame at the moment of printing. The method was occasionally used by Edvard Munch (see Pl. 11). To distinguish in a particular print which of these two methods had been used would not be easy; it is likely, however, that in the latter case the white lines separating the colour elements would be less uniform in thickness. Both these devices are evidently applicable only to hand printing. The woodcuts of Miró printed by Frélaut at the Atelier Lacourière mentioned in Chapter 7 were done by similar methods.

12. JOSEPH HECHT. Deluge. 1927. Burin engraving $9\frac{1}{2}'' \times 11\frac{7}{8}''$

13. GEORGES ADAM. Penhors No. 5. 1956. Burin engraving 36″×24″

3

THE MAKING OF INTAGLIO PLATES. I

By etching, aquatint, soft ground, and texture

ALL prints produced by the techniques known as intaglio show
certain characteristics which distinguish them clearly from prints made
from the surface in relief, as in the category we have just described.
The whole surface of the plate, owing to the pressure with which it is
applied to the damp sheet of paper, will be impressed into it and
around its edges a visible 'plate mark' or 'cuvette' may be seen in-
dented within the margin of uncompressed paper. Of course this
plate mark will not be seen if, as sometimes happens, the margin has
been cut away after printing or, as in some cases, the image was
printed from a plate which was larger than the sheet of paper on
which it was impressed. Then the actual deposit of ink on the surface
of the print, whether from lines, dots, grains, or texture, can with
a glass be seen to lie in relief above the surface. This character abso-
lutely distinguishes the results of printing from intaglio, though in the
case of aquatint or mezzotint the distinction may be very slight.
However, in no case will any indentation of the printed elements be
perceptible. But plates worked in drypoint show a slight indentation
due to the burrs which stand above the plate surface: it can be
seen together with ink in relief above the surface, as in other forms of
intaglio printing.

Of all the actions required to produce a plate which can be printed
in this manner, the direct carving of furrows into a plate is the sim-
plest. Known as line or burin engraving, it is a practice far more
ancient in the history of man than that of making prints. As I have
suggested elsewhere, examples of this action, not of course intended

for printing, are to be found in some of the earliest human artefacts. On objects of horn, of bone, and of stone, as on the walls of caves decorated by Palaeolithic man, incised lines accompany and may even predate drawn and painted images. There is internal evidence in many of these actual lines that they were made by driving the pointed tool in the direction of the line rather than drawing it across

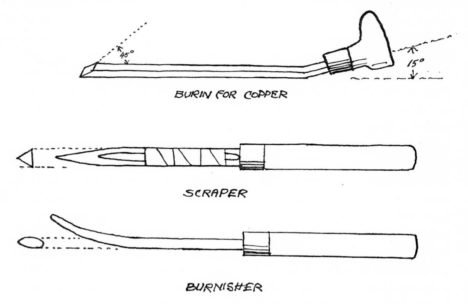

BURIN FOR COPPER

SCRAPER

BURNISHER

the surface, and as we shall see, the peculiarities of these two sorts of lines can still be recognized by an expert in contemporary examples. From this time on there is an uninterrupted history of the use of the engraved line by man, leading in some cases to relief, to sculpture in the round: from the engraved bronze doors of the Temple of Solomon to the decorative work of fifteenth-century goldsmiths from which the first prints were probably made.

The tool still used for cutting into the surface of metal has hardly changed in form since the fifteenth century or even earlier. Shown above, it can be seen as a square or diamond section piece of steel cut off at an angle (generally of 45°), set into a handle so that it can

be driven by the palm of the hand to plough out a groove in the metal. The plates on which such work is now done are usually of hard-rolled or hammered copper, as this proves to be the most convenient metal to engrave, but they may also be of steel, of brass, of zinc, of magnesium, or of aluminium. Very exceptionally hard wood and plastic plates have been engraved for intaglio printing (see Arthur Deshaies, Pl. 6), and it is nearly always possible to distinguish prints made from such plates by peculiarities of the line or surface seen under a microscope. What appears as a line on the printed sheet is in fact a cast in ink and damp paper of the groove in the plate. Consequently careful examination of the direction and the quality of the edge of the line will show the incised quality arising from a direct cut which the amateur can quite easily learn to distinguish from the etched or bitten profile. Another quality of arabesque determined by the forward movement of the tool, as distinct from the pulled or drawn action of the tool in etching or drawing, is very much harder to distinguish. In fact where the burin has been used to retrace or to copy a drawn line, this quality may not even exist. It is clear that even if a careful labour of comparison is needed to distinguish this line it might well be worth the effort, as it could lead to very definite evidence of the order of originality of the print itself (see Chapter 11).

I can offer no simple description of the freely cut line of the burin that will enable the reader to distinguish it at a glance from that produced by drawing. However, if he is willing to examine and consider the trace of a skater on ice, the trails of jet planes in the sky, the track of a car driven across smooth sand, the groove that a child leaves in a wall by drawing a nail across it as he runs, he may begin to distinguish a quality in such lines which is unlike the slow trickle of water, the form of a strand of wool, or the line he draws with a pen across a sheet of paper. In the examples given it is clear that the distinguishing characteristic of burin-type lines is that they are the product of two simple forces: a direction of movement against a uniform resistance, and that movement in a forward direction. This action has an obvious similarity to that of the sculptor in carving: the goldsmiths who originated the craft were sculptors on a small scale, and it

is to be expected that the results of such action might be more closely allied to sculpture than to drawing or to painting. In the print of Joseph Hecht (1891–1952), reproduced as Pl. 12, it is easy to see a certain sculptural quality, and yet even the purest use of engraved line does not really resemble either sculpture in the round or relief. It has always been my intention, if ever a suitable subject presented himself, to put a burin in the hands of a competent sculptor, if possible with no previous experience of print-making, and invite him to carve a sculpture with this tool in a copper plate. It might appear that the impression of such a plate, if it could ever be made, would be the negative of a sculpture: that is, the work which was hollowed out in the metal would be in relief on the paper; thus, the plate being a positive, one might expect the print to be a negative. But when we look at the Hecht engraving and also the print of Armin Landeck (Pl. 16) we see that the result of direct cutting with a tool is neither a positive nor a negative sculpture; in fact, though we might take it to resemble a wire sculpture it is not even like a straightforward structure of wires in space. Finally the best analogy we can find for the type of line which results from this action is a kind of mobile Calder sculpture which alternates between a positive and a negative configuration. Of course it is not necessary to speculate in this way on the ultimate significance of the engraved line in order to appreciate and enjoy engravings; in fact this comment is offered only to the curiosity of those of speculative mind.

The other usual method of making the grooves and incisions in metal plates to print from intaglio is based on the idea that the effort of overcoming the resistance of the material can be avoided. If a protective coating of some kind is put on a metal plate and lines are drawn through it, exposure to the corrosive action of acid will widen and deepen these lines to any required extent. Long before printing was known in Europe, as early as the twelfth century, armourers used to decorate steel in the following manner. The breastplate was coated with a layer of beeswax; with a sharp point a quite elaborate design was drawn through the wax, after which bags of salt were laid on top and soaked continuously with vinegar. When the wax had

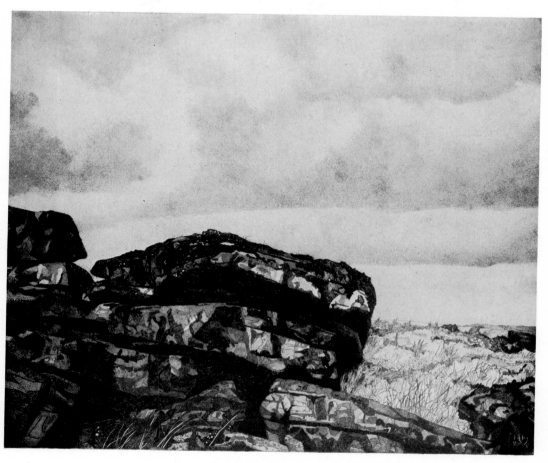

14. NORMA MORGAN. Granite Tor. 1954. Burin engraving $14\frac{7}{8}'' \times 17\frac{1}{2}''$

15. S. W. HAYTER. Sorcerer. 1953. Etching and line engraving 19¼″ × 15⅜″

been removed a sufficient groove had been eaten out of the steel for brass, silver, or gold wire to be hammered into it. To the warrior who wore it, the slight loss of protection was no doubt amply compensated for by the gain in elegance. As with printing from engraved line, plates made by this means were not printed until the methods of printing in relief from wood blocks had become generally known in Europe. The first of these etched plates seem to have been made of iron, etched in a single operation to give equal strength to all lines, and to have been designed in very much the same character as line engravings on copper, of which they were on the whole imitations. The reason for using iron at this time was probably that acids capable of etching copper, although known to alchemists, were not as readily obtainable as the simple materials which the armourers had used for centuries to etch their steel. Although a great elaboration of means has developed since the time of these first crude etchings, the complex textures and qualities of the print of Anthony Gross (Pl. 17) were the result of an action exactly the same as that used on the earlier plates. The wax coating has been replaced by mixtures of asphaltum, resins, and even plastic varnishes, generally called grounds, having the same purpose as the wax—to resist the action of acid—but permitting much freer and more sensitive design, and progressive biting to give a variation of strength in the line. Acids are available to produce a wide variety of qualities and textures, reaching a very high degree of precision where this is needed. The plates, although generally of copper, may also be of zinc, brass, aluminium, magnesium (the print of Frederick Becker, Pl. 48, being on this metal), and even plastic. In the last case the 'mordant' is rather a solvent than an acid, and plates have been made recently in which the surface is built up by dripping, pouring, or splashing plastic solutions on to the plate. Boris Margo in America has made this technique very much his own and the results of printing from such plates by intaglio methods are curious, but I have seen no other artist who seems to have been stimulated by them.

Although it may seem of little interest to the print collector to be informed of the quality of the wax coating used to protect a plate

from acid, where this character changes the whole appearance of the print it may still be worth while to know how that appearance was caused. A mixture of similar hard grounds (already described) with tallow or grease, known as soft ground, has some peculiar properties, and its use can be immediately recognized in the print. One can see that on such a surface the fingers, a stick of wood, a scraper, or any irregular texture could be used to open up the metal to attack by acid. One ingenious method of using such ground was current in the nineteenth century: a drawing traced over a sheet of paper laid over such a ground would pick up the grease (and expose the plate) wherever the pencil touched its surface, leaving a pencil line having

the texture of the paper on which it was drawn, or any other texture intercalated between paper and plate. Whenever in a print from an etched plate a pencil line is found, it is most probable that it was made by this means. Overall textures can also be laid on such a ground by rolling, pressing, or rubbing: if a woven texture is laid over a plate coated with such a ground and passed through a press with a moderate pressure, when lifted, every thread will expose a line in the soft wax. Acid can then be used to bite this trace to any needed depth. The purpose of the use of such screens in a print may be simply to decorate a surface, to fill between lines, to produce in black and white the equivalent of colour, or to serve, as in the prints of Gillray (1757–1815), as a general background. It has been in use by the Atelier 17 since the late twenties when we arrived at it independently while seeking to find a neutral surface to contrast with the active and violent line of the burin. As with many such discoveries it proved to have resources quite unsuspected at the time of its invention, one of the most valuable of which was its use in overlapping interference to

16. ARMIN LANDECK. Fourteenth Street Subway. 1952. Burin engraving 8" × 16"

17. ANTHONY GROSS. Valley No. 2. 1959. Etching $14\frac{5}{8}" \times 19\frac{1}{2}"$

demonstrate depth in space. This use of textures has been very widely followed in most countries where prints are made, but perhaps not always with understanding. The way this demonstration of depth can work can be shown by a simple example. Imagine the possible space to be demonstrated in a blank plate as a box, like an empty stage on which two figures are represented, one down stage and one up stage. If a translucent screen is interposed between these two figures, representing the etched texture in the plate, the separation in space of the two figures becomes unmistakable. If on the same stage a series of such screens overlap, whether the stage is empty or not, the eye will be able to follow different depths with certainty, the space, having a certain density to it, no longer being the simple absence of an object. Once given such a method it becomes simple to make on a plate by successive operations the exact equivalent of a 'collage' with odd pieces of material stuck down to a board—a procedure dear to the cubists, dadaists, and surrealists. But when complete we have some conditions here which are not available to the maker of direct collages: because of the relative transparency one texture can be seen through another; the possibility exists of recording stretch and strain in them; and all these disparate materials have as it were been transmuted into one uniform material, the copper or zinc plate. Examined on a print with a glass the textures produced by this method will appear as irregular dots, the original surface of the print (and so of the plate) still remaining intact. The typical quality of transparency in this medium is due to the fact that in each successive operation the soft ground fills and protects earlier work against further attack by the acid. However, this transparency will eventually disappear when by the application of further textures all the virgin surface has been destroyed.

In certain prints textures will be observed which are not artificially applied materials such as tissues, wood-grain, leaves, fibres, the bark of trees, &c., but which have been produced by chemical or even electrolytic means in the plate itself. In the etching of open areas of metal plates by certain acids, bubbles of gas (as hydrogen or nitric oxide) are formed; if left undisturbed, action around the circum-

ference of the bubble will be more vigorous than in its centre, so that a sort of pebbled texture of overlapping circles will appear. Again a slow but prolonged acid action on most metals will reveal a texture due to the crystallization of the metal. Another texture of this general type arises from the use of partially resistant coatings on the plate: an example is the use of alcohol varnishes which, if put into the acid before they are dry, are gradually penetrated by it. As the alcohol in which the resin is dissolved will mix with water, the coating becomes spongy and acid soaking through it etches a moss-like texture into the plate. The reason these textures have been described in such detail is that they have greatly influenced the development of contemporary print-making. Possessing no intrinsic virtue, they become of great interest—and, indeed, vital—only when their use enables the realization of ideas otherwise impossible to project. A curator of prints in America (where competence alone no more qualifies a man for such a position than it does in Europe) was heard to criticize a print submitted to him as having insufficient variety of texture. Having been entertained by the ingenuity of many of the members of our group with everything from nylon hose to crêpe de chine, the simple organic quality of the crystal pattern seen through the pebbled texture produced by the acid made no appeal to his jaded senses.

Another order of print from an etched plate in which areas of different tone are employed rather than linear systems, is generally known as aquatint. In one variety, known as sand-grain, the whole plate is prepared by pressing sandpaper into a hard ground; we have here in fact another case of the texture method described above and possessing its characteristic transparency. But the most generally employed method of aquatint is that in which resin dust or asphaltum powder is dusted over the whole plate surface, heated to cause it to adhere, then each separate area etched to the depth needed to hold layers of ink to give the different tones. The grain of such a print, which can easily be seen through a glass, is determined by the size of and interval between the specks of resin or asphaltum. Mechanical devices, such as a sort of box in which a cloud of dust is allowed to settle on the plate, are used when a very even and uniform grain is

needed; its use is characteristic of the artisan, etching plates for printing in black or in colours, intended for the reproduction of original works. The artist using the medium will often scatter the dust irregularly from a silk bag or even deliberately vary the size of the grain. It is clear that an optimum quantity of dust is needed; a greater quantity will cover too much of the surface and, as the grains will fuse together, produce a coarse texture; too little will again give a coarse texture and, offering so few points, will wear rapidly in printing. Now if we consider a plate on which some line or texture already exists and it is to be treated wholly or in part by this means, while the surface is being etched away all previous work is open to the attack of the acid; furthermore, with the exception of the points of resin, it is itself being destroyed; thus the tone being produced will be characteristically opaque as compared with the transparency of texture of sand-grain. These qualities, which can be easily verified by inspection, are none of them absolute; we have seen that if repeated often enough textures can arrive at opacity; on the other hand, when lightly etched or when the proportion of surface protected by the resin grain predominates over the exposed surface, some degree of transparency may be found in aquatint.

It may be worth while to describe the usual procedure in making such plates which is, of course, similar to the operation in work with textures. A plate, already etched with line or not (the pencil line made by soft ground is often used so that it will disappear into the tone of aquatint), is prepared with the grain and areas to be white stopped with a liquid varnish. If this varnish is transparent it will be easier to follow the progress of the biting. Etching to the different degrees of grey, each step being covered with varnish, is continued until ultimately only those parts to print in full black (or in full colour) are exposed to attack. Such a succession of operations on a plate will give on the print a mosaic of white, of greys, and black (or corresponding depths of flat colour side by side). In many aquatint prints, however, gradations of tone from white to grey to black are found. These are produced by progressive biting of the prepared plate, which might be lowered into a tilted acid bath little by little, dark

edge first. Another method of obtaining a similar result, quite distin-
guishable with a glass on the print, is to accumulate more resin in the
parts intended to be lighter; here, owing to the fusing together of the
particles of resin, a change in texture will occur as well as a change in
tone. Again, if a plate has been completely re-prepared and re-grained
several times, interference between flat planes or gradations becomes
possible. Detail modelling can be realized by manipulation of the
acid with brush or swab; or by progressive stopping of the tones with
such material as wax crayon—in which case an effect is produced
similar to the appearance of white chalk on grey or black paper. An
even more precise method, and one in which the action taken re-
sembles more closely the action of a sculptor modelling, is to scrape
and burnish away the tooth of the plate already etched to print black
(see mezzotint, Chapter 4). The quality of such passages, due to the
direct work of the hand tool on the metal, is warmer, richer, and
more organic than the result of chemical action on the metal: it gives
to the print a quality rather like that of hammered silver. This again
is a character that the layman can distinguish; to carry out this work
a considerable degree of competence is necessary, and the collector
who exercises discrimination could recognize in this the difference
between the work of an artist and that of an artisan. Its interest once
more is the presumption of originality in the medium itself, rather
than the intelligent transposition of an artisan.

I recall about 1937 Picasso was making an enormous aquatint of
one of the Guernica weeping heads. In a second state, when the main
lines of the head were already etched, the background was aquatinted
a uniform black. He then proceeded, with scraper and burnisher,
patiently to remove the whole area which again became white. In a
number of his paintings at this time a somewhat similar operation had
been followed. After the whole canvas was covered with black and
violent colours, at the last stage the entire background was heavily
covered with white with a spatula. Through this white, however,
pinpoints of powerful colour appeared which animated the white
surface in a subtle fashion as if the white itelf were slightly tinted
with blue, with green, with orange, &c. As he pointed out to me

18. ENRIQUE ZANARTU. Image de soleil froid. 1949. Etching $14\frac{5}{8}'' \times 18''$

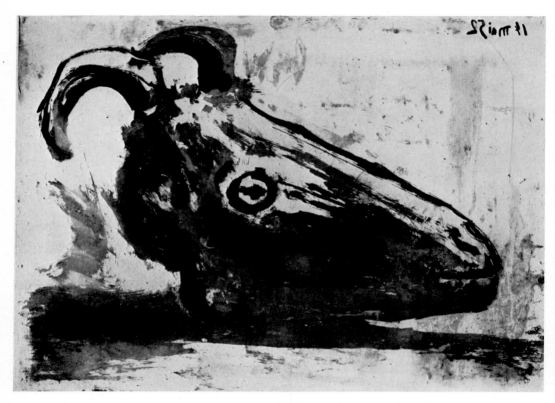

19. PABLO PICASSO. Goat's Head. 1952. Aquatint 12″ × 20″

at the time, the labour of scraping and burnishing the final white back-
ground of the plate was not misspent; like the burnished passages in
some Goya prints the white of this background was the white of satin
while the unworked plate showed the blank white of cotton.

In the classical technique of etching, a line of space so wide that it
would not effectively hold ink in printing was known as a 'crevé' and
was considered to be an error. The appearance of such a shape on the
print is grey, in relief, the edges being black. This appearance is due to
the fact that unless the depth of the hollow in the plate is at least one-
half its greatest width ink will be retained only in its margins and the
central part will print grey. In preparing a plate for aquatint, if the
grain is insufficient in an area intended to be etched black, or if biting
has been prolonged until the points protected by the resin are etched
away, an effect of this sort will appear. In the past, to provide the
tooth necessary to retain ink in these open hollows a fresh aquatint
grain might be deposited and bitten or the interior of the form cut up
with drypoint (see below) so that ink was retained between the burrs.
In the Atelier 17 it occurred to Arpad Szenes to make use of such bitings
deliberately on a very large scale to complete a plate begun with
etching or engraved line. The effect he produced was rather that of
several depths of transparency, as when water spreads across a flat
surface. Further investigation showed that this method too had quite
unsuspected consequences. When a large part of a plate, already
strongly worked, is exposed to the attack of the acid, that previous
work is very slowly washed away until it becomes both in the plate
and in print like the weathered 'sgraffiti' on a rain-washed wall.
Throughout the area a character due to the bubbling of the acid may
appear, and in certain cases a pattern due to the crystallization of the
metal may also show itself.

But further experiments in the demonstration of space showed that
one particular consequence of this operation had more importance
than any of these other qualities. Let us suppose a round hole is
etched out of the plate in this manner; as the print from this plate is
like a cast from a mould this hollow will be embossed on the paper
and will be seen as such; it will stand up above the background of the

rest of the plate. Now let us suppose that the reverse operation is carried out: a round spot is covered with a resist and the remainder of the plate, as background, left exposed to be etched away by the acid. Strangely enough, when this is printed, although by touch one can verify the fact that the central form is indented with relation to the background, yet it will appear unmistakably as a concrete island floating in an indefinite space, in fact as it actually is on the plate but the exact reverse of what is really on the paper. It must be clear that, both these effects arising from the same action and differing only in the situation or configuration, one operation can produce the two at once.

To the student of prints this particular situation is of very great interest as it illustrates an expressive quality in intaglio print-making which does not exist to the same degree in any other medium. With practically every means used in an etched or an engraved plate to produce an effect of space, the relief is actual relief, there is a real change of level: in other words the space is real, and not implied. However, as we have seen above, the space though real is ambiguous; that is, it will work under certain circumstances as effectively in the negative as in the positive sense. Again we have gone into great detail about the consequences of this operation, as the method has been greatly extended in recent print-making and, as I will try to show, involves some possibilities which have hardly yet been exploited and are of great interest. In the print of Helen Phillips (Pl. 22) it should by now be easy for the reader to recognize near the edge of the plate deep bitten spaces which are clearly seen as background of undetermined depth. Now if the reader will follow with his eye one of these spaces as it narrows and in consequence becomes capable of retaining more and more black, it will be found to have become a concrete element in relief in front of that original surface of the plate which was near the margin. At the same time there is no point that one can define at which the two elements can be seen on the same level. If we continue to follow one element right across the plate it will be seen again to have become a space of indefinite depth at the farther edge. Physically what we have is a concrete demonstration of a curved space (convex in this case) interpenetrating the plane of the

original surface of the plate. It is as good a demonstration of the curvature of space as I know. I want to make it clear that this is totally different from the representation of an image dissolved around the edges into a vague background. The means used in the case we have cited are completely concrete and verifiable yet the result remains completely mysterious. Why this should be done at all is another question which I shall deal with elsewhere. The etching of plates in different depths for the purpose of printing multiple-colour images from a single operation has been much employed by the Atelier 17. As this effect depends chiefly on the method of printing applied to it, it will be described in detail in Chapter 5, together with other methods of printing from intaglio plates.

4

THE MAKING OF INTAGLIO PLATES. II

By line-engraving, mezzotint, and sculptural methods

ANOTHER method of producing plates capable of printing lines and textures by the same operation as printing from intaglio is generally known as drypoint, from the fact that the direct scratch of a steel, sapphire, or diamond point on the plate, without the action of the wet acid, is the only means used. A moment's experiment will show that in drawing a point across a polished copper surface, as much burr is raised above the surface as groove is scratched into it; and if a little oily black is rubbed into this scratch, far more of it is retained by the burr than is held in the groove. Thus when a print is made from a plate worked in drypoint, except in those parts where the burr has been removed carefully with a scraper, more ink will lie level with the surface of the print than will be seen to stand up in relief above it. Using the same point, three quite different lines can be made depending upon the angle between the point and the metal surface at the moment of cutting. One of these angles produces a single strong razor-edged burr on one side of the line (away from the hand); a second where the point is drawn in the direction of the line produces a double, but slighter, burr, also with a knife-edge; the third with the needle more or less upright and almost at right angles to the line, produces a saw-edged burr and prints as a very powerful blobby line. These three qualities are quite readily recognized with a glass on the print, sometimes one after another in the same line. From the foregoing one sees that the technique of drypoint demands considerable skill of hand; it is unfortunate that, misled by its apparent simplicity, many artists have made plates by this means without giving them-

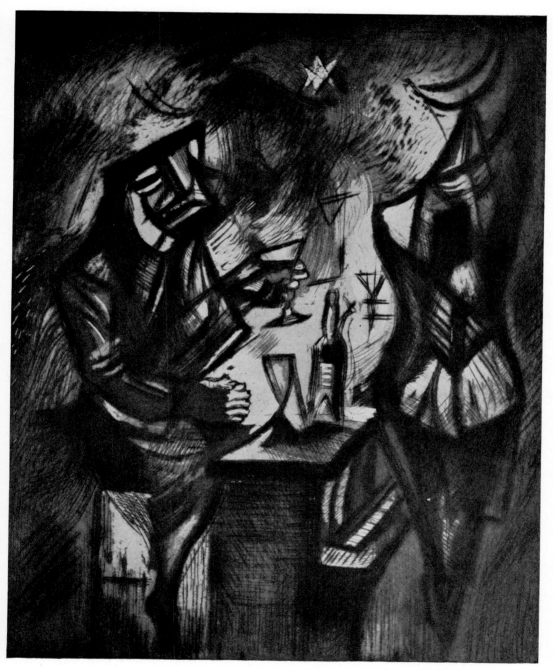

20. MERLYN EVANS. The Drinker. 1949. Aquatint and drypoint $8\frac{3}{4}'' \times 6\frac{7}{8}''$

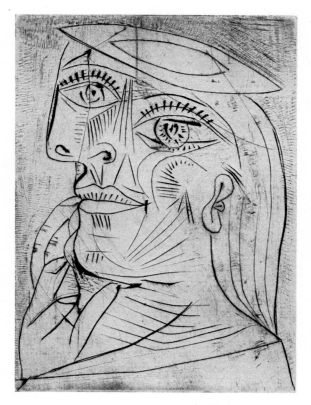

21. PABLO PICASSO. Woman's Head. 1937.
Burin engraving $4\frac{1}{16}'' \times 2\frac{15}{16}''$

selves the time to acquire such skill. Although the rich velvety blacks and subtle greys of this technique have special qualities, it has the disadvantage of being somewhat fugitive for the following reasons. If we visualize the drypoint plate at the moment of passing under the press, it is clear that the very great pressure needed to print is being borne by the saw and knife edges of fragile burrs raised above the surface of the plate; it is to be expected that, even if reinforced by steel facing, these burrs will be bent down and worn away, and owing to the difference of their resistance, not uniformly worn away. It is a commonplace when one is making drypoints that never again will the same strength and richness of the first proof be seen; that first passage through the press will have reduced the sharpness of some burrs. The usual practice is to aim at an effect which is realized in about the third proof, when the plate is steel-faced in an attempt to maintain this effect as long as possible. One of the attractions of drypoint to the collector of former times was that if two unnumbered proofs of one same plate could be obtained, even without a glass it was possible to determine which one was first printed.

One more variety of technique, now rarely used to make complete plates but frequently to repair or complete errors in aquatint, is known as mezzotint. Invented in the seventeenth century as its name suggests to produce half-tones, it appealed so strongly to our forefathers that it became known elsewhere as the 'English Manner'. A print made in this manner looks rather like a charcoal drawing and close inspection with the glass will show that the tone consists of ordered rows of dots. In the classical use of this technique a tool with a curved, serrated blade is rocked, generally in four directions, over the whole surface of the plate. When the operation is complete this surface is completely covered with small pits each carrying a slight burr; when printed, a velvety black, similar to the black of the drypoint line, will appear over the whole surface. Work on this surface with a scraper and a burnisher can then produce a complete range of tone from black to white. The reader will immediately recall the procedure described above to obtain modelling in aquatint, and in fact plates to be worked in this manner, also known as 'Manière Noire', the black manner,

could as well be prepared by aquatint, by covering the complete surface with drypoint lines, or closely-set etched lines. The operative point in this category is the working of the plate with scraper and burnisher from a uniform black to a complete range of tone. The reason that this technique is seldom used by artists today is not so much its mechanical difficulty, but rather the fact that the form in which these artists visualize their image is seldom that of the soft gradations of a charcoal drawing. It is, however, to be expected that the technique would prove a great resource to skilled artisans for reproducing in black or in colours the work of masters. In the early nineteenth century plates of Turner, begun by him in soft-ground etching, were completed in mezzotint by skilled artisans. In the reproduction engraving by Jacques Villon, after a painting of Georges Braque (Pl. 36), traces of mezzotint are to be found, as in the 'Lobster' of Roger Lacourière, after Picasso (Pl. 33); though in these cases a small toothed wheel called a roulette is used where an increase of tone is needed rather than the rocker used in classical mezzotint. A true mezzotint plate, depending as it does upon the burr for the richness of quality, suffers like drypoint from the pressure and wear in printing; like drypoint no other print will have quite the richness and intensity of the first proof. For this reason, when the roulette is used as above to repair an aquatint plate, the passage is frequently overworked and the burr then removed with a scraper before printing.

In some line engravings (as Hayter, Pl. 15) white elements, apparently whiter than the paper of the print and embossed in relief in front of it, are to be found. These forms were first used by me in the Atelier 17 about 1933 with the notion of extending the actual relief of the print; inspired probably by the example of certain Japanese prints of the nineteenth century in which the paper is formed into the hollows of an uninked wood block to provide white reliefs above the print surface. The device was quite simple: either by etching out or carving out hollows in a plate which could either remain uninked or be readily cleaned out after inking, or again by drilling out a hole through the plate, when wet paper was moulded into the plate surface by the press a white embossed relief appeared. Once we had made

22. HELEN PHILLIPS. Composition. 1955. Deep etch surface colour $4\frac{1}{4}'' \times 5\frac{1}{2}''$

23. BERTIL LUNDBERG. Landscape. 1956. Soft ground, aquatint, and deep etch $9\frac{3}{8}'' \times 14\frac{7}{8}''$

such shapes we found that prints made in the sixteenth century from plates intended for the decoration of boxes, having four holes in the corners, showed exactly this white relief where the paper was embossed by these holes. In the light of this experience the device has since been available to any engraver; the reason it had never been previously employed as far as I am aware is undoubtedly that no need for it had been felt.

The Hungarian-French sculptor Étienne Hajdu has recently used this device in a very simple but effective form (see Pl. 26). Seeking for a graphic equivalent to the flattened marble forms he was pursuing in his sculpture, he cut out a number of shapes from the zinc plate, arranged them in patterns on the bed of a press without inking, and printed them white on white on damp paper. As, of course, the paper will be embossed around the forms and compressed on their surface, a curious relief is obtained upon the paper in which the polished whites on the plates appear to float on the rougher texture of the sheet which still shows the original grain of the hand-made paper. These polished whites have a texture which is somewhat similar to the surface of his polished marbles. When he first made these prints he consulted the *patron* (myself) as to whether one could really call these prints at all. I gave him my view that anything made by impression was a print: if it had never been seen before in that form, so much the better.

Working with soft metal plates (generally zinc) Pierre Courtin has made a most interesting development from this technique. There existed in Mycenaean times in Greece a method of making clay figures which consisted of hollowing out one half of the complete form in each of two stone slabs, then making a pressing in wet clay between the two moulds. The late Moissey Kogan in France used to make such sculptures, in which, as he pointed out to me, the deeper one cuts the fuller the final form becomes. Courtin has hollowed out his plates to a very considerable depth, as much as 2 mm. After inking with some black and often a little colour, damp paper is moulded into this matrix, to produce a coloured relief. As the third dimension in all such prints appears greatly exaggerated, a depth of $\frac{1}{2}$ mm. being very

conspicuous, the sculptural effect of the print appears at least half-round. The reproduction of this print (Pl. 27) gives the effect of a sculpture in monumental scale, although its actual dimensions are about 4 in. by 5 in. It is interesting to compare this work with certain of the very large prints we have reproduced. While the small work of Courtin has very large apparent dimension, some of the others could well have been smaller. As I have suggested elsewhere in discussing the problems of scale in print-making, my own view is that if the observer has the feeling that the work could have been smaller without loss of effect, or even with greater effect, then the work itself should have been smaller in scale.

Some curious and unexpected consequences arose from the use of such forms. It was found that the slight trace of ink driven into the edges of such hollows by the hand in wiping the plate surface formed dark haloes around the embossed whites (see Chapter 5 on printing methods) which isolated these whites from the apparent print surface, making them seem whiter than the paper background and as if on a glass in front of it. Here a most peculiar result was observed: if a certain figured space had already been developed in a plate, when these elements were present, this space became very much deeper. In a stage set, where a painted backdrop suggests a perspective, let us say a row of trees, the result is unconvincing and would not deceive a child. Let us, however, place a practical tree in such position before the backdrop that there is apparent continuity with those in the painted scene, and an enormous increase in apparent depth is immediately obvious. If cuts are made through a plate with a saw, or even the plate cut into pieces which are afterwards reassembled on the bed of the press at the time of printing, it is clear that white lines in relief corresponding to these saw-cuts will appear on the print. The print of Georges Adam (Pl. 13) shows this effect. An experiment made by Fred Becker in the Atelier in the 1940's gave a very interesting result. He cut into a plate from the edges in a number of directions in such fashion that no two cuts actually met, so that the plate did not fall apart, producing an abstract composition of white lines above the compressed surface of the printed sheet. The first use in the

Atelier that I can recall of plates cut apart and reassembled for printing was by Georges Lecoq-Vallon about 1934.

There exists a method of making the exact equivalent of an etching or aquatint by photographic means, often used for making facsimiles of etchings and engravings, or even for reproducing photographs. Known in France as heliogravure, it depends on the properties of a light-sensitive coating, somewhat like a photographic emulsion. If a copper plate is coated with a solution of gelatin and potassium bichromate while wet (often by spinning the plate so that centrifugal force distributes the coating evenly), it is not sensitive to light. However, when dry it becomes sensitive to light: if it is then exposed under a negative, those parts of the coating which are protected from light (hidden by the black of the negative) remain insoluble in water, while those exposed to light can be washed away. Prepared in this way, the plate may be etched with acid (generally iron perchloride as this does not destroy the coating) in line or tone similar to aquatint, and the results are very difficult to distinguish from original etchings. There are ways of distinguishing them, however, which are described in Chapter 12, where reproduction techniques are compared with direct autographic methods of print-making.

Another method of applying aquatint comes in a way under the heading of methods of reproduction. In the use of aquatint previously described, it is clear that each form to be etched has to be left out on the plate: i.e. the forms to appear have to be drawn in negative. Means were found to avoid this (considered by laymen as one of the chief difficulties of etching) and to permit an action on the plate in which the stroke of a brush could itself appear as an aquatint tone. The procedure is as follows: a mixture is prepared of enough ink to be visible, and syrup, sugar solution, sometimes a trace of soap, gum arabic, or gamboge. The essential of the mixture is that though it sets on the plate it does not dry completely. The design is drawn freely on the plate with brush or pen and the whole plate covered with an acid resist, generally by dipping to avoid disturbing the sugar solution. When dry the plate is soaked in hot water, when the sticky material lifts, exposing the plate to attack by acid in those forms that have

been drawn. For this reason the mixture is known as a lift ground. A resin grain is sifted on to the plate, heated to make it adhere, before the plate is bitten exactly as in the other forms of aquatint described. From the foregoing description the whole operation, which needs to be done with extreme care, would seem to lie more in the domain of the skilled artisan than in that of the artist; the illusion of direct action due to the fact that the brush-stroke on the plate does appear, after many vicissitudes, as a brush-stroke on the print, can be contrasted with the far simpler action of drawing directly on soft ground. However, when it is essential for the true expression of the artist that the stroke of the full brush appear on the print, the whole procedure is justified.

In the print of Georges Rouault (Miserere, Pl. 29) the heavy blacks are done by this means, to resemble the strong black gouache outlines in his drawings, but nearly every other technique of acid on a plate has also been used with great freedom, and even slight retouches with mezzotint. About these plates a story exists, which I will repeat as it was told to me, but with no guarantee of its authenticity. It appears that Vollard had contracted with Rouault to make a series of plates, and after the passage of many months or even years without the work being completed, became understandably impatient. He is said to have borrowed the whole set of drawings for the series from Rouault, had them photographed on to heliogravure plates of the formats required, etched, and delivered to Rouault. Of course the latter was furious, and at first intended to throw the whole pack of plates away, but to a good French artisan that much good copper seemed too precious to waste, and he proceeded, with aquatint, etching, possibly soft ground, deep bite and some mezzotint, to complete the plates, removing in the process practically every trace of the heliogravure preparation. I recall when these plates were shown some years ago at the Museum of Modern Art they were enormously admired, and the fact that they had been made from a heliogravure preparation was noted. This unimportant detail impressed very strongly the aspiring etchers who saw them and immediately thereafter there appeared in New York a fearful rash of heliogravure

24. JOHNNY FRIEDLAENDER. Composition. 1955. Aquatint and etching $18\frac{1}{4}'' \times 14\frac{1}{2}''$

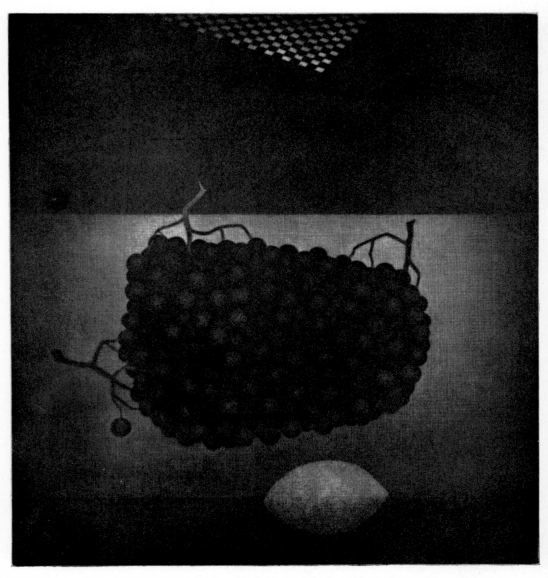

25. YOZO HAMAGUCHI. Bunch of Grapes. Manière noire, colour $12\frac{3}{4}'' \times 11\frac{1}{2}''$

plates, many attempting to out-Rouault Rouault, a thing manifestly impossible, and the results were on the whole lamentable.

From the foregoing it is apparent that a variety of methods can be employed to make the surface of a metal or even a plastic plate retain ink which can be transferred by rolling pressure to the damp paper, and are recognizable on the print. Even when no great degree of indentation into the surface exists, any operation that will cut up or roughen the surface will cause it to retain ink. In fact whenever a tone is seen in a print its darkness will be an exact measure of the degree of roughness of the ink-holding surface. Almost any device to roughen a plate surface not only can be but has been used. At one time in Philadelphia a number of artists were making a variety of mezzotint in which the initial roughness of the plate was realized, not by the action of the serrated edge of the rocker, but by scoring across the plate with a block of carborundum stone or by grinding carborundum powder into the surface of the plate with a flat-iron. In Plate II, Apocalypse series (S. W. Hayter, published by Éditions Jeanne Bucher, Paris, 1932), the greater part of the surface, after the burin line had been engraved, was scored horizontally with just such a coarse carborundum stone, producing a uniform black held between the parallel burrs as in a drypoint. The transparency of the double figure was later realized by the careful work of the burnisher: the light which appears in the silhouette of this figure arises from the reduction of the roughness of the plate.

Any plate which has been hammered, dented, or scored in any way will give a print, and a method of engraving exists from the earliest times which never seems to have been much exploited. Known as criblé (literally riddled, as the plate is riddled with holes), the design was hammered into the generally soft metal plate with a series of different-shaped punches: round, oval, straight-edged, curved, wedge or square-shaped, they were used just as a letter or number punch is used by metalworkers today. Such a plate could be printed either in intaglio like the engraved or etched plates, or like a woodcut or typographic line-cut by inking the surface as described in Chapter 2. In a small plate of a head engraved by Picasso in 1938, after the

profile was complete he hammered the surface in places, giving a tone in the print which resembles this method of work. Then the background was scraped; the tool being held lightly so that as it was drawn across the metal, a typical vibration occurred, imposing a pattern on this part of the print. The effect of handwork of this kind on a plate gives to the print the quality of hammered silver in goldsmiths' work, richer and more primitive than the ordered action of etching and engraving. Abraham Rattner has made some use of this technique in America, but I know of no other cases in recent times.

It must be clear that almost any number of these methods can be combined on one single plate. As it is the final condition of the plate that determines the appearance of the print, the order in which different techniques have been applied to the plate will not generally be apparent in the print, except that work with scraper and burnisher which might have been used to correct or complete will obviously have been done last. Although perhaps not apparent on the print, if the amateur wishes to understand the thinking of the artist in elaborating and developing his image (this only in the case where the image was actually developed in the medium), some account of the order of the operations is of interest. The most reasonable order will in all cases have reference to ease of execution: i.e. where the free surface of the metal is essential to the particular operation this will be done before any operation tending to destroy or interfere with the continuity of this surface. Engraved line or etched line in hard or soft ground will plainly be easier to execute on the clear plate, and so would be done before aquatint or deep bite which destroys the surface. Textures through soft ground also demand a level surface and so would be applied after line, but again before that surface is seriously interrupted. Deep bite, being an extremely radical procedure and almost impossible to correct, would be left almost to the last. This general rule is, however, not invariable; to act in any other fashion on the plate may be very much more difficult, but if in the pursuit of the idea it is necessary to adopt a different succession of events, then the difficulties must be overcome. Thus if the line system to be engraved arises only as a result of bitten textures, the

difficulty of engraving through the broken surface of the texture will have to be overcome. Owing to their difficulty of execution, those hollows in the plate intended to print as embossed whites might be easier to carry out on a clear plate before other work was done. But for other reasons this is hardly ever possible: in view of the all-important effect of these spaces on the total configuration of space present in the print, all other elements generally need to be in view before the form and position of these whites can be determined. So it becomes necessary to master the difficulties of executing these hollows at a stage when no error can be corrected.

There is one case, however, a technique very seldom used, which we did not emphasize when it was mentioned above, in which the order of events is invariable. If a plate prepared for etching (the hard or soft coating having been opened by line, texture, or other means) is drawn on with a protective varnish, when etched the plate covered by varnish will be seen as a white line. One of the reasons for the in-frequent use of this technique is that it must be foreseen before the first biting with acid: if the plate has already gone through a suc-cession of operations it is clear that such whites must be re-covered against the attack of acid every time. However, these whites will be within the plane of the print surface, not outside it like those resulting from the operation of carving into or drilling through the metal. A curious case of this particular effect is to be seen in the Paul Klee print 'Kleinwelt' of 1914 (Pl. 32) which I was once asked to vet by a museum curator in the United States. It was clear to me, particularly in view of the technique of certain of his drawings, that this was drawn through some such material as carbon paper (which resists acid to some extent) on to a plate, further drawn through with a needle, and then etched out. The technique of drawing in question, which he employed to give a curious anonymous line, was to trace over a sheet or even a canvas previously prepared with paint, partly dried so that it remained slightly tacky. The paint then acted like carbon paper in making a tracing.

5

THE PRINTING OF INTAGLIO PLATES

In black and in colours ★ Multiple-plate and single-plate methods

THE printing of intaglio plates to provide the proofs of etching and engraving, which are currently offered for sale, is a subject on which much has been written, and more could be. I am inclined to doubt that any amount of written description would enable an amateur to take hold of the elaborate equipment used for this purpose and make a print. However, in so far as every action taken by the printer (in the ideal case the artist himself, in the particular circumstance that he has the necessary training and experience to print well) will affect the appearance of the print in the collector's hands, it may still be worth while to describe step by step what is done, and what effect it has on the final product. The press already described is nowadays built of steel; two rollers, one above the other, carry a flat steel bed between them; and one, generally the upper roller, can be turned with a star wheel, gears, or, in big and heavy presses, by a motor driving a train of gears. These rollers are in a frame which has such rigidity that it permits very high pressures to be used, up to about three tons on a big one, generally by means of screws acting on the bearings of the upper roller: the pressure can be adjusted and the travel of the bed must be slow. Between the upper roller and the bed of the press the pressure is distributed through two to four woven woollen blankets—that facing the print below is very finely woven (known as face- or swan-cloth), the others being coarser and very resilient. To ensure this quality, no material but the finest of wool is usable; even when it is subjected to extreme pressures, water (in this case from the damp paper) can pass through the wool, whereas it would be retained in any other fibre.

Close by in the press-room will be found a hot-plate, evenly heated by means of gas, hot water, electricity, alcohol flame, &c., and all the preparation of the plate for printing takes place on this heater. Beside this will be found a glass or marble slab on which the ink is prepared. As the whole quality of the print depends on the character of this ink, which is entirely different from the inks used in typography to print from the surface of the blocks already described, it will be necessary to give details. The essentials for this ink (known as *encre taille-douce*) are that it shall hold in the hollows, and that it can be wiped clear from the surface on the hot-plate. The component of the ink which causes it to hold in the lines is a certain oil, known as plate oil or sometimes burnt oil, which is prepared in the following fashion. Raw cold-pressed linseed oil is heated in a container at its boiling-point for some 4–6 hours, when a very violent reaction takes place (oxidation and polymerization) and very frequently the oil will take fire spontaneously. When extinguished by covering the container and allowed to cool, its character is completely changed and it has become greenish in colour and very adhesive.

Various kinds of black pigment are ground into a mixture of this oil and some raw linseed oil, to such a consistency, found by experiment, that it will be retained by the lines and can still be wiped clear from the surface. The plate for printing is laid on the heater, which is kept at a temperature which the hand can bear, and ink is applied with a roller or dabber made of rolled canvas. Several balls of semi-stiff tarlatan have been prepared. The first of these, which is saturated with ink, is used with a circular motion to ensure that all hollows in the plate have been filled. A second gauze, used with a very rapid movement but with very light pressure, then begins to remove the ink from the surface and the design shows itself. Further cleaning with a softer and sometimes finer gauze reduces the film of colour still retained by the surface of the plate but leaves a well-marked halo of colour around the ink-filled hollows. The plate can be printed at this stage, particularly if a soft blurred quality is required. However, for the printing of many plates the wiping is completed with the palm of the hand: an operation which absolutely determines the

surface character of the print, and which traditionally requires many years of practice to master. Even then the individual character given by the hand of different printers is recognizable. One of the great printers of the late nineteenth century, Delâtre, printed the plates of Meryon. In his workshop were several printers, one of whom, his foreman, also printed from these same plates. The character of the hand-wipe of the two printers is so distinctive that it is possible for an expert to say with certainty of two different prints from the same plate that one is from the hand of Delâtre himself and the other from the hand of his *contremaître*. It has become the custom to print most plates hand-wiped; but at one time practically all etched plates and many aquatint plates were further treated by dragging a loop of soft gauze lightly across the plate in all directions (known as *retroussage*), which pulls out and spreads a trace of the ink from the lines, and, in the case of aquatint blacks, draws some ink over the pinpoints of white which represent the presence of the resin dot in the plate. Even without a glass it should be quite easy to distinguish the sort of woolly halo that this treatment gives on a print from the very subtle halo left by the hand of the printer, which, particularly when found around a burin line, gives a sort of vibration to the lines as if it were at a slight distance from the printed surface. Then the unworked surface of the plate shows a slight tone, due to the film of ink left by the hand of the printer; the least clumsiness on his part—if ever his hand falls on the plate with its full weight or stops in its movement—will interrupt this film and one of the most precious qualities of a print will be lost.

Paper, previously damped (perhaps 24 hours before), is often pressed between glass slabs and arranged within easy reach of the heater and of the press. (The completely rational organization of a press-room will be described in detail in Chapter 7.) Once the plate has been prepared as described, it is placed face upwards on the bed of the press, a sheet of paper laid over it in a position marked out to ensure the margins being equal, and the press turned so that it passes through, often twice, thus bringing it back to the original position and giving an even and regular pressure. The blankets are then lifted

26. ÉTIENNE HAJDU. Estampille. 1958. White relief 25⅝″ × 19⅝″

27. PIERRE COURTIN. 1956. Print from hollowed-out plate in intaglio $5\frac{1}{4}'' \times 4\frac{1}{2}''$

and the printed sheet slowly and carefully removed from the plate. Now what actually happens during the passage of the press is that the damp paper is moulded by the pressure of the press into the hollows of the plate where it takes a firm hold on the thread of ink in the line, and in the background is practically remade on the warm plate surface. The grain of the paper, which is quite visible on the margins, particularly in the case of hand-made papers, will be seen to disappear or to have been very strongly modified by the pressure of the press. Printed sheets are often laid to dry between sheets of blotting-paper which are themselves laid between heavy sheets of cardboard; to get a flat print without crushing the relief of the ink on the paper, the prints are frequently left to dry for some hours before pressure is applied. As all this takes a certain time, in making trial proofs the sheets are sometimes stretched. A sheet of fine paper when damped may stretch as much as 3 per cent. of its size dry; if such a sheet when still damp after printing is pasted down by the edges on to a board and allowed to dry it will stretch as tight as a drumhead. A serious disadvantage to this way of treating proofs is that the indentation of the plate mark will be stretched out flat, the relief of the lines be reduced, and the relief whites which have been embossed into the hollows of the plate will almost disappear.

From the foregoing it might appear to the layman that once a plate is complete and is given to a competent printer, all prints from that plate will be alike. In actual fact the quality of printing can change the total appearance of the print so completely that it is usual for the artist, having some knowledge of printing, to be present while the trials are being made, and to initial that proof which represents his intention ('Bon à tirer' in France), when the rest of the edition will be made as far as possible uniform with this print. The factors which will modify the appearance of the print are: (A) the composition and character of the ink (which is itself affected by the temperature at which the plate is prepared); (B) the manner of wiping the plate; (C) the quality, dampness, and preparation of the paper; and (D) the pressure used in printing, which depends also on the resilience and condition of the blankets. In the case of (A), if the ink is a very

intense black, very stiff and heavy in consistency, and if the wiping be carried as far as possible (the hand of the printer being dried on a block of whiting), the result will be a print of the greatest possible contrast on that particular plate. If the plate itself has been allowed to cool at the time this final wiping is done, the ink will at this time be correspondingly stiffer and the effect exaggerated. But let us suppose that raw linseed oil has been added to the ink to make it more liquid (but not of course so liquid that the pressure of printing will squeeze it out of the lines) and that the whole preparation of the plate is carried out at a high temperature, then the unworked parts of the plate will be quite grey instead of being white, deep-bitten passages will carry a heavy tone, and the total difference between the darkest and lightest part of the plate very much reduced. This might very well be done to reduce the contrast and preserve the unity of the image on a plate which has been, intentionally or not, violently overworked. A completely unsized paper, particularly if it has been dampened insufficiently to soften and expand its fibre, could give a print with practically no tone in the background; though showing a violent contrast, it might be poor and dry in quality. A paper which is too wet at the moment of printing, particularly if actual liquid is visible on its surface, may show a pebbled texture in the background of the print due to the interference of water drops with the film of ink on the plate. If the paper is too dry, points or parts of lines may fail, showing white points similar on a small scale to the relief whites already described, and these (unless intentional) are frequently retouched—such retouches can be easily seen and are considered to detract from the quality of the print. Another frequent error in print-ing arises from the use of a sheet which, having dried somewhat at the edges, is saucer-shaped from the consequent contraction of the margin. It can readily be seen that if a saucer is flattened, folds will be made—such a printing fold, which will show a white band when the paper has been stretched, is again an error of printing.

The procedure when printing is done in colours is very similar, but the resultant print generally shows more trace of the colour in the background than the grey of the black and white print. Another

peculiarity of colour-printing will become obvious if we examine a print made, let us say, in red. At once it will be seen to have, not merely different tones of the same red, but quite definitely two or three different hues of red. Thus in what would be blacks, although a scarlet has been used, the thickness and density of pigment will almost give an equivalent of black, particularly when after looking at the print for some time the eye has become saturated with the sensation of colour. In these conditions every variation in colour will appear exaggerated, as if due to a different pigment. Further, in lightly-worked parts of an aquatint or in texture or open bite on the plate, the colour will appear as if progressively colder (in this case more bluish) until in the very faint pink of the background one has almost the sensation of violet. A general rule for printing in colour is to employ pigment distinctly warmer as seen on the slab (that is, closer to the red end of the spectrum) than the effect intended on the print. In the case just quoted, to arrive at the effect of scarlet it is almost necessary to start with a red-orange pigment which will give a general effect like vermilion. (Vermilion itself cannot be used to print from copper, as a reaction takes place to produce brown copper oxide and mercury which amalgamates with the metal.) Had a pigment the colour of vermilion been used, the print would appear a much deeper plum red. In comparison with a black and white print from the same plate all the values in a colour print will be reduced: the contrast between white and black being very much more violent than that between, say, white and red. Hence plates worked intentionally for colour are overworked in terms of black on white.

To preserve the contrast in a plate and still give some degree of colour, a proportion of intense colour is often mixed with the black: the persistence of the black colour being so great that a very strong pigment is needed to modify it. Blacks in such a print are hardly less intense than when the pure pigment is used, but the second colour shows itself increasingly as passages become lighter. Yellows or other very light colours require very special precautions in printing: as traces of black ink are to be found almost everywhere in a printing shop, extreme care has to be taken to keep the hands, the gauzes, and

consequently the plate free from any trace of black, which would immediately spoil the freshness of colour.

To achieve a print showing a number of different colours a method was devised in the nineteenth century in which patches of different colours were applied to different parts of the plate with dollies (*poupées*), each colour being wiped with an appropriate gauze. The effect will be a series of tints, one melting into another; if black is used in the plate the colours are unlikely to be either clear or brilliant. The method was used at one time to produce a variety of print known to the trade as 'Bedroom Etchings'. These works, frequently oval in form, represented elongated females, dogs of similar configuration, or fur-bearing animals; with a basis of sepia or brown they were delicately tinted in pinks, pale greens, and yellows. I dare not imagine the function for which these objects were intended. Yet even as unlikely a technique as this has been used for instance by Krishna Reddy to vary the intaglio colour in the very powerful print reproduced as Pl. 34. Also, in the printing of successive colour plates described below, if one colour is to appear only in one part of the plate it is often possible to ink one half of the plate in red, wiping it outwards from the centre, and the other half of the plate in, let us say, blue, which will then be wiped outward from the centre in the opposite direction to avoid mixing or blurring the two colours. As such an operation will avoid one complete printing it will always be employed where the elements of colour are sufficiently separated to permit it.

To produce a print in complete colour a method is used which has not changed essentially since the early nineteenth century. A series of plates is made, generally by means of aquatint; each plate carries a single colour and they are printed in succession on the same sheet. The operation of printing these plates is in no way different from that described above once the analysis of the colour original has been made in terms of 'separation'. The problem of causing the different images in colour to arrive in the same position on the different plates is sometimes resolved by tracing, by photography, or by printing back on to each fresh plate from a proof of the first plate (or key

plate). If a print in black is made from the first plate and while still wet placed on a fresh plate exactly the same size and passed through the press, the image will be printed back on to the new plate. But even here some method is necessary to ensure that the edges of the print coincide exactly with the edges of the plate. The system used

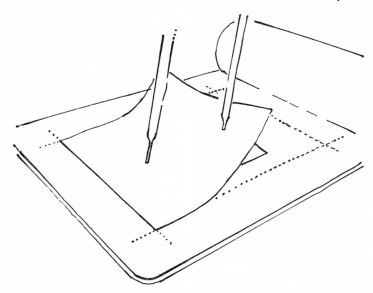

is the same as that for the final printing of the edition. All the plates are assembled together with their edges in line and two small holes drilled through the whole pack, in such a position that as far as possible the pinholes in the plate will be concealed by a strong dark in the print. All the paper is then pricked through with a needle passed through each of the two holes in one of the plates. Owing to the expansion of the paper when damp, it can be seen that for the greatest possible precision it will be wise to do this with paper already damped; in fact for all the subsequent operations of printing to register perfectly it is in theory necessary that every time the sheet is to be printed on it shall be damped to the same degree. In making the 'counter-proof' the still damp print from the key plate is placed above the second plate on the bed of the press, a needle in a wooden

holder threaded through one of the holes in the paper and engaged
in the corresponding hole in the plate. A second needle passed through
the other hole is then used to feel gently for the second hole in the
plate; when in position, the sheet is allowed to drop down the
needles and should thus fall exactly into place.

The counter-proof having been made on the plate, the image to
represent each successive colour is then etched on it in line or aqua-
tint. A simpler device for reprinting an image back on to a plate was
used in the Atelier 17 at one time. In this method the position of the
plate was marked with great precision on the bed of the press and the
first print made on a sheet of paper rather longer than usual. As soon
as the roller of the press had passed over the plate, blankets and proof
were lifted and laid back over the roller, all being still held in the press.
The key plate was then replaced by the second black plate, blankets
and print pulled down over it, and passed through, when a print was
made exactly registered on the plate. It is worthy of note that none of
these methods is absolutely precise: in the first method stretching of
the paper can involve an error of a millimetre or so; in the second
case, after only one pass through the press, the paper has become
stretched in length, and even when dry will never return exactly to
the length it once had; then again, owing to the slight displacement
of the blankets as the roller passes over the thickness of the plate, the
register cannot in theory be guaranteed to less than one-half of this
thickness. In this connexion I have known Haasen to 'calender' the
whole pack of sheets through the press before printing. Examination
of the edges of colour prints made by this system will nearly always
show some errors of registration between the different colours, and,
unless extreme care has been taken and the paper been very tough,
will also show a great weakening along the plate-mark which has
been subjected so many times to pressure. Another disadvantage of
this method of colour-printing arises from that relief above the surface
of the paper which the amateur can easily distinguish on any intaglio
print. Even when each printing in colour has been allowed to dry
completely before the succeeding colour is printed over it, it must be
obvious that the full, sharp relief can only be seen from the last

plate printed, that of all other plates having been flattened by subsequent passes through the press. The whole of this procedure will by now seem to the reader typical of the practice of a skilled artisan rather than a process by which the original thought of the artist becomes visible directly in a print. It is true that in workshops like that of Roger Lacourière such prints have been and still are made with astonishing skill from paintings, gouaches, or water-colour originals; the artist having touched neither the plate nor the proofs except to sign them. It must be clear to the reader that I would consider this last performance the most abject abandonment of the artist's freedom. The 'Langouste' of Picasso (Pl. 33) is a case in point, and is beyond dispute a very beautiful print. In other cases the artist may actually have worked on or entirely made the key plate, or even all the plates.

However, in the past there have been collaborations between two artists, of very similar stature, one being an extremely skilful artisan, which have resulted in works of collaboration of the quality of the Jacques Villon–Georges Braque print reproduced as Pl. 36. During this same period Villon was by similar methods making plates of his own invention like the one reproduced (Pl. 1). But in order to survive he was carrying out for a publisher a series of reproduction aquatints of which very many were of originals of artists one might consider of lesser interest than himself. This seems a waste of talent but let us not criticize the taste of the publisher: it is rare that a publisher of prints has any; or, if he should have, that he exercises it. His criterion must be what he estimates to be saleable to the public, and if we feel that Villon's time was wasted, only the taste of the public of his time can be accused.

Apart from these two methods of printing in full colour, a method has been developed in the Atelier 17 which is based on the idea that when a plate is inked for printing in intaglio a considerable proportion of the surface of the plate remains free and can be used to carry thin layers of colour, even several layers one over another. To the layman this process will seem so obvious that he will be surprised to hear that it was not carried out successfully long before, as the

advantages of producing a full colour proof in a single operation, rather than having to recommence the whole operation three or four times, are obvious enough. Of course it had been tried before, and what happened to the printer attempting it was probably what happened to us many times during the fourteen years we spent developing this method. To return to the description (p. 52) of intaglio printing, we have seen that to print successfully the damp paper must be moulded by the pressure of the felts into the cracks containing ink. Almost any printer will have had the experience of a drop of oil falling on the plate before printing; of an oil spot on a sheet of paper prepared for printing: in both cases a state of affairs in which a film of oil comes between the intaglio ink in the plate and the damp paper to which it must adhere. In both cases the print will fail in these spots. Thus if a surface layer of ink is heavy enough to isolate the ink inside the plate from the damp paper the print will fail.

There turned out to be other difficulties, due to the fact that pressure is applied in printing by a roller: that is to say a narrow band of pressure passes across the plate, and will have a tendency to push any liquid film on its surface in front of it across the page, ending in a general mess. Mr. Hyatt Mayor, curator of prints at the Metropolitan Museum in New York, has in that collection a print which has failed in this fashion: a plate I was attempting to print in two colours in 1946. In it the print is perfect for about one-third of the width of the plate, after which the colour on the surface (orange in this case) has broken down, has started to mix with the black in the lines, and at the far edge of the plate is a complete mess. The reason he wanted this print in his collection was to demonstrate to students in the future that these methods, now accomplished with apparent ease, were perfected by overcoming very serious difficulties. As I have described elsewhere (*New Ways of Gravure*, chapter 10), these difficulties were finally overcome by using surface films of colour which were in actual fact so thin that even when as many as five of them had accumulated on one part of the plate, the combined layer of surface colour could be seen to be microscopically porous, and so would permit the damp paper at the moment of impression to pass through

28. GABOR PETERDI. Cathedral. 1958. Etching $31\frac{1}{2}'' \times 22\frac{3}{4}''$

29. GEORGES ROUAULT. Miserere: 'Celui qui croit en moi, fût-il mort, vivra.' 1953. Aquatint 22¾″ × 17″

it and adhere to intaglio ink in the line. The problem of surface colour shifting under the rolling pressure of the press, once clearly understood, was solved by controlling the surface tension of the ink.

The actual procedure in making a print in full colour from a single passage through the press of one single plate is as follows. The plate is first inked in black or intaglio colour and wiped as described above. The colours to be used on the surface are prepared and rolled out in very thin layers on glass slabs with gelatin or rubber rollers. Only actual experience with printing will show how the thickness and consistency of these layers are determined, and yet on them depends the success or failure of the proof. Now let us suppose a number of flat elements of colour, with some overlapping, is required to pass through a web of engraved line and texture in the print. The astute reader will immediately recall the multiple offset used to print from three woodcuts mentioned in Chapter 2; it is clear that in that last position, where a paper was placed to take the impression, a plate previously inked in intaglio could have been used; and when the colour has been offset on to it, one passage of the press will transfer the whole to the paper. By the same means—an offset from another surface or series of surfaces—it is clearly possible to transfer any texture of any surface, as wood, linoleum, rubber, paper, card, plastic (or another worked metal plate), and lay this in colour on to the available portion of a plate worked for intaglio printing.

Another means of defining the forms of colour on the plate is to use a cut-out stencil of paper or thin metal, possibly hinged to the edges of a board arranged to take the plate, so that the relative positions of each of the stencils will be fixed. It is clear that convenience alone will determine which of these devices is used: any number of spots can easily be made by cutting holes in a stencil; however, a ring or form surrounding another form would be much less convenient, as the stencil would fall apart. But just those forms which are inconvenient to make by stencil are those most easily made in wood or linoleum. The special case of serigraph (essentially a stencil in which all parts are retained by a screen of silk) will be described in detail in Chapter 6; but it can readily provide means of making colour forms

of the greatest complexity and freedom, though it has to be applied
to this particular variety of printing with great caution to avoid
depositing too heavy a layer of colour on the plate. Prints made by
any of the variants of this method will show one characteristic easily
recognized: the complete system of colour modifying the surface of
the paper, neither indented nor in relief, appears to pass underneath
the relief elements of the intaglio of the plate itself—no overlapping
margins due to registration of successive impressions of the plates are
seen, and the colour has a freshness and brilliance impossible in multiple
plate processes.

 All these devices can be used to give a clearly defined pattern of
strong flat colour, modified as to value by a line or texture system in
the intaglio plate. If, however, the artist needs to use colour of great
density and opacity, and perhaps that colour in a wide range of
variants, he would choose one of the intaglio methods to produce his
plate. Occasionally, where all these qualities were needed, together
with a clear-cut change in the colour pattern (not possible by the
poupée method described), the plate has been sawn apart, each in-
dividual piece inked in a different colour and wiped as for normal
intaglio printing; the different coloured parts of the plate, reassembled
together on the bed of the press, are printed on to the sheet in one
passage. The result, which is a parti-coloured version of the same sort
of effect as that shown in black in the print of Georges Adam, also
shows the elements of colour separated by a white line which is due
to the paper being embossed by the pressure of the felts into the
crack between the pieces of the plate, exactly similar to the white
reliefs produced by hollowing out the surface of the plate. These
methods are, in my opinion, of limited application, but they have
been mentioned for the sake of completeness.

 If a plate made by the processes of etching or engraving, instead of
being filled with ink and wiped to print in intaglio, has its surface
inked with black or colour from a gelatin roller exactly as a wood
block would be inked, a relief print could be made on a typographic
press. This method has in fact been used for illustration, where it
presents the very great advantage to the publisher that it can be set

up together with type and printed like a line-cut in the same opera-
tion, instead of requiring a separate operation as with an engraving.
But if a plate so prepared is then printed on damp paper by means of
an etching press, a completely different effect will be seen. Against
a background, indented into the sheet, of either black or colour,
embossed white elements formed by the moulding of the damp paper
into the hollows of the plate by the pressure through the blankets
will be seen in front of it. The reader will recognize the similarity to
the effects seen in the print of Misch Kohn (Pl. 5), and his most
recent etchings are in fact done by this means. However, it occurred
to the sculptor Hajdu, following experiments made in the thirties in
Atelier 17 with cut-out elements of copper plates, that a parallel to the
sculptures he was making in white marble slabs could be found in
printing uninked pieces of copper plate in different arrangements on
to the sheet. These prints are, of course, white on white; they have
the quality of sculptured reliefs and do in fact constitute a category of
prints of considerable interest. Owing to the compression of the
white paper by the polished surface of the copper in printing, the
indented elements have a surface, when printed on hand-made paper,
similar to marble, which contrasts with the embossed original surface
of the rough paper surrounding the elements.

Similarly, if an engraved plate is inked in black as for ordinary
intaglio printing, and before printing its surface is then inked with
typographic black or with the original colour, the resultant print
will be a relief in black on black (like an ebony relief) or in mono-
chrome. So far very seldom employed, this particular approach
seems to me to have great possibilities, particularly for a sculptor.
Again in this order of ideas, an experiment made by Raoul Ubac in
the thirties produced not an actual relief but a very interesting illusion
of a relief. The idea arose from some experiments he was making
at that time in photography by printing simultaneously through a
negative and a slightly weaker positive. An engraved plate was first
printed in intaglio on a sheet, and without removing the sheet from
the press the plate was removed and its surface re-inked in black for
relief printing; this plate was put back on to the bed of the press

about ½ mm. out of its first position, and reprinted on to the same sheet. It can be seen that in the case of a black line in intaglio on the print, this will be doubled by a white line from the relief printing, both being seen in front of a black surface, which, owing to the lesser intensity of relief black compared with intaglio black, gives the illusion of strongly illuminated lines in relief. Although this is an illusion, like all illusions in print-making, the 'fact' is that which is seen: whether illusion or concrete reality is in this case academic. Later, another variant of this method of double impression was developed for an entirely different purpose by Karl Schrag in the Atelier 17. I have an idea that this method was suggested by a very common error which arises in intaglio printing when the press is badly adjusted and bears on the two edges of the plate with unequal pressure. As the plate returns through the press that edge carrying the least pressure is slightly displaced with relation to the plate, causing a double impression along this edge. (There are trial prints of Rembrandt that show this effect.) This blurring Schrag observed to give a curious vibration and he applied it to render the strange mood of certain of his plates. In the print 'Night Wind' the etched and engraved plate is first printed in deep green on to the sheet, the plate then cleaned and re-inked in black and overprinted very slightly out of register below and to the left of the first impression. The strange atmosphere in this print could hardly have been obtained by any other operation, and in my opinion completely justifies the means.

6

THE PREPARATION OF LITHOGRAPHIC STONES

*Printing from them in black and in colours ★ Offset printing,
stencil, and serigraphy ★ Monotype*

WITH the exception of the rather unusual method of printing in
offset from wood (described in Chapter 2), all the prints we have so
far considered are from plates either cut away to leave a surface in
relief which carries the colour or cut into so that ink is retained below
the original surface; hence all such prints show either the indentation
of the printed elements or colour in relief in the print above the
surface of the paper. But there exists an important category of prints
made by methods known for this reason as planographic, in which
ink is held on a surface in such fashion that neither indentation of the
paper nor relief of the ink above it is to be found: i.e. there is no
interference with the level of the sheet. The typical example of this
manner of printing is lithography (stone-writing), which appears to
have been discovered by Senefelder in the eighteenth century by
doing just that—writing on stone. He was, among other avocations,
a playwright, though it does not seem to have interested history to
preserve his plays. While seeking a simple and inexpensive method of
printing the parts for his plays, he had the idea that a fine-textured
local limestone could replace metal (as type) or wood. He would for
this purpose have attempted to use bitumen, wax, or other resist,
somewhat as the etcher on metal, and then to etch away the stone
with weak acid, leaving his lettering in relief. The story of the dis-
covery by pure hazard of the principle of lithography is most
beguiling. Lacking a piece of paper, Senefelder is said to have written

H

his laundry list with a wax crayon on one of the stones: in attempting to wash it off with water he wetted the stone (though it would be enough to breathe on the stone) and rolling up with oily ink showed that this ink adhered to the crayon trace and not to the wet stone—pressure applied to a sheet of paper laid on this stone transferred the trace of the crayon with extreme fidelity.

In the literature of print-making there are found various ways of describing the underlying principle that makes such printing possible, one of the most popular being to compare the effect with the failure to mix of oil and water. Thus if on an absorbent surface (such as Senefelder's stone, or a grained surface of suitable metal) saturated with water an oily trace interrupts the water layer, an oily ink carried on a roller passing over this surface would leave ink only on the oily or wax trace. However, if we wanted to analyse this action with greater rigour, a physicist would state it more precisely in terms of the viscosity (which is determined by the rate of flow: that which flows faster being lower in viscosity and so on). Now the viscosity of water is low, that of wax at ordinary temperatures very high. The oil-base ink used for this sort of printing is more liquid than wax but less so than water. Thus the principle can be stated more exactly as being dependent on the fact that a liquid of lower viscosity will repel an ink of a higher viscosity; but the ink will adhere to any material of a higher viscosity than itself. Or more simply one might say that the more sticky material takes the less, but the less sticky does not take the more adhesive. (Incidentally this is not exactly the same thing as a difference of viscosity, but the comparison is sufficient to make clear what happens.) This will become more clear when we describe the actual procedure.

A stone of the quality required is ground level with water abrasives, often with another piece of the same sort of stone, and left to dry. Drawing is begun on the surface with various crayons containing wax or resin, of different degrees of hardness; pigment in such crayons is unimportant for the result except in so far as it renders the work visible. If a pen or wash effect is sought a liquid ink is used, having essentially similar constituents to the crayons already mentioned—

30. HANS HARTUNG. Composition No. 10. *c.* 1957. Aquatint $15\frac{1}{4}'' \times 20\frac{3}{4}''$

31. ABRAHAM RATTNER. Crucifixion. 1948. Aquatint and criblé 6″×7⅞″

that is to say a wax or similar substance, a pigment to make it visible, and generally some sort of soap or other emulsifying agent to keep it in suspension. Extreme care has to be taken that no other grease of any kind gets on to the stone. Any procedure which can be used in drawing can be used on the stone, although, as in the case of all the methods previously cited, the image is reversed with relation to what should appear on the print. It is possible to scrape away with a knife or to grind with a soft stone after the work has been done on the stone, so that work in white on black is quite simple. To overcome the difficulty of the reversal of the image, the drawing is sometimes made on a grained paper, and then transferred by pressure to the prepared stone. Here, as the image is reversed once in transferring and again in the process of printing, the final image will be in the same direction as the first drawing. In the print of a lithograph it is often possible to see whether the work has been done in this way, or whether it was done directly on the stone. In the latter case, only the close, slightly irregular grain of the stone itself can be seen on the print, whereas in the case of a lithograph made from transfer paper, the interference of the mechanical grain of this paper with the finer grain of the stone itself can be seen under a glass (see Chapter 12).

Once the drawing in lithographic crayon or ink is complete on the stone, it is very lightly etched with weak acid to free the pores of the stone, washed over with a solution of gum arabic, and when dry the pigment of the ink is removed with turpentine. The stone is placed on the bed of a press which consists essentially of a sort of carriage on rollers which can be pulled underneath a yoke which provides the pressure. For printing, the surface of the stone is wetted with a sponge, inked with an oily pigment using a leather-covered roller; a sheet of paper often very slightly damped is placed over it, and over that a sheet of fibre which is greased so that it will slide under the wooden yoke which provides pressure as the carriage is drawn through. This action of etching is nothing like the action used for making plates for either relief or intaglio printing; the level of the surface of the stone is not perceptibly affected by it and so there is no deformation of the paper itself, the ink lying on the surface without indentation or relief.

It can be seen that in these circumstances there is practically no wear whatever either on the surface of the stone or on the image, which is actually held within the pores of the stone and not above it; hence with careful printing there is almost no limit to the number of prints that can be taken; nor is it possible even with the most careful examination to distinguish let us say the two-hundredth from the second, as one can in more fugitive techniques like drypoint, mezzotint, aquatint, and even etching and engraving. Printing in colour from such stones involves repetition of exactly the same action on a number of stones, each stone serving to carry one colour only, though of course that colour can be in as many variants of intensity as can be obtained by working in crayon, pen, or wash. The problem of printing a number of colours so that they shall fall exactly into place on the print is solved by a method very like that used by the intaglio printers described in Chapter 5. Near the margin of the image on the stone two small holes are made and the whole pack of sheets to be used in printing is pricked through with two holes in corresponding positions. Using needles, the printer will engage one of the points passing through the sheet with one of the holes in the stone; with the needle passing through the other hole he will then feel for the second hole, when the sheet is allowed to drop down and will be in position.

The colour used for this sort of printing may be either transparent or opaque; for some reason, perhaps because it is easier to handle, lithograph printers seem to prefer opaque colour, although owing to the grain of the stone already referred to the colour will be only relatively opaque. Examination of a colour lithograph under a microscope will show an irregular pattern of dots of colour; and as the dots of different colours will not fall on the same spots, so some degree of interference of colour will take place, whether the colour is opaque or transparent.

All the foregoing will suggest that, as in the case of reproduction etchings described in Chapter 4, a colour lithograph is more likely to be the work of a skilled artisan than to have been originated on the stones by the artist himself. Few artists possess the elaborate equipment or the technical knowledge to prepare stones and to print them them-

32. PAUL KLEE. Kleinwelt. 1914. Etching $5\frac{5}{8}'' \times 3\frac{3}{4}''$

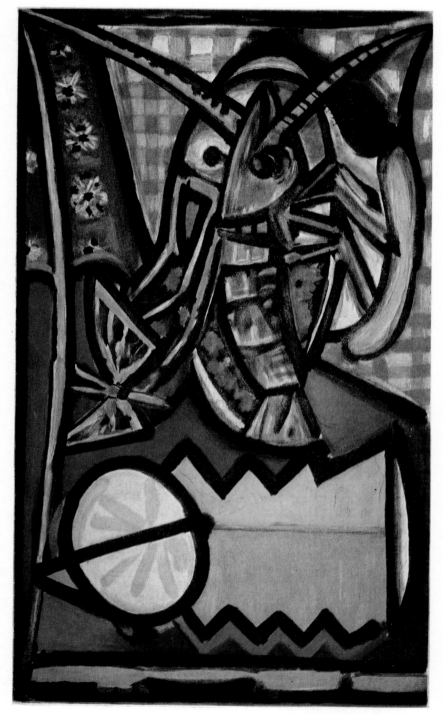

33. PICASSO–LACOURIÈRE. Langouste. *c.* 1946. Colour aquatint 10½″ × 18″

selves. Yet the colour lithograph of Ceri Richards from the Hammer-klavier series (Pl. 38), made in the printing workshop of Curwens, can be seen to have been conceived in the medium and, although printed by an artisan, is a truly original work and not a reproduction made by hand. Each colour must have been understood, together with its effect on other colours, the interference of the colours, and the play of the coloured forms against the white paper, and the design composed in consequence; just as a musician, having become familiar with the colour and range of all the instruments, can compose music for a complete orchestra. However, as we have already seen, litho-graphy is a form of drawing; in fact, of all the reproduction methods it is the most faithful, in that it is the actual touch on the stone which prints, and not the photographed, etched, cut, or copied trace. Thus in comparison with certain of the other techniques we have described, where a complete transposition of the idea takes place in the use of the medium (a transposition as complete as the development of a drawing into a sculpture) or where some concrete material arises not present in the drawing, lithography has much less to offer.

The crude autographic method of lithography just described has given rise to far more elaborate photo-mechanical methods which, important as they are in commercial printing, are of less interest from the point of view of fine print-making. Thus in the reproduction of a complex image, to avoid painful copying by hand, a photographic trace can be transferred to the surface of a stone, though in practice it is more usual to do this on to a prepared metal plate, frequently of zinc. Then when it becomes necessary to print in very large quantities, hand-printing of sheets one by one is replaced by the extremely rapid and efficient system known as offset. Based on the same transfer principle as that described in Chapter 2, the stone is replaced by a thin sheet of metal, which carries a lithographic image and is held on a drum on the press. Rollers passing over this cylinder wet the back-ground, just as the lithographer passes the sponge over his stone before each printing, and other rollers ink it. As the cylinder continues its revolution the imprint is transferred to a second roller covered with a smooth rubber blanket, which itself revolves against a third roller

carrying the sheet of paper. Thus the final printing is from the transfer on the rubber blanket of the middle roller to the sheet, and not from the original lithographic trace. It will be clear that the image on the plate is reversed and appears on the blanket as in a mirror, and is then again reversed so that it appears on the sheet of paper the same way round as it was on the plate.

The reader will probably ask himself why it was necessary to describe in detail one of the photo-mechanical processes used in commercial printing when our subject is fine prints. Unlikely as it may seem, this mechanical process has exceptionally been used for making fine prints, and in fact many of the commercial processes of printing could be used in such a way on condition that, as with the creative lithographer referred to above, the artists were willing and able to acquire such familiarity with the medium as to be able to compose freely for a result which would never appear until the last printing. I had intended just before leaving the United States in 1950 to get together a number of well-known artists and have each one make a free composition on a series of plates intended for offset, and to print them in full colour in a fairly large edition. These works would of course be originals, but owing to the sensitivity of the market and the print-dealers, it was proposed to publish this new category of print as reproductions. This would have enabled them to be sold at comparatively low prices without hurting anyone's feelings. In 1949 in New York a society called Artists' Equity, intended to protect artists from being unduly swindled by dealers, was holding a ball to raise money for its good works. The programme for this function was in the form of a booklet. Advertisers were invited to nominate the artist they desired, who made an original plate which was set up and printed by offset as we have described, on the pages of this programme. But the most interesting use of this method of printing for creative purposes I discovered when visiting Malmö in Sweden in the spring of 1956. There I found a very original and active group of artists, nonconformists with regard to the well-organized if conventional artists' groups in the country and consequently entirely dependent upon themselves. As many of them were engaged in the

field of publicity and printing and furthermore had access to an off-
set press, they were producing with their own hands a magazine,
Salamander, containing illustrations in full colour which were in
effect originals. The print by C. O. Hulten (Pl. 40) is taken from this
magazine, and is printed from what are called in the trade 'separa-
tions', but which I prefer to consider rather as components, the usual
phrase suggesting that one has separated that which was once to-
gether for it to be put together again in the final result. This print is
perhaps out of the category of 'Fine Prints'; it is in fact a page from
a magazine, yet owing to the manner in which the technique is used
it is in reality a true original and nearer to the definition of a fine
print than many a reproduction in colour lithography offered, with
signature, as a collector's item. Hulten would have drawn freely on
the grained aluminium plates already slotted for the machine; each
plate being intended for a different colour which he must be able to
visualize, together with the effect of its opacity or transparency in
relation to the other colours. He is then composing for a quartet if not
for a complete orchestra and the finished result is the only original
in this case: no preliminary drawing, even made with sheets of
tracing paper each carrying the colour to be used, would give a clear
idea of the final print; only experience and knowledge, which
through familiarity with the process has become almost instinctive,
can be called upon to produce such a result.

Of the methods of print-making used to produce a print in colour
without relief, there is one which has been frequently employed in
France though seldom in England or America. Colour is laid on the
sheet, generally with short brushes, the areas being defined by
stencils, sheets of special paper, or even thin metal, in which holes
permit the colour to pass, the remainder of the sheet being masked.
The practical difficulties of such an operation will be obvious:
although any shaped hole with a profile not too complicated will be
extremely simple to make, the moment it is required to make a form
in one colour surrounding the form of another a single stencil will
not suffice, as the centrepiece would fall out. The difficulty is overcome
by making the shape in two halves, coloured in two operations in

such a way that the edges overlap and are not seen. Such a method will only be employed where the fairly skilled labour needed for it can be easily found at reasonable rates. It will be employed only for fairly small editions, since for large printings it would become very expensive in comparison with mechanical processes. Where opaque colour is used the quality of such a print is exactly the same as the original gouache from which it was made; or the original water-colour, where transparent colour has been used. The characteristics which render stencil prints easily recognizable are the mosaic-like forms of the colour, and a very slight thickening of the layer of colour around the edges of each form. The method clearly belongs to the category of reproduction by another hand; it is practically never executed by the artist and only mentioned here to introduce another category of techniques which, though they produce extremely different results, are based on exactly the same principle.

The disadvantage mentioned above in stencil printing, viz. that the parts of a very complicated stencil will fall apart, could obviously be overcome if some web which did not prevent the passage of the colour held all those pieces together. The use of a silk screen, parts of which were filled to prevent the passage of colour, seems to have originated in China some centuries ago, to have passed from there to Japan, and to have been used by artists on the Pacific coast of the United States at least from the 1930's. I have seen no really reliable testimony as to the origin and history of this method and it would seem to me of some interest to investigate the matter. The procedure in making a silk-screen print begins with stretching a piece of fine silk with a fairly open weave on the under side of a solid wood frame about 2 in. thick, so that when prepared the apparatus resembles a tray of which the silk is the bottom. Different products are used to paint on to this silk to fill its pores either wholly or partially, according to the sort of ink which it is intended to use in the printing. In one of the simplest methods in which oil-base inks are to be used, the stopping material is simply glue, sufficiently diluted with water to make it easy to handle and yet capable, when dry, of filling the screen effectively. It is clear that those parts of the screen covered in this way

34. KRISHNA REDDY. Les Nénuphars. 1959. Single plate, colour $13\frac{1}{4}'' \times 18\frac{1}{8}''$

35. YOSHIKO NOMA. Le Fleuve. 1959. Single plate, colour $19\frac{3}{8}'' \times 14''$

will appear as whites against the colour used. It can be seen that it would also be of great advantage if the artist could draw freely in lines or forms which were to be in colour and not in white. An ingenious device is used for this purpose which may remind the reader

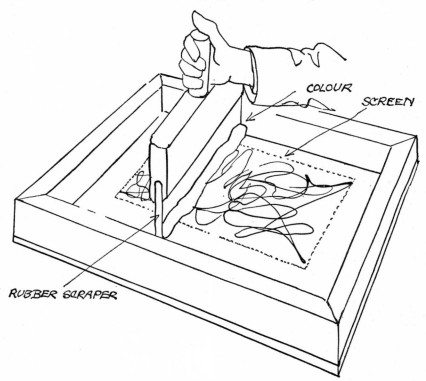

COLOUR

SCREEN

RUBBER SCRAPER

of the use of sugar-lift ground in one form of aquatint. Before covering with glue, one can draw with lithographic crayon, lithographic ink, or any other readily soluble substance that resists water; after covering with glue, scrubbing the surface of the silk with turpentine will remove the glue over these parts, since it has been prevented from adhering to the threads. At this point we have a very complex stencil which is open in those large areas not stopped with glue and, within the areas covered with glue, along those lines or forms drawn with a lithographic crayon, wax crayon or 'tusche'. To

find and maintain the position of this print on the sheet the frame is
often hinged to a board on which there are stops or a cut-out mat
into which the sheet falls. Into the stopped-out margins of the tray
an ink, often prepared with a sort of soap (aluminium stearate), is
poured, the screen lowered on to the sheet of paper, and a kind of
squeegee or scraper with a rubber blade pulled firmly across the
design, when the required quantity of colour is forced through the
silk, where open, and leaves a print. In printing a series of colours a
number of screens may be prepared to fit on to the same hinges and
the operation repeated after the first colour has dried. If the method
is used simply to reproduce a gouache original, each successive colour
screen, owing to the translucency of the screen, can be simply laid
down on top of the original and the elements of each colour traced on
to its surface. But in a method often used by artists to originate a
work by these means, after the first screen has been printed the glue
is washed out, a second preparation on the same screen (which
generally shows the trace of the first colour forms) is made for the
second colour which, after printing, is again washed off—and so
forth. Where it is required to print in water-base colours (where a
base of starch, gum tragacanth, or other water-soluble gum may be
used) other products are used for stopping or for opening the screen:
a fast-drying plastic varnish fills the screen very effectively, and a
rubber solution, not soluble in the ester solvent of the varnish, will
effectively replace the tusche used for reserving the white line through
the glue screen.

To the print collector all this may seem tedious and unnecessary,
but what he will find interesting in a particular print may well be
not the success of such a series of operations so much as the failure,
which may result in errors of register between colours or other
peculiarities which can arise in a particular print when printed by
hand. Since the apparatus necessary to make this sort of print is cheap
and not particularly cumbersome, a great many prints have been
made directly by artists themselves. And yet it is difficult to see in
what respect such a method could be said to add to the means of
expression at the artist's disposal. What would be necessary to make

a print in colour by such a method turns out to be a very similar succession of operations to those needed to make a reproduction in colour with successive printings from wood blocks or from etched plates. That is to say, first an analysis, a separation into individual colours, followed by a synthesis, the recombination of these elements to match the effect of the original. During this process it is hard to see where any conjuncture arises in which a transposition of ideas takes place; in which the exercise of the technique reveals matters not already present in the original—in other words, in which the operation itself excites the imagination or reveals images or ideas hitherto only latent. However, the fact that, as already mentioned, a large number of artists make use of this method has caused them, particularly in the United States, to band together in a National Society which, making a virtue of necessity, has claimed for this method the qualities of a medium of original expression. It is true that with a great number of these artists their serigraphs are simpler, clearer, and more effective than their paintings, gouaches, or water-colours; it appears to me, however, that in this case the virtues of the medium have acted rather in a negative than in a positive fashion. Thus the necessity of analysing the project to be carried out, the mechanical difficulties of execution, have imposed the necessity of simplifying and understanding clearly the elements of the design which were too complicated and confused in the original. If then their serigraphs are superior to their paintings it is not because the practice of the medium has added to what was there; in fact it is because the paintings were not better.

Although printing is generally done by the primitive hand method already described, in recent times a number of ways have been devised to do this mechanically and very much more rapidly. The existence of such a method of reproduction and a large number of trained people willing to practise it for comparatively small reward could be expected to interest the publishers of reproductions of works of art and of fine prints, and in a later chapter when we discuss the mechanics and ethics of publishing we shall have occasion to refer to the use of this method. Then just as the process of printing has been mechanized, so the means of making the screens by photographic

methods has been developed, so that it is possible to transfer any image from a photographic negative to a light-sensitive film on the silk which can afterwards be treated so that it permits colour to pass in lines, masses, or half-tones. It is of course quite possible to distinguish prints in which half-tones have been rendered photographically somewhat as one can distinguish lithographs made from transfer paper, or reimposed on a fresh stone; the mechanical screen used in making the negative for the half-tone interferes with the grain of the silk screen itself, and under a glass this effect can be seen. The probability of a silk-screen print, signed or not, having been made by the artist himself is clearly less if such methods were used, but as with all predominantly reproductive processes it is difficult from internal evidence in the print itself to determine the degree of originality. As with a stencil process, of which silk-screen printing could be considered an elaboration, although the surface of the paper has not been either indented or embossed, a definite deposit of colour is left on its surface, in theory equivalent to the thickness of the silk in the screen. This deposit will show the weave of the screen that has been used, although where the silk is extremely fine, or, in some cases, has been replaced by extremely fine woven wire, it will need a microscope to distinguish it. But the presence of a definite deposit offers obvious advantages in the reproduction of gouache or opaque colour in oil painting. Where this resource is made use of, the organization of colour is likely to be of the order of a mosaic of pure colour; as the operation of printing from a screen is fairly rapid and simple any number of screens may be used, ten or twelve in some cases, to build up a mosaic of great complexity. However, although rather more difficult to manage, and as we have seen far more difficult to design, transparent colour may also be used, in which case all the consequent interferences of the colours used must be foreseen. In such a case it is seldom necessary to use more than four colours, since if well understood the interferences between the various intensities of four components will result in a complete field of colour, and the addition of further tones will for each operation add less than the one before.

Having described the complicated results of the most involved

processes of planographic printing, it might be interesting to conclude with the most elementary method. Known as monotype, as only a single impression is produced, its result is frequently excluded from print shows on the pretext that, as it cannot be repeated, it is in some way unfair. It is, however, an impression, and I would not agree to limit the definition of a print to that which existed in a large number of copies, or could be produced in a number of copies. To ignore such nursery rules, it is of some interest to ask why, if only one can be obtained, should one make a monotype when a simple drawing or painting would give the same result? This, of course, is the point: it would not. The operation is to spread, dribble, splash, or smear black or coloured inks on a smooth glass or metal plate. One may work in it with a match, a stylus, a rag, fingers, &c.; drop solvent on it—in fact, take any action one pleases until something of interest appears. The paper is then laid over it and the image transferred by pressure. Here perhaps we have an answer: the reversal of the image as in most of the techniques of print-making will conceal the result in some part from conscious attention until it has been printed. Effects appear due to the physical qualities of viscosity, density, and thickness of the colour film which are not easily obtained otherwise and whose effects on the sheets are practically unforeseeable. It is true that the practice of this method is more or less by trial and error; but its result, if it possesses any intrinsic value at all, will clearly belong to our first order of originality, in that it is a work created in the medium for itself alone and not in any sense a reproduction or a translation from another technique.

PART II

Printmakers and Printers
Their Studios and Workshops

7

INTAGLIO WORKSHOPS IN FRANCE

IN Renaissance times there were two orders of artists, domestics and shop-keepers, for all that they might in their own generation become ennobled. Many artists of our time are heard to regret that they are not living and practising their crafts in the spacious days of the Renaissance; but the actual conditions of the artist of that time I think would not have pleased them. Most of our information comes from what correspond to police court records of the troubles they got into and account books of the households of princes to which they were attached. Thus we read in the conditions of employment noted in such records that Messire —— the artist, together with Messire —— the poet, will assist the second hostler with stabling the horses when the court is travelling. His status is clearly that of a domestic and the work that he executed was done to order and would be required to satisfy the demands of his patron. It may be that the artists today have equally ungrateful chores to do all the time, but at their own choice; with the loss of patronage they have acquired a considerable degree of independence, not excluding the freedom to starve; but they have in some cases reverted to the other category, the shop-keepers. But these in Renaissance times were skilled artisans and not mere ped-lars. They kept an open shop, wore a leather apron, and undertook almost as the domestics to make works of art to the orders of gentle-men who, at this time, seem even exceptionally to have been gentle. Generally goldsmiths, frequently sculptors, painters, and architects as well, these artists lived in the free cities which remained as islands of order in the chaos left by the downfall of imperial authority in Italy, in Flanders, and in Germany.

The print-makers belonged almost exclusively to this latter

category and already in the sixteenth century the necessity of assembling elaborate equipment had caused them to associate together in workshops like that of the Finiguerras, not yet specialized for the making of prints only but producing also other objects of the goldsmith's craft. In the field of printing from woodcut, such workshops had a more specialized character: associated with the printing establishment a workshop, in which *Formschneider* cut the blocks needed for impression, was set up. The organization in all these workshops had the character of the medieval guilds, with their apprentices, the journeymen (known to this day in France as *compagnons*), and the Master (*contremaître* or *patron*). As with the typographic printers, the working artisan engraver, and later etcher, was most generally associated with the printing house, which was frequently also the publisher. The illustrations of an atelier in the book of Abraham Bosse in the seventeenth century represent such a workshop, and in France in our time workshops exist similar in all details and in general organization to that of Abraham Bosse, except for the detail of the slightly unpractical costume in which the seventeenth-century compagnon worked, and the enormously heavy wooden presses which have been replaced by exactly similar presses of steel.

The workshop of Roger Lacourière in Paris, from which great numbers of prints in black and in colours have issued over the past thirty years, is a case in point. On one of the walls of this workshop, as one enters from the steps leading up to the Sacré Cœur church in Montmartre, there is a print of the Abraham Bosse atelier, and the picture facing p. 107 represents an attempt by a photographer to reconstitute in the Atelier Lacourière the workshop of Abraham Bosse. The press-room, of extraordinary shape and considerable size, contains eight presses, some of them very large, together with the steel hotplate, inking slab, stack of damp paper, &c., which constitute the 'station' of each printer. All this is beautifully organized to fill every inch of available space and permit each printer to work with the minimum displacement and unnecessary gesture. At every available place cords stretched across the corners of the workshop

carry the damp blankets hung up to dry; there is a pervasive odour of the oils used in the inks—rather like cats in springtime. Apparent disorder conceals a very rational organization which is needed to ensure that while printers work with black inky hands the proofs are perfectly clean; a clear separation between those places where ink is everywhere and the perfectly clean stacks of wetted paper and drying boards carrying the finished prints has to be observed: with time it becomes habitual to the printer, and his *mitaines*, the cardboard clips with which he handles everything that must be kept clean, are an essential part of his equipment. He wears a coarse canvas apron, often stiffened to the rigidity of boilerplate by ancient crusts of ink, and a belt with a flap of canvas on which he dries his hands. An experienced printer never seems to make a hurried movement, yet the amount of work he has completed by the end of his day (at one time a day of ten hours) is astonishing.

The hierarchy of this atelier is traditional; for uncounted generations youths have entered the guild of *taille-douciers*, the printers in intaglio, and served four years learning every operation of this intricate craft: grinding black pigments in oil by hand (it is said that a good printer must know the feel of the ink); preparing different sorts of paper; mastering the order of the workshop; and finally learning the stages in the preparation of the different sorts of plates to be printed, the hand-wiping which so strongly affects the surface quality of the print, the care and operation of the presses, the horned beasts (*les bêtes à cornes*). After at least four years the apprentice, probably convinced like most young men of his complete knowledge of the craft, reached the dignity of *journalier*, a journeyman, compagnon in the guild. He will now start undertaking the printing of whole editions that present no special difficulty; though it is likely that completely mysterious troubles will arise, as they always do in these workshops, when it will be necessary to call upon the master printer, the contremaître, who has merely to be able to resolve all problems and answer all questions. Monsieur Frélaut described to me such a situation, which is by no means rare. Paper had been prepared and the whole quantity of colour was ground to begin printing an

edition. However, when Frélaut, a journalier at that time, started to print, not one print was perfect. After a few more attempts, the contremaître told him to leave everything standing and get to work on something else. A week later he again took up this edition and from the first print everything proceeded normally and without difficulty. Frélaut told me that probably the too energetic grinding of the ink had heated the oil in the mix; when left for eight days some oxidation would have thickened the ink which then worked perfectly. I was reminded of an edition which I undertook to print in the thirties, on a Japon nacré paper, which if a little ornate did at least print perfectly and without difficulty. Trial prints on some sheets of this paper I already had were perfect; paper was ordered and everything prepared for the run. But in the morning not one single proof was good—neither by changing the consistency of the ink nor by treating the paper with ammonia, with alcohol, heat, &c., could it be made to take a good impression. In the end I went back to the importer of this paper who immediately admitted that its manufacture had become commercialized—in order to produce a sheet apparently stronger, a hard size was added to the pulp before the paper was laid; then sealed into the fibre by heat. Such a paper will not absorb water into the fibre and consequently will never give a perfect impression from intaglio plates. But the text of the book these engravings were to illustrate had already been printed on this paper; so in the end we had to *contrecoller*, that is lay a small piece of Chinese paper (cut exactly to the size of the plate and damped with gum) over each inked plate and cover with the defective nacré paper, whereby the print inset on the China paper appeared on a background of Japon nacré.

To return to the hierarchy of a taille-doucier. I questioned Frélaut as to the exact length of service needed before a journalier could become a *maître imprimeur*; he replied that if ever (for few journaliers will ever become masters), it could well be fifteen years; he knew of no case under the age of thirty-five, and the determining factor he thought was the chief's going round the workshop at the end of the day and measuring with a yardstick the height of the stack of proofs on the end of each man's press. Still, I would maintain that a hierarchy of

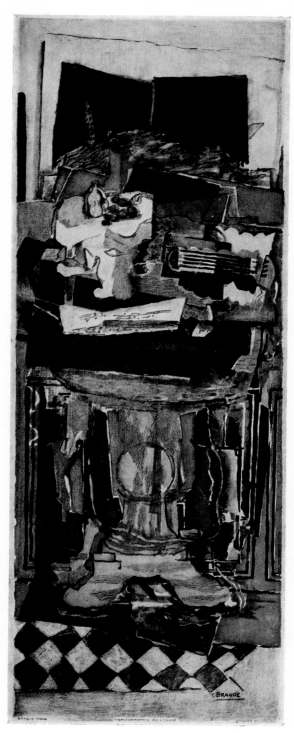

36. VILLON–BRAQUE. Still Life. *c.* 1926.
Colour aquatint 23″ × 8½″

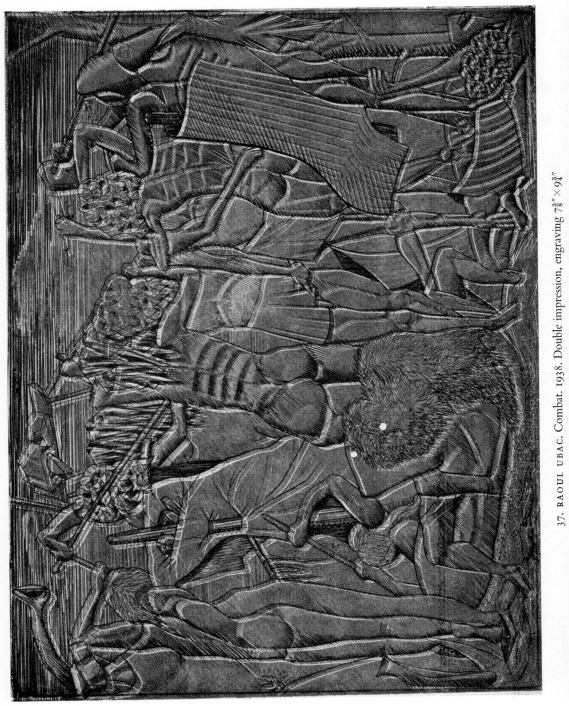

37. RAOUL UBAC. Combat. 1938. Double impression, engraving 7⅞″ × 9¼″

quality also establishes itself in a workshop, and promotion is gener-
ally accepted without cavil. I have laid such stress on the traditions of
these workshops chiefly because they are now very few and, as few
apprentices offer themselves to a craft which is both laborious and
unattractive to youth today, may well disappear entirely within
another generation.

The atelier of Roger Lacourière, however, presents an unusual
resemblance to those Renaissance workshops we were describing.
Beyond the great press-room a long bench with screens against the light
provides a place for artists to work on the plates that are ultimately
to be printed in the workshop; and Lacourière himself is one of
the most highly skilled artisans of colour reproduction still active.
The 'Langouste' of Picasso, reproduced opposite p. 69, is an extra-
ordinarily faithful reproduction of an original oil painting by this
artist: three successive printings in colour from carefully aquatinted
plates are followed by one in black; altogether ten different colours
are applied *à la poupée* to the three colour plates. The method used to
make the black plate (compare with Rouault, Pl. 29) is predominantly
sugar-lift aquatint, varied in the more delicate passages by means of
very subtle bitings with a brush full of acid directly applied to the
prepared plate. The skill and experience needed to analyse the original
painting and then to reconstruct the matching colours by means of
aquatinting plates could hardly be appreciated by the layman, nor yet
the difficulty of reproducing the free gesture of the artist in paint. This
print is typical of a considerable number made during the last thirty
years by Roger Lacourière from the originals of different artists. How-
ever, no more of them are being made, as the cost of the operation of
making plates and printing is almost prohibitive. It will be noted that
the prints will not only be signed by Picasso (who after all originated
the painting even if he never put a hand on the plates) but also in the
margin 'Gravé et Imprimé par Lacourière à Paris'; so that there can be
no doubt in the mind of the collector as to the respective functions of
artist and engraver or as to the relative originality of the work. The
absolute probity of this presentation is characteristic of all the works,
originals or reproductions, printed and published by this atelier;

though, as we shall see later, in the hands of less reputable dealers works issued by the atelier as reproductions are sometimes offered for sale as being from the hand of the artist who signs them. With the exception of the 'Tranche de Melon' plate of Picasso, reproduced by the same methods by Jacques Villon in the twenties, where we have a collaboration between two artists of comparable stature (if not of equal renown, particularly at the time when the work was done), this print is perhaps the finest example of the results that can be achieved by this method.

So in this workshop not only are both original and reproduction plates actually made in the press-room, but almost any unusual job of hand-printing is undertaken. A woodcut by Derain, in which the colour elements are separated by grooves and inked in different colours with brushes, was printed on a hand press in this atelier. Some illustrations of Miró were printed from blocks made by cutting out small pieces of wood, pieces of wire, &c., and gluing them down to a sheet of plywood: the islands of wood again were inked separately in different colours with small rollers (often made up by Frélaut for the purpose) and then printed by hand. Only where an edition is already sure to command a ready sale at a very high price (due, as we have suggested, to the prestige of the artist) can such work be undertaken by expert professionals; the humble hand-printing by the lesser-known artist himself in a corner of his studio, however, is more apt to produce an exceptional and inventive work, together of course with the great number of completely banal works from some other source. It is too easy to criticize the activity of workshops like that of Roger Lacourière as establishments to which a dealer requiring saleable sheets of the work of an artist of his stable may send them to be, as it were, processed. Any criticism in this case should be first addressed to the dealer, and perhaps to the artist for his inability to defend himself against such demands. It has occasionally happened that in these circumstances an artist has become excited with the possibilities of the medium and has evolved in this workshop into a capable, original print-maker (see print of Soulages, Pl. 45).

Near the Place d'Italie there is to be found another of these work-

shops, that of Raymond Haasen, still bearing the name of Paul Haasen, his father, who printed my 'Paysages Urbains' for me in 1930. Most of the intaglio prints of Chagall are still made and printed in this workshop. Here in the small atelier of the patron himself is a great press; on different floors of the building a press-room with eight more presses—now, alas, mostly idle—and a complete and very modern workshop where serigraphy, mechanized to some extent, is carried on. Raymond Haasen may well be the most competent master printer in Paris: his descent from Paul Haasen, once contre-maître of the atelier of Paul Delâtre who printed the Meryon plates at the beginning of the century, and his long and varied experience of the craft could lead one to expect it. An artist in his own right, the only student, with Jacques Villon, of the art of interpretative colour aquatint in those years when he was making the colour reproductions for Braun already referred to, at twenty-two he was already a master printer and (echo of the ancient guilds) obtained for four colour prints etched and printed by his own hand the diploma of 'Meilleur Ouvrier de France'. Does anyone, I wonder, still labour for such honour, and are there people left to respect, or even to judge, the competitors for such a distinction? His real titles to distinction are the reproductions made by most unorthodox methods in collaboration with Fernand Léger and applications of orthodox plate methods in incredible reproductions; and even some prints of plates of mine which I had entirely forgotten.

None of these establishments can exist at this time, or possibly at any time in this century, for the sole purpose of producing fine prints. There was just never enough of such work, nor was it sufficiently regular: at certain moments book illustration, demanding a far greater number of prints, was being done in sufficient quantity to keep the ten or twenty presses working. As in all commercial establishments overhead costs are continuous and if the supply of work to be done is intermittent, a serious problem arises. At one time tickets, stamps, catalogues, and labels for fine products were printed by taille-douce, but by 1900 lithography had begun to replace engraving as being cheaper for such purposes, so that the everyday maintenance of

these workshops began to fail. Then for some years heliogravure
reproduction for most art books continued to be printed by these
means, and another great resource known simply in the workshops as
bondieuserie ('goodgoddery'), the religious image, found an enormous
demand in Catholic countries. But when even these began to be made
by lithography and offset, and cheaper photo-reproductive processes
replaced heliogravure for the illustration of art books, innumerable
printing-houses disappeared. From one such house, 'Tanneur's',
where once thirty presses turned for ten hours a day, I bought a press.
The building is now a storehouse for sanitary fittings if it has not been
demolished. Of the scores of workshops existing at the end of the
last century there are now no more than three or four with any con-
siderable number of compagnons still employed, and in every case
some subsidiary activity is necessary to maintain the establishments.

Of course there remain a number of individual printers work-
ing alone or with a single assistant who survive by reducing their
overhead costs to a minimum. It is for this reason that we find one
of the most brilliant printers and plate-makers, Raymond Haasen,
employing the greater part of his time in making covers for chocolate
boxes, labels for expensive perfumes, book jackets, and so on, by the
methods of serigraphy. It is to be noted that in one particular work of
Fernand Léger the quality and intensity of the four elements of colour
which are printed on the sheet by silk screen before the black image
(which is etched) is overprinted, could not have had as much brilliance
and luminosity, particularly in the case of the yellow, if printed by
any other means. I have seen the original drawing from which this
reproduction was made, and the colour in it is far less intense and less
effective than that in the print. That is to say, the collaboration
between the artist and the artisan resulted in a print which was
superior to the original. Again, the plates on which Raymond
Haasen was working, together with Marc Chagall, when I visited the
atelier had by that time attained four colours from a black and white
etched plate, made of course by Chagall himself. Then to the first-
state print from this black plate Chagall had added progressively
different colour elements in wax crayon, which Haasen would then

repeat precisely, even in the identical texture, on the colour plates to be ultimately printed by the methods of registration already described in Chapter 3. Clearly such a print falls into the category of the original print made in part by the artist himself, although by methods of reproduction; and when employed in this fashion the technique, being perfectly appropriate to the image in the mind of the artist, is practically indistinguishable from category (A) defined in Chapter 12. But economically the house of Haasen must be maintained by serigraph reproduction printing to permit the necessary leisure for such collaboration, as no publisher could be expected to pay what the long hours on such a work would require.

In the rue St-Jacques not far from the Sorbonne the printing shop of Leblanc is perhaps one of the most typical of the taille-douciers working entirely on fine prints and illustrations for fine books. Entering from the street one crosses the courtyard of a seventeenth-century building and through a second arch one reaches a courtyard in which a low nineteenth-century building, built specially for this purpose, houses the printing shop. Leblanc himself is at work in one of the studios with a black canvas apron and all the equipment of his craft previously described. This house was inherited from Porcabœuf who died at the age of ninety and it was founded by Salmon, his grandfather, early in the nineteenth century. Charles Leblanc, the father of the present owner, was another of the master printers trained in the atelier of Delâtre with Paul Haasen and his son, and after a course in the École Estienne was apprenticed to his father together with Monsieur Frélaut, the present director of the Lacourière workshop. It can be seen that almost all the present master printers are connected by family and professional relations. In another workshop across the court from that of the patron eight printers are working, and so far this house has been able to maintain itself by making fine prints and book illustrations, thanks to the large number of artists who bring their work to be printed here. However, like the others, the workshop only continues on condition that the patron himself works at least as hard as any of his employees, no non-productive person is employed, and all accounts and records and the

ridiculous quantity of returns demanded of small businesses by the authorities are done by the patron or his family after his day's work is complete. There are no apprentices any more, young men do not come forward to serve four arduous years to prepare for a craft notoriously precarious and underpaid. Leblanc will ultimately retire, when I believe he intends to take one of his beloved presses down to his country house near Orange. Then I suppose his house will disappear unless times are prosperous enough to justify the group of compagnons in keeping it on as a co-operative enterprise.

In a building of the Louvre Museum in Paris, seldom visited, is to be found a printing establishment where plates belonging to the Chalcographie Nationale are still printed by hand by a printer trained in the traditions of taille-douce. Maps from the sixteenth century, many of the colour reproduction plates of Jacques Villon, and contemporary plates (even one of my own) are there printed in more or less unlimited editions and sold for a fraction of the cost of another work by the same artist published privately. The Villon–Braque plate (Pl. 36) comes from this workshop, as does the original cubist Villon (Pl. 1), and they can be bought there for a very low price. The interest of this establishment, which is little known as it is not allowed to advertise, is that it offers a possibility to students and to modest collectors interested only in the artistic or technical quality of the print to acquire important works at low cost.

Such institutions exist in certain other countries: in Spain I saw some of Goya's plates being reprinted at the Chalcografía in 1937; and again in Rome at the Calcografia Nazionale, under the direction of Dr. Petrucchi, early Italian engravings are reprinted, in some cases from the original plates. A stamp clearly distinguishes such reprints from the originals, although in the case of early prints there are, as we shall see, other means of distinguishing the original editions from later reprints.

8

THE ATELIER 17 AND INDEPENDENT GROUPS

Artists and printers in France, England, America, and Japan

To understand what is likely to replace these master printers and their institutions we shall have to consider what has happened already in many countries where either there never were such workshops or where they have been eliminated by competition: a state of affairs which also exists to some extent in France in spite of the survival of a few of the traditional workshops. In most countries in which prints are made from intaglio plates, they now come from two sources. On the one hand there are official or unofficial educational establishments; on the other, small groups of artists working co-operatively or isolated in individual studios. As my Atelier 17 is a rather special case, having something of the qualities of both, as it has been going quite a long time in two different countries and its example has been followed by groups in about six more, and furthermore as it is the one I know most about, I will try to give some account of it.

Unlike the traditional workshops, this Atelier has to do with an idea rather than with a fixed place, a permanent band of workers or artists, a uniform unvarying application of a known technique. How it came into existence, by pure accident if one believes in accidents; how it has changed and developed, moving to three different sites in Paris before being transferred to New York where it had three more homes, extensions of a sort to Philadelphia, Chicago, and San Francisco; its three different sites since its return to France in 1950; all this seems to me of far less interest to the general reader than a brief description of what it is now.

Although it has been mistaken for such by innocent people, the Atelier 17 is not a school, except in so far as the whole group and those who have worked in it, now in a dozen countries, could be said to constitute a 'School' in the historical sense. At any time, mature artists of world-wide reputation may be working in it alongside lesser-known artists of different ages and even some few art students, often holding fellowships or *bourses* from the French government or other foundations. Among some thirty to thirty-five people working, a dozen nationalities may be represented. It is directed by me personally, though the assistant director Zanartu knows as much about any of the processes as I do, as does the *'massier'*, Krishna Reddy. Housed in the slightly dilapidated premises of the Académie Ranson owned by Monsieur Angebault, at first sight it offers an aspect of confusion beyond that of any of the establishments we have described. And yet this apparent confusion also conceals a certain order, like the disorder in an artist's studio which permits serious work to be done. A number of large tables give space and sufficient light for work on plates, and for the glass plates on which colours are rolled out; a corner contains the acids and a sink; in another, paper and drying prints are stacked. There are three presses and all the equipment, although very expensive, is rudimentary compared with almost any of the workshops set up in public or private educational establishments by ex-members of the group in other countries. The reason for this is that whatever monetary support the Atelier has ever received has in all cases been employed to supply subsistence and material to promising students rather than to buy equipment. Work is carried on independently by each member of the group and in so far as there can be said to exist any instruction, this is not by precept and interdiction, nor does there exist the voice of authority.

The initiation of new-comers into the peculiar methods of the Atelier is done in such fashion that, from the first, work is originated in the plate itself and not copied from a drawing already existing. Instruction consists of involving a student in experiments in conditions completely unfamiliar to him in which a development, not necessarily by logical means, is carried on until the plate is destroyed. As the 'state'

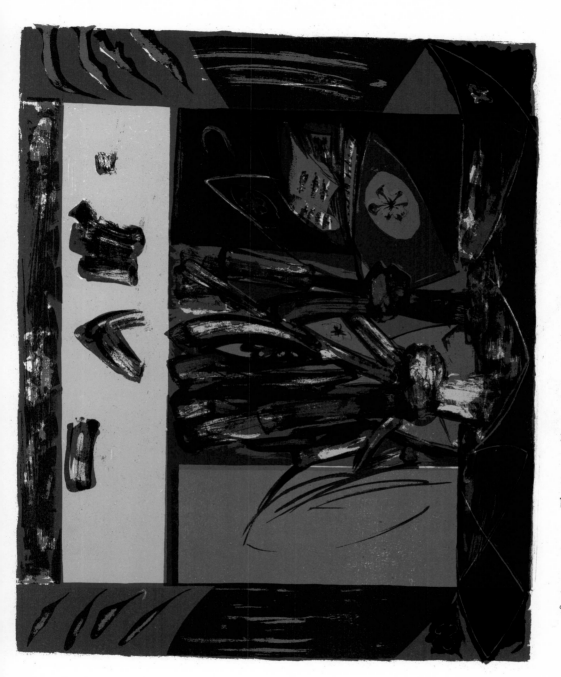

38. CERI RICHARDS. The Hammerklavier Theme: La Cathédrale Engloutie I. 1958. Colour lithograph 20″ × 24½″

proof of each stage of development is kept, a complete record exists; development is by metamorphosis rather than by accretion, and in the hundreds of times such an experiment has been made I have never seen two alike nor one in which something I did not yet understand had happened. The object of all this is to arrive at knowledge which really belongs to the person, in the sense that word of mouth can only give the illusion of knowledge to the students of that which is known to the professor. It is strange that to the average art student and even to many mature artists the idea of initiating an action which is not intended to result in a work of art is completely foreign; and yet no student of science will have failed to make experiments leading to knowledge of his subject. These experiments are in a sense more psychological than mechanical; during the development one or another of the transformations will excite the particular student; the first 'serious' plate will be attempted by the method which has been identified in this way. The connexion between the different stages of this and many other types of experiment is a relation between forms for which we use the expression 'counterpoint', borrowed from musical terminology for lack of a better word. In fact the whole system is based on a sort of game of consequences, not necessarily rational. Devised over the last twenty-five years, it works somewhat like an extrapolation in mathematics, in which the earlier stages can be calculated logically; but with the increasing number of unknowns the student at a certain stage either makes use of his imagination or is compelled to stop. A certain hardiness is necessary to undertake what amounts to personal research in these conditions, and it is not surprising that a considerable number of beginners eliminate themselves in each term.

Together with this activity, more advanced research into new methods of expression is being carried on, by senior members of the group, which so far in every year of its existence has provided the Atelier with fresh possibilities. In recent years the possibilities of printing in multiple colour from single plates worked to different depths in a single operation, already initiated in the forties in the New York Atelier, have been very greatly extended. Every one of

the techniques of plate-making cited in the first part of this book is practised in this workshop, no two artists using exactly the same methods but seeking known or unknown means appropriate to their own expression; so that the output of the workshop has no general uniformity nor does it bear the stamp of one master, which I should myself consider to show complete failure on the part of its director. The point that distinguishes this workshop from nearly all other institutions in which print-making is done or taught is the shared conviction that a technique is an action in which the imagination of the user is excited, whereby an order of image otherwise latent becomes visible; and not merely a series of mechanical devices to produce or repeat a previously formulated image on paper. It is this idea over the last twenty-five years which has penetrated every country in which prints are made and created a major revolution in print-making.

On the ground floor of the establishment of Desjobert, a house of lithographers described in Chapter 9, there is a space set aside for the atelier of Friedlaender. Typical of another type of school of etching, this group has been in existence since 1950 and has produced under the able direction of Johnny Friedlaender a number of interesting print-makers. The workshop has the usual equipment: large tables on which the students work on their drawings and their plates; a section where acids are used at a distance from tools, plates, &c.; and an excellent press on which the trial prints are made of the plates that are being executed. The complete editions of the finished works are generally printed by the house of Leblanc (p. 89), in whose ateliers this workshop was first founded. Some colour work is done here, but only by the classical methods of printing from successive plates described in Chapter 5. The character of the work in this studio, as far as it is possible to generalize, has a rather more *picturale* approach than that produced by the Atelier 17, where the sculptural aspects of print-making are perhaps emphasized, and where the special characters of the ambiguity of space in the print are being exploited.

Except for official institutions such as the École Nationale des Beaux-Arts, of which perhaps the less said the better, the other centres of propagation of the arts of etching and engraving in France are the

individual studios of competent etchers and printers who take a few students at certain hours into their own workshops. Typical of these is the workshop of Calavaert-Brun, a very able etcher and experienced printer. In the studio in which his own painting and print-making is carried on, he receives a certain number of private students at certain hours who are taught the classical crafts of etching and engraving; their works being printed on his magnificent press. Together with the graphic departments of various printing-trade schools of the character of the École Estienne, intended to prepare students for all the printing trades, these are now the only centres in which print-makers are trained. It is true that most art schools, both in Paris and in the more important provincial towns, offer a course in gravure together with instruction in drawing, painting, and sculpture, but such departments are seldom well equipped and the instruction has to do as a rule with techniques originally devised for the purposes of reproduction of drawings and paintings and having very little bearing on the art of our time. To get an idea of how hopelessly out of touch with any requirement of the present this instruction can be, I will cite a case that I observed some years ago. The delivery boy for the house that prepares our plates, when making a delivery to the Atelier 17, remarked that he had studied engraving for many years and had won the Rome prize. On his return he found himself completely competent in a craft for which there was no demand whatever, and he had in consequence taken this job to make a living. It would appear to me that the responsibility of the professors who are paid to teach these subjects is very definitely involved; though I suppose that their prejudices and their desire to put the clock back would override this consideration.

In England printing and plate-making establishments on the scale that existed in France barely survived the turn of the century; they were far more specialized printing houses, seldom associated with groups of artisans who made the steel engravings (engraved or etched on steel, generally reproductions). The replacement of hand-made reproductions by those made by photographic methods and printed mechanically was more rapid and more complete than in

France; the workshops from which issued the prints of the early part
of this century employed one or two men, master printers sometimes
trained in other countries, or in the departments of art schools in
which one experienced artisan was employed to print the plates
produced by the professors and by the students. The evolution of such
workshops, depending as it must upon the economic position of the
print trade, was affected by the vicissitudes of the market in fine
prints and in fine reproductions over this period. In the late nineteenth
century no middle-class interior was complete without a steel engrav-
ing or two after the works of such artists as Landseer and Wilkie; with
the passing of the taste for such works there was a rather surprising
development of a taste for 'etchings'—almost anything etched or
scratched on a plate, frequently no less banal, though in a different
way, than the steel engravings of the generation before.

Of course the latter did not replace the former, and in no case were
they produced on such a scale; so that where those houses responsible
for printing the steel engravings were converted to mechanical
methods or disappeared, the number of small workshops or establish-
ments of a master printer working alone or with one assistant did not
greatly increase. With the collapse of the market in conventional
etching in the twenties many of them disappeared, and the present
production of prints of another character stems almost entirely from
art schools and institutions in which new methods, or new applica-
tions of old methods, are being taught. There are three schools with
flourishing intaglio departments which have for two generations very
strongly influenced the production of etching and engraving in
England. At the Slade School (University of London) the late John
Buckland-Wright, once my associate in the Atelier 17 in Paris,
directed this department very brilliantly until his death in 1954 when
he was succeeded by my old friend Anthony Gross, who has made of
this workshop one of the most lively centres of the new approach to
etching. From his workshop today the most varied experimental
work in England is produced. Julian Trevelyan (once a member of
Atelier 17) has for some years made the Royal College of Arts a very
lively centre for intaglio work, above all deep etch and some colour

work; while Merlyn Evans at the Central School has initiated some most remarkable work with aquatint, lift ground, and some line engraving. In spite of the personal qualities of these masters the quality of the work, as in all such centres, is limited first by the type of student presenting himself and, even more, by certain institutional requirements which control how much of his available time and over what period he can concentrate on print-making. Again, as most students in these schools have their academic requirements to fulfil and as their aesthetic formation is not entirely in the hands of the graphic department, the conditions are not absolutely ideal. One much more serious weakness of the system (shared as we have seen by students in the American centres) is the conditions imposed upon the younger artist by present-day civilization. Briefly one can say that as his world will not provide him with subsistence solely for the exercise of his function as an artist, so before he has had time to learn (and we used to consider ten years in the wilderness a reasonable allowance) he will be called upon to teach if he intends to eat with any regularity. Now where will he teach? In nearly all cases in provincial schools or universities, entirely lacking the facilities for intaglio printing, and consequently his development may well be arrested or badly delayed. Possibly the institution of fellowships on a post-graduate level might remedy this by keeping the most gifted print-makers in touch with their schools for a further period, now only possible very exceptionally when a single student may be given an appointment on the teaching faculty. Of course such a measure is no more than a palliative; nothing will really change this state of affairs short of a general change in the conditions offered to artists.

Outside the schools there exist some few printers, often from families in the same craft, and in England it appears that the apprenticeship was even longer than in France—some seven years. Goulding was associated for a time with Sir Frank Short at the Central School of Arts and Crafts until the mid-thirties; McQueen was printing until very recently, when he joined Ross, who continues to print commercial plates. David Strang, the son of the etcher William Strang, was

printing until 1950; but Mr. C. H. Welch still continues to print in the
traditions of the master printers. The son of a printer, considered by
Anthony Gross to be the finest in England, the brother of a com-
mercial colour printer in St. Albans, he was installed with magni-
ficent equipment in a large workshop. We have already pointed out
that the print-making centres in other countries also tend to be
eliminated by adverse economic factors, so it is hardly surprising to
hear that Mr. Welch has been forced to move to a smaller workshop
on account of the Rent Act. As we have seen at the Paris ateliers,
when such printers retire there will be no master printers to take their
place, as none are being trained. Those few printers who are being
trained are nearly always practising artists trained in the schools, and
from a purely technical point of view it is unlikely that they will be
as good artisans as the generation that is disappearing. However, we
will hope that the skills that they develop will be equal to their
intentions; it is a little too easy to become sentimental over the dis-
appearance of workshops whose major production over the last fifty
years was of works better not made at all. The individual print-maker,
installing his press in his own studio, remains to carry on the tradition.
Anthony Harrison, who also assisted Merlyn Evans at the Central
School, has installed himself with a good press, and in Essex Michael
Rothenstein works in woodcuts and linoleum on a large scale to
make prints which clearly have the function of mural decoration.
In these circumstances a technique which can be carried on with
inexpensive materials in the corner of a bed–sitting-room, such as
serigraphy, will obviously have great attractions for the individual
print-maker, while the production of prints on a very large scale
seems likely to call upon mechanical printing and the techniques of
reproduction.

In America workshops for the making of intaglio prints of the
type of Leblanc, Haasen, and Lacourière have never existed. There
is no uninterrupted succession for centuries of heritage of a craft
from apprenticeship to printer to master as there was in Europe.
Experienced printers and artisan engravers, as well as the skilled
workmen who made the tools, did of course arrive from Europe as

39. LYNTON LAMB. Composition. 1961. Lithograph $11\frac{1}{4} \times 9\frac{1}{4}$

40. C. O. HULTEN. Composition. 1956. Original offset $9\frac{1}{4}'' \times 12\frac{1}{2}''$

immigrants, but as individuals, and I know of no case of the whole organization of an atelier being transferred to the new world. However, in America they would often continue the practice of their craft but would necessarily adapt it to the requirements of the place. Thus the makers of burins and engravers' tools, the descendants of E. C. Muller, a Swiss toolmaker, supply practically the whole needs of the United States in this small but very specialized field. The engravers would normally find demand for their services in the making of visiting cards and announcements; the printers, in the printing of such things. As they found themselves in conditions where the rhythm of production was accelerated compared with Europe, they even devised an engraving press with a D-shaped roller, half-round; and a bed controlled by a counterweight so that it would return to its original position automatically as soon as the half roller had passed, thus permitting the printer to turn out several hundred prints an hour instead of the scores possible with a normal press.

In the absence of workshops as centres of intaglio printing, there have in the past been a certain number of painters who practised etching and engraving, in some cases of American origin. In the early part of the twentieth century one of the most influential etchers and teachers of etching was Joseph Pennell; from his workshop in New York students carried his example and his very conscientious technique of etching to most of the States of the Union. Donald McLaughlin, of Canadian origin, was another of these etchers and teachers although his influence was less widespread than that of Pennell. But these men and their students had to rely for their printing either upon a printer, often European, employed by an art school, or on the very few individual printers who had withstood the current of progress so far as to maintain a one- or two-man workshop for a craft which, if it offered a modest livelihood, could never promise a fortune to the craftsman. It is likely that the technical and aesthetic principles of the etchers of this time were of the order of their contemporaries' in Europe, the heritage most particularly of Piranesi, of Rembrandt, of Lepère and Whistler (incidentally a friend of Pennell's). Although before 1940 a considerable number of the members of the Atelier 17 had returned to America

and had there begun to practise more experimental methods, they were working individually and found no very wide support. In 1940 I set up a workshop in the New School for Social Research, in perhaps the most liberal atmosphere to be found at that time in New York, and within a few years it became possible to organize other workshops directed by our members in a large number of colleges, art schools, and universities. This workshop, which served as a centre for research in methods of print-making, was later moved to other premises and continued under my direction until 1950, and under the direction of Carl Schrag, Peter Grippe, and Leo Katz until 1955, when it was finally closed.

In 1945 Mauricio Lasansky, who had worked with us for two years on a Guggenheim Fellowship, was appointed to the University of Iowa, where he set up what has become one of the most important centres of print-making in the United States. Funds were available to install large presses, electrically driven in some cases, and to provide the best of equipment; here not only could plates be made but editions printed, and with the aid of the very active art department of this university exhibitions could be organized of the work of this group, even on an international scale. Together with the advantages of the support of a State university, certain disadvantages that we have already noted in the case of the English educational institutions tend to limit the ideal scope of this workshop. Where a very large number, perhaps hundreds, of students apply to take courses in print-making, their time allocated for this purpose is comparatively short, the usual requirements of other subjects further interfering with their work, and so not too much can be expected of their first years of study. Then when it becomes of interest to retain a group of the more promising members, only the few who can be given appointments as instructors can be retained, so that it becomes very difficult to keep the nucleus of experienced men which is so necessary as an example to stimulate new-comers. A large number of the graduates of this school are directing print departments in American colleges and universities, most of them having served also as instructors at Iowa.

Gabor Peterdi, originally with us in the Paris Atelier, set up another print group about this time in the basement of the Brooklyn Museum. This art school, which has now become very important, was founded to cope with the enormous number of ex-service students supported by the U.S. government after the war. An astute business man observed that a great deal of space, so far unused, existed in this building; a considerable number of artists, having a sufficient following to attract students, were invited to set up individual studios and share the proceeds with the organizers. Here the quality, efficiency, and practical organization of each individual workshop is entirely dependent upon the individual who directs it. From the point of view of the student this lack of system has the apparent dis-advantage that in going from one studio to another he may hear contradicted in the second everything he has heard stated in the first. In view of the quality of instruction in the arts in the four or five countries I am acquainted with, perhaps this is just as well. I under-stand, however, that this state of affairs has been completely changed and that the school is now affiliated to Long Island University. Peterdi himself no longer teaches there; he is now visiting professor at Yale and at Hunter College. However, while in existence his group produced some excellent print-makers, again many of them teaching their craft elsewhere.

In the Middle West of the United States at St. Louis my old associate Frederick G. Becker is directing a very lively group of print-makers at the Washington University. Many excellent engra-vers and etchers have emerged from this workshop; some of them have worked with me in Paris later. In this city a most interesting experiment was carried out by the leading newspaper, which like many papers in America prints by rotogravure a Sunday supplement in full colour. This process, as we have indicated elsewhere, is funda-mentally a method of intaglio printing; similar in principle to etching and engraving in that the inks are carried in pits in the surface of a roller, wiped by a ductor blade, and transferred to the paper under pressure at great speed. A print of Becker's, made from four plates each carrying a different colour (and in this case one of the four

process colours used in reproduction), was transferred directly from
the four separations on to the rollers from which the newspaper was
printed—thus bringing the hand of the artist into closer touch with
the printed newspaper sheet than it had ever been since the days
when illustrations were printed from wood engravings made by
hand, around the turn of the century. The enterprise of this paper
compares very favourably with that of metropolitan papers in
Europe as well as in America; I can hardly imagine a London
paper listening to such a proposal—even if their technical means
permitted it.

Of the older schools the Art Students' League, also organized on
the very loose system of the art schools in many other countries,
has always had workshops where intaglio and also lithography were
taught. Under the able direction of Sternberg and Barnett this work-
shop kept the interest of artists in this medium alive during the
difficult times preceding the great revival of interest in print-making
which took place during the forties. Incidentally the lack of system,
and with it the lack of academic requirements and the loose orga-
nization of such workshops, permitted the exceptional student (the
only one that really interests us) to develop far more freely than in
the academic institutions. The Art Students' League was, and for all
I know still is, administered by a council of students, who invite
individual artists to direct the different studios; and if the instruction
is somewhat contradictory, and if furthermore the choice of a group
of students is not the best possible way of selecting instructors, these
disadvantages are compensated for by the atmosphere of freedom in
which talent seems to develop best.

In Philadelphia in a converted stable in an old quarter of the town
the Print Club has for a great many years defended the interests of
print-makers and collectors. Here on one floor of the gallery a sort of
free workshop was set up for occasional use by local artists. Presses
and equipment were installed, and on certain evenings after the
gallery was closed visiting instructors would be invited to work with
a group. From this centre many now well-known print-makers
derived their first acquaintance with the craft. Their annual inter-

41. KARL SCHRAG. Windswept Coast. 1959. Etching and burin engraving $21\frac{5}{8}'' \times 27\frac{3}{4}''$

42. DEAN MEEKER. Crowd. 1958. Serigraph $18'' \times 25\frac{3}{4}''$

national exhibitions, when selected by competent juries, are of great interest. I conducted monthly courses there between 1943 and 1950 and again in the winter of 1951–2.

In the fifties the late Margaret Lowengrund was able to set up as a non-profit corporation an institution called 'The Contemporaries' in a building in New York. Planned on somewhat similar lines to the house of Lacourière in Paris, described above, there were certain differences. Gallery space existed for exhibitions, and not only of those artists using the workshops. No professional printing establishment of the form of that directed by Frélaut in Paris existed, but the editions of prints made by artists of note were published by the house. Instructors were employed in the workshops equipped for intaglio, lithography, serigraphy, &c., and the conditions of work for artists must have been somewhere between those in which the artist alone makes his plates or stones and those in which he presents a sketch or design and the work on plates and stones is carried out for him. Although continuing as a gallery, I understand that these workshops are no longer operating.

The Art Institute of Chicago, at the time I was teaching a special course there, was about the biggest art school in the world, having about seven thousand students and several hundred people on the faculty. Here also there exist presses and equipment and competent instructors in the various techniques of print-making possessing, however, neither the craftsmanship resulting from the guild system nor, I think, the incentive to seek for techniques other than those already known. I taught a special group here in 1949. Similar centres exist in almost every big city in America, such as Boston, San Francisco, Cleveland, and St. Louis.

But all this demonstrates the tendency for free workshops to disappear and for any serious invention, if it is found at all, to arise from the work of individuals isolated in their studios. As one of the best-known American teachers stated in a recent book, from their point of view research over the last thirty years was most valuable but is no longer of much interest; what is needed is the exploitation of methods already discovered. It must be obvious that I do not agree

with this view; that the expressive possibilities of a process in the hands
of an artist who has himself devised it can give results in the category
of the print as a major work far beyond any result to be expected
from the ingenious adapters of other men's methods. However, it
is not intended to put a premium on pure device; as I have already
suggested, it is the importance of the idea (communicated by whatever
process), and this alone, that determines the validity of the work.
And our industrial civilization, in Europe as in America, offers far
greater reward to the exploiters of other men's ideas than to those
who originate these ideas. Yet as I shall suggest later, success in
the field of art does not resemble success in the world of affairs:
and it is more than doubtful whether these principles can be taken
over from industry by the arts.

 In Japan the traditional workshop in which Ukiyo-e woodcuts were
made and printed in the eighteenth and nineteenth centuries has not
entirely disappeared although there are no longer perhaps artists of
the standing of Utamaro, Sharaku, Hiroshige, or Hokusai providing
the images for them. The workshop is often a family unit: as with
many artists in Japan, grandfather, sons, daughters, and grand-
children may all work together. The family of Yoshiko Noma (see
Pl. 35) have been artists for many generations; the print in the
classical technique of Ukiyo-e but of a modern motif by Toshi
Yoshida (Pl. 3) comes from such a workshop. Perhaps in Japan the
pressure of economic conditions, which we have seen tends to destroy
the Western workshops, is less; in any case the 'overhead' is less
onerous. There is no mechanical equipment, the whole family works
as a group, and the same specialization in function exists as before:
that man trained to cut key blocks may still cut only such blocks,
another will cut colour blocks; and still others do nothing but print
with the water-base pigments in rice paste, rubbing off the indivi-
dual prints with the classical 'Baren' still covered with a bamboo
leaf. The sacrifice to popular demand represented by the making of
Christmas greetings and postcards as well as slight water-colours
involved much less adaptation in a country where the print was always
a popular object, almost a broadsheet, and not a work artificially

rarefied into an expensive collector's item. The attitude of these artists to their work is much closer to that of medieval artisans in Europe, where it was clearly understood that work was done to order or to meet a demand. Thus not all, but some, of the members of the family group will make the necessary concessions to provide post-cards for sale to visiting Americans without feeling any great derogation of their dignity.

9

LITHOGRAPH WORKSHOPS IN FRANCE
AND ENGLAND

OF all the prints circulated in big editions, which have partially replaced the demand for fine reproductions, well over half are made by lithography (see Chapter 6). The workshops from which such prints issue are of various kinds: some almost commercial printing firms whose chief purpose is to make posters, labels, publicity and advertising matter; others ateliers specializing in fine prints and colour reproductions of a high order, with perhaps some commercial activity to maintain a regular flow of work; groups of artists in countries and places where no such facilities exist who band together to acquire and install the equipment needed; lithographic departments of educational institutions, chiefly intended to teach the elements of the craft but seldom organized for the production of editions; and finally, all these lacking, the individual artist having some previous knowledge of the craft who has installed a press in his studio and works more or less alone. Of the same order is the individual artisan printer (who may even double with the artist) who has, alone or with the support of others intending to make use of his services, set up equipment. It is only in France that there exist now groups of artisans, printers from stone that have descended in uninterrupted succession from the houses that printed in their generations the popular lithographs of Daumier, later of Toulouse-Lautrec. Elsewhere the hand-printers of lithography were either eliminated by the competition of the more mechanized printers, or themselves became converted to mechanized production for other purposes.

The house of Edmond and Jacques Desjobert occupies two wide floors of a fairly modern building at the end of a narrow impasse off

43. FIORINI. Le Déjeuner. 1959. Intaglio print from wood $22\frac{3}{8}'' \times 16\frac{1}{8}''$

44. THE LACOURIÈRE WORKSHOP

the Avenue d'Orléans (now Avenue du Général Leclerc). Some ten simple lithographic presses, all I should think dating from the last century, with inking slabs, rollers, and stacks of paper, fill the first floor, leaving room for a set of tables against one row of windows for the artists to work on the stones to be printed. The employees and directors will in some cases assist and instruct inexperienced artists in the fairly simple operations to be carried out, but at present seldom do the actual work on the stones. Of course the subsequent preparation of the stones for printing and trials, retouching, &c., is done by the staff. Artists from a dozen countries where such establishments do not exist are to be found working there: from America, France, England, Switzerland, Spain, Holland, Belgium, Italy, Japan, and South America. Under the direction of the son of the house they now make chiefly colour prints or sometimes posters. My own knowledge of lithography began in this way when Edmond Desjobert lent me stones and provided me with instruction to make the prints of 1927; very conveniently his workshop was situated two doors away from my own atelier, then in the rue du Moulin Vert. On the ground floor of the present establishment two machines are installed, of an old type which reproduces the moving bed carrying the stone; the cylinder covered with rubber presses the paper on to the inked stone; inking is done with leather-covered rollers and another covered with cloth wets the stone as it passes each time. Registration of the image is done by the margins of the sheet, and not with pin-holes as described in Chapter 5; it is even possible to print two different colours simultaneously if they are clearly separated in position on the stone. With stones or sometimes grained zinc plates, such machines are used to print posters; they can turn out some 600 to 800 sheets an hour compared with the maximum of 20 or 30 that can be made by hand. They do, however, lack some of the delicacy of effect possible in hand-printing: the effects of wash (*lavis*), the subtle tones and textures made by diluted tusche, soap solution, &c., on the stone cannot be counted on in mechanical printing.

Before founding this house in 1921, Desjobert père had for many years worked with the firm of Engelmann, which dates from the

nineteenth century, where he finally became contremaître (the direct English translation, 'foreman', does not really express this function: the contremaître advises and directs the whole workshop, himself printing very delicate or difficult stones). His son Jacques at the age of sixteen studied at the École Estienne, the great printing-trade school of the city of Paris, becoming an apprentice under his father on leaving; and it is to be noted that both father and son were themselves working and the son still is. As in the intaglio printing craft, apprenticeship of four years is about the minimum, and many more years are needed before a workman becomes really experienced. But as one might expect, the guild conditions are less clearly estab-lished than with the far older craft of taille-doucier. In the twenties most of the artists working at Desjobert's were making what amounted to drawings, and in black and white, but at the present, with the exception of a few beginners learning the work on the stones, almost all are working in colour and with the methods of painting rather than drawing. In this house nearly all the artists are themselves mak-ing their stones; help with retouching or tracing for registration may be given, but hardly a case exists of the stones being made entirely by the artisan and not by the hand of the artist. Thus although posters and such, even using some photographic elements, may be made in category (D) (see Chapter 11), most of the work is found in the (B) and (C) categories. The reason that I would not myself consider these colour lithographs to fall into category (A) (the work origin-ating in the medium for itself alone) is merely that I do not recog-nize in this medium any direct action of the technique on the spirit of the artist—that the action of making a lithograph on one or six stones tends to liberate image not previously realized. The limitation of the number of employees in this house to ten is due to the some-what peculiar conditions under which small businesses operate in France: under regulations which no doubt seemed most appropriate to Colbert, any French business which employs more than ten men is involved in obligations such that it could only again become profit-able if expanded threefold.

Perhaps the biggest house from which lithographic prints are issued

today is that of Mourlot Frères, near the Gare de l'Est. Housed in an ancient wood-frame building of very considerable size, it gives the sensation on entering of a hive of industry; every foot of space being completely occupied by presses and stacks of proofs, which even over-flow into the entrance. Although here artists like Chagall and Picasso have themselves worked on stones, two extraordinarily competent draughtsmen make most of the stones, one of them, Deschamps, being so skilful that he is capable of approaching the touch and the gesture of the artist whose work he is translating. Picasso has been known to say that he cannot himself distinguish between a work executed for him by Deschamps and one that he has done himself, but I do not think he really believes this. In this workshop the one or two corners in which I have seen certain of my colleagues working on their own stones afford very much less space, and for less people at a time, than is provided in the house of Desjobert. Like the house of Desjobert, this house also is in direct descent from one of the nineteenth-century lithograph printers. The building, in the rue Chabrol, formerly housed the firm of Honoré Bataille, founded in 1852. At Créteil, an inner suburb of Paris, the father of the present Mourlot sons already had a printing establishment and in 1940 he purchased the plant and good-will from the surviving Bataille; and the two sons, after their demo-bilization, undertook the direction of the whole establishment. In 1946 for a considerable period Picasso was working there daily from eight in the morning to seven at night; arriving sometimes by the métro, sometimes on a bicycle, and rarely by car, he made a large number of lithographs, some entirely from his own hand and others with the assistance of the draughtsman in the house. The training of these men takes many years and it requires very exceptional capacity in a young man for it ever to be possible for him to become a really capable *chromiste*. Monsieur Soulier, the other draughtsman (together with Deschamps), was originally, like several of the artisans we have already mentioned, a student of the École Estienne, ably directed by Professor Rank.

Artists from many countries have produced lithographs with the firm of Mourlot Frères, the English painters Graham Sutherland and

John Piper and the sculptor Henry Moore among them. A very important part of the activity in the rue Chabrol is the printing of posters in colour on the machines we have described. At the time of my visit a number of stones for colour posters were being prepared by Monsieur Deschamps and a poster made from a 1947 work of Soulages to announce the exhibition 'Antagonismes' at the Musée d'Art Décoratif was being printed on one of the machines. This poster, which reproduced a painting in brown, ochre, and black, showed quite clearly the limitations of machine-printing as compared with printing by hand. The complex texture of the underlying yellow ochre form in this painting could in this case not be transferred to a stone but was printed on the sheet in half-tone by typographic means and the other colours overprinted by lithography. On the sheet the characteristic mechanical grain of the screen used in the half-tone can easily be distinguished with a glass from the more irregular grain of the stone in lithographic printing.

In England houses of this character hardly exist; chiefly because there is not the large amount of printing of posters and material for publicity by lithographic means that is necessary to maintain such houses; nor until very recently were any great number of artists interested in making original lithographs. Those who were would frequently go to Paris and do their work there. Recently, under the impulse of the St. George's Gallery and its enterprising young director, the Hon. Robert Erskine, a commercial offset house, Harley Brothers of Edinburgh, having some hand presses, made about twenty stones. The operation, however, is not commercially profitable under present economic conditions and I understand that no more are being done. In the East End of London a large printing house, whose directors were always interested in autographic and experimental printing methods, would, a generation ago, occasionally make hand-printed lithographs from stones. I recall going there on one of my visits to London with the late Oliver Simon to see an experiment in which a wet proof from a print by Graham Sutherland was transferred directly to a lithographic stone and afterwards printed by hand. Just recently Mr. Stanley Jones, who worked for a

45. PIERRE SOULAGES. Composition V. Deep etch colour $21\frac{1}{2}'' \times 14\frac{1}{2}''$

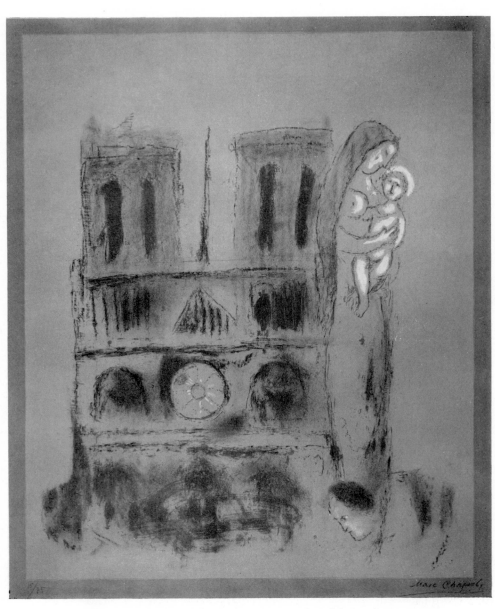

46. MARC CHAGALL. Notre–Dame. 1953. Colour lithograph $26\frac{3}{4}'' \times 20\frac{3}{4}''$

year with the Atelier Patrix in Paris, has been set up there with excellent equipment, and the lithograph of Ceri Richards reproduced as Pl. 38 was one of the first to be made in this workshop.

In the west of London there exists a small proofing studio with presses for lithography as well as intaglio, run co-operatively by the group of artists who use it. As it is not very large it is generally used in turn by the different subscribers. Apart from these, the only opportunity for artists to learn and apply the techniques of lithography is in one of the three chief art schools: the Slade School (University of London); the Royal College of Arts; and the Central School of Arts and Crafts. Under the direction of Lynton Lamb, Ceri Richards, and Stanley Jones, the Slade School has produced some of the most experimental and inventive prints in England; while the lithographic department of the Royal College of Arts under the direction of Edwin La Dell has issued a large number of interesting colour prints. These institutions (with the exception of the Central School where artists who are not regular students can, I understand, work at certain hours) suffer from the usual institutional limitations, whereby the facilities are more or less reserved for regular students, for whom of course they are intended. Thus it is unusual for artists not members of their teaching staffs to make prints in these schools. Outside London some facilities exist, again chiefly in art schools, those at Southampton and at Manchester (which I visited some years ago) being particularly active. It appears that there are very few individual artists who have themselves installed the very cumbersome equipment to make lithographs in their own studios.

IO

SOME CONTEMPORARY PRINT-MAKERS

OF the artists who themselves make prints or who have prints made
for them, a few have no other function but that of print-makers: that
is to say, the making of prints occupies the greatest part of their time
and attention and is more important to them than any other activity.
Courtin, Vieillard, and Friedlaender in France, Rolf Nesch in
Norway, Becker, Lasansky, and Kohn in America are artists of this
category; and it is to be supposed that their works will be done
for their own sake, and will be definitely major rather than minor
works. Other print-makers will be painters, sculptors, architects,
whose major function is in another field and whose prints reflect
more or less their interests in it. The categories are not exclusive: one
could quote cases in which a man's prints, although not representing
his major activity, are far more widely known than his painting or
sculpture—and this for a very simple reason. Prints can be sent by
mail: there may well be fifty or two hundred copies, meaning that it
becomes possible for one work to be exhibited simultaneously in two
hundred places, whereas one painting is seen in one place; a sculpture
also, and this, if of any size, is even more difficult to transport. Thus
it has occurred to the Print Council of America to hold an exhibition
showing all the best production of the United States in sixteen
museums at the same time. Whether this department-store technique
is of greater advantage to the arts than sixteen separate exhibitions
each focused on an idea without attempting to cover the whole pro-
duction of a continent, is arguable, but at least the feasibility of making
simultaneous exhibitions is demonstrated, if it needed to be.

Confronted with a print, and possibly having some information on
the career of the individual who made it, how is the collector to

identify and evaluate the incentive, the sincerity, and the seriousness of the artist? It is perhaps not enough to say that any matter not immediately obvious in the print itself need not be considered. In some respects the observer is almost certain to attempt to put himself in the place of the artist making the work; even though we might consider such a position impossible to realize. To assist him in this entertaining, if perhaps futile, attempt I want to call attention to a certain dichotomy in the conditions under which serious works of art are made today. Even to consider this matter we are compelled to exclude those artists who, intentionally or not, are producing an acceptable product for sale; and those whose chief object is to behave as they imagine an artist should, for which purpose works of some kind must be produced.

Limiting the inquiry to artists whose major preoccupation is with the work to be done, to the exclusion of how one looks when doing it or what immediate reaction is to be expected of the buyer of the work, we have a state of affairs in which the artist is out of step with the organization of everyday life which goes on around him. I am not suggesting that the serious artist is always the only man in step in the regiment, although it subsequently becomes clear that the most important thinkers in the arts and the sciences have been in this position. Nor am I suggesting that it is either feasible or desirable for an artist to isolate himself completely from the common people, their common task, or their everyday preoccupations. I am quite sure that an artist is not to be considered as a spring, a source; occupied with nothing but giving out from the inexhaustible store of his imagination. In fact he seems to me very much more like a sponge, absorbing continuously from the atmosphere about him the sense of the life of his time. His function may be a transposition or even transmutation of an idea which he is absorbing, and not merely emitting. In fact he is seeking, and perhaps not alone, that which is and not that which is not. But between times he has the ordinary requirements of any other citizen: food, shelter, clothing, and heat; and to get them he will need either to sell his work, or in some other way to earn his living. Now it seems very clear to me that if while elaborating

his works of art he has in mind how the market will react to them and the immediate prejudices of those he sees from day to day, then that will prevent his works from going beyond a very pedestrian level. Further, when selling his product (made, we will assume, without any reference to its possibilities of sale), aesthetic considerations must be neglected to the extent that he will offer any work available for whatever it may fetch, without engaging himself emotionally in sentimental considerations of whether he is being adequately rewarded for so many hours or such exceptional effort. It is not always possible to realize all these conditions, but this attitude seems to me a desirable one. The two fields of activity of the artist have to be kept separate if the best results are to be attained and the individual to keep his thinking separated in these two fields with as little communication as possible. I do not suggest that this state of affairs is desirable, but merely that it is so; the artist and thinker cannot be blamed for it, as they are very little consulted in the everyday organization of their world. Briefly, the practical organization of our frame of living is based on material values and the pursuit of immediate material gain. In fact, if this book had humorous intentions it would be quite possible to demonstrate that in many countries the failure to react to elementary greed is considered to be evidence of insanity. An artist who does not demonstrate daily this order of insanity is unlikely to produce works of serious importance. Actually he illustrates a point made by Einstein in an interview shortly before his death, in which he pointed out that success in our time is generally considered in terms of receiving more than one gives; whereas a man of value is honoured in giving to his world more than he receives. This point of view, by no means restricted to the artist alone, can be seen to be very much more 'practical' than it may appear. It is not only a question of the means of living but of the self with which one has to live. And from this point of view the artist's way of living, involving perhaps the completest privilege of nonconformity and freedom, even freedom to starve, may offer compensations which greatly outweigh its apparent disadvantages.

All this may seem very remote from the position of the collector examining a print to estimate whether it is a major or minor work or

without significance. But there is an analogy to be found between two different values which he can distinguish, somewhat parallel to the two attitudes of the artist. The first and most obvious of these is clearly the price that has been paid or would be offered for the work— dependent as we have seen upon a large number of factors such as fashion, the prestige of the artist, size, real or artificial rarity, and the product of all these factors, demand. The other factor, which has no discernible relation to the first, is to do with the direct reaction of the work upon the imagination of the observer and the consequences that this reaction may provoke. Now it is at this moment, when the observer has registered a very definite reaction (and if he has not it is unlikely that his interest will be sustained), that he will attempt in some degree to put himself in the position of the artist making the work; attempt to relive the actual making of the work; participate in a more intimate fashion in that action which could be under- stood as going on. It is probable at this time that he will recognize, even though possibly he may be unable to identify, the incentive of the maker of the print; in fact I suggest that without this recognition he would not have reached this stage of investigation at all. The functioning of a work of art has been understood at various times as decoration or ornament; as entertainment—and characteristically most words used to describe this in our language, as distraction, diversion, suggest a turning away from life, a sort of escapism. Others have seen a didactic purpose, the inculcation of morality, the incentive to virtue; or again the pursuit or creation of 'beauty', a relative, personal enjoyment; or the creation of a more general and universal canon. And even, on quite another level, the means of art have been used, and still are used, by different agencies to influence the thinking of people for purposes of power or domination, and even more regrettably, of salesmanship. It is perhaps just as well that the exercise of the latter function is well recognized by those engaged in this industry to provoke a phenomenon known as 'sales-resistance': and had we not assumed this protective instinct in the reader, the dis- cussion would not have been attempted.

But beyond all these functions, though perhaps together with

them, it would seem to me that the general consideration of art (with special reference in this case to prints) offers to the observer a possibility of even greater value. Not only do we suggest that the individual artist is a member of a very small but ingenious minority who has succeeded in escaping into a sort of nonconformity with our current industrial civilization, but the contemplation of his works has a tendency to encourage the escape of the observer from the conformism of everyday life. This is something very different from the out-of-life escapism we listed among the functions of art; it is in fact, if properly understood, an escape into life.

I am aware that such statements assume a definition of life in a somewhat special sense. The assumption is that life, which seems to us to have importance, is not the accumulation of daily incidents but is in fact a life of the imagination acting in the specially human sense on everything that comes within the knowledge of the individual. Thus let us suppose that one meets an intimate friend after an absence of twenty years, and in the first moments of reunion attempts to give an account of what has happened to one in the intervening time: it is beyond dispute that the details of rising in the morning, eating, driving on the proper side of the street, and gaining one's livelihood within the framework of our system will not be referred to at all. Those things that would be mentioned as having importance will, if carefully considered, be found to belong to the imaginative life of the spirit; will have reference to the immediate incident only in so far as they were provoked by the reaction to incident, which itself has by now acquired less importance. Thus it is to be supposed that in the contemplation of the exceptional print, which by chance is able to engage completely the spirit of the observer, he may be able to escape, as through the doorway in a dream, out of the banal conformism of our everyday banal existence into a fuller life of the spirit. All this may appear to the reader as pretentious nonsense; but such a reader is unlikely to have the absorption in image that we predicate. And that such absorption is conceivable I believe on the evidence of a woman bookseller I once knew in New York. She had stuck up over her desk a somewhat obscure and to me unimportant little print of

47. ATELIER 17

48. FREDERICK G. BECKER. Insect–Beast. 1953. Print from four colour plates 8″×12″

mine. She informed me that when completely discouraged with her futile bookselling she would look at this print and manage to forget her immediate bothers; to return refreshed to a job which did after all interest her very much.

To return to the sort of people who make prints and why and how they come to make them, I will give some account of a few cases which, if not typical (I doubt even that there is a type), give some notion of the very diverse circumstances under which prints are made. One story starts in an English public school: at the ripe age of sixteen a probably unhappy schoolboy who had picked up some knowledge of the craft of etching, sent one of his prints to the Royal Academy Annual Exhibition and it was accepted. Whatever opinion we may have of the aesthetic standards of this august body, this represents a solid achievement; unless the work was completely defensible technically it could not have been accepted. At eighteen this boy was under contract with a print-seller in London to deliver a certain number of plates each year, for a stipend just sufficient to permit him to travel and pursue his studies in France, Spain, and Italy. When I met him in 1926 in Paris he had already evolved to a point that together we scandalized the Professor in the Académie Julian by presenting cubist compositions for the weekly *concours* to determine the place of each student for the following week. Our places were of course the last in all cases. In the thirties he became a member of the Jeune Gravure Contemporaine, a very select French society of print-makers: by this time he had developed faster than the taste of his London dealer or of his market, and his paintings were beginning to attract attention in France. I can clearly recall his periodic returns to Paris from the country, copper plates etched in hotel bedrooms strapped to the outside of a battered suitcase. In the more stable conditions of the Slade, where he is now the instructor in etching, he is still making plates which are as unlike those of any other etcher as they are unlike those he made in the twenties.

The late John Buckland-Wright, originally from New Zealand, was trained as an architect. But it seems that the drawings that architects must make for their projects beguiled him at the expense of

his architectural studies; perhaps the meticulous organization acquired in his training gave him special access to the techniques of wood-engraving and etching. Before he joined me in the Atelier 17, of which he became a director, he was a finished craftsman as well as a brilliant artist; he had produced for the Golden Cockerel Press and for Stols in Holland magnificent illustrated books. In the Paris studio he was responsible for many of the technical innovations which have since been disseminated in most countries, and in his later position as instructor at the Slade School, he inspired many young print-makers with a sense of the unlimited scope of their craft.

About 1935 a young French banker, Roger Vieillard, whose interests had hitherto been divided between banking and tennis, came to work at the atelier. Without formal art training, his previous activity in this field had been chiefly the making of wire structures—a sort of drawing in three dimensions which turned out to be a magnificent preparation for his work with a burin. From the beginning the burin was his tool, and he rapidly mastered a very personal use of it. With the natural fear all needy men have of bankers, I did at this time entertain myself with images (probably false) of Roger happily engraving copper plates in his office while anxious borrowers waited outside. He has since become one of the leading engravers in France. Later in America another banker, known in art circles as Ian Hugo, after his duties as vice-president of a bank were done for the day, made the most remarkable engravings with us. He developed such control of the burin, generally considered as a stiff and deliberate method of print-making, attacking the plate more with regard to the copper itself than to a print to be made from it, that he demonstrated the possibilities of unconscious, almost automatic, action with the tool.

The block-printer Louis Schanker at the time of my arrival in New York in 1940 was still directing a project in print-making under the Works Project Authority: a most imaginative scheme set up under the New Deal to provide subsistence for artists. Directed at the time by a general, having no doubt a thoroughly military ignorance of aesthetics, it always seemed to me the more effective in that it was completely indiscriminate, requiring from its artists nothing but the

obligation to work and supplying them with materials and mere subsistence. Every major artist of the time in America was involved in this scheme. Such an organization, if continued for over a generation in any country with sufficient potential, could be expected to promote a magnificent development of talent; and even if it did not last so long, the enormous subsequent development of the arts in America and her present position as one of the major influences of the day owe a great deal to this scheme. Within this organization Schanker inducted a great number of young Americans into the craft of wood-cut—more especially his particular technique of printing from different blocks wet on wet, to give results approaching the richness and complexity of oil painting.

When I returned to France for the first time after the war in 1946 Roger Vieillard introduced me to a young engraver from the neighbourhood of Orléans. The son of a small farmer and able to escape from labour on the farm only by military service, yet from an early age he had found in Soulas, an excellent engraver in Orléans, aid in procuring tools and initiation into the engraver's craft. Considered completely mad by the people around him, Pierre Courtin persisted with his strange figures and I was able at that time to have his work exhibited in America, where it had some success; and Vieillard introduced him into the group of the Jeune Gravure Contemporaine in Paris. Later he developed the curious sculptural method shown in Pl. 27 and his work is now widely recognized.

In New York, shortly after the installation of the Atelier 17 in the New School for Social Research, a young engraver from Argentina who had arrived from Cordoba with a Guggenheim Fellowship joined the group. Of Polish emigrant and Spanish parentage, he had, almost alone, developed a style based on pre-Colombian and Indian motifs and later a method of printing from drypoint plates in successive warm and cold colour on the same sheet. As we had at this time several Spanish-speaking members of the group, he found at once a familiar atmosphere and in the following two years greatly extended his technique and ideas. At the end of this time I was able to recommend him to the University of Iowa, where Mauricio Lazansky has

since organized and directed the biggest and one of the most important centres of graphic art in the United States.

These few accounts of the conditions in which certain print-makers have worked recently make it clear that there is no typical case: the only quality that can be found in common among these artists is perhaps the perseverance and determination to fulfil the ends they set themselves, coping with the various difficulties they met in various fashions, but never losing sight of the object to be attained. Supported in some cases by fellowships and grants, encouraged sometimes by prizes, often without either, it seems that the most important part of their effort was made alone.

PART III

Quality and Value in the Print

II

FIVE DEGREES OF ORIGINALITY IN PRINTS

To speak of an original may seem to be claiming that the work is unique, that there is only one of it. When applied to prints which, as we have seen, exist in a number of examples, perhaps a stricter definition of the work is needed: that it has originated from the hand of the artist who signs it. But many qualities are offered in the print: (A) an idea, an image; (B) the process by which it has been manifested (if these can be separated); and, generally, (C) the action of printing from that source (as plate, block, stone, &c.) which was itself originated.

In the commerce of print-selling a wide variety of prints of very different orders of 'originality' exists and they are offered for sale at an equally wide range of prices; except on the part of one or two of the more conscientious international dealers, they are seldom distinguished or classified even by the salesmen, still less by the uninformed buyer. For the moment we will leave aside the question of what determines price or temporary value (discussed elsewhere) and will furthermore ignore the category of photomechanical reproduction, which embodies the idea of the originator of the image but offers no pretence of being directly from his hand.

Now it is a peculiarity of the fine print that, although it exists in a number (possibly a limited number) of copies it can yet be a work from the hand of the artist—autographic in character—where, as we have seen in such techniques as lithograph, the actual touch of the crayon may be witnessed in all the copies printed from the stone: in engraving or etching, that groove cut or eaten into the plate carries the thread of ink where the artist intended it on to every proof made.

This order of originality may be claimed for every print in which no other hand has intervened between the artist's trace and that seen in the print. But I think another degree of originality, or perhaps better, authenticity, can be distinguished in the consideration of prints.

If we consider the very remoteness and indirectness of the action taken by the artist compared with the result finally apparent in certain print-making techniques (see especially Chapters 3 and 4), it becomes clear that the ideal category of print, (A), would be a major work, undertaken by the artist having sufficient mastery of the craft and elaborated for itself alone (not as contributing to or derivative from a major work in another kind). In my view the majority of prints reproduced in this book belong in this category. As it is by far the most important and probably the least well understood category, I shall try to make this clearer. Let us suppose that a sculptor with the intention of making a plastic work has prepared a sketch or drawing of the sort of image he has in mind. Now he takes a handful of clay and starts to model with it. In the first moment of his action a quality of concrete figuration has emerged which was not visible or even conceivable in the drawing. Some new matter of interest has arisen by his action on the clay which was not and could not have been in the sketch. One of its specific qualities, but I think not the only one, is of course the dimension. Now in the category of print-making we are considering, even if a preliminary drawing or sketch-plan exists, the work itself has evolved through successive actions on the plate or other medium, whereby elements have emerged which do not seem even implied or latent in the sketch. Here too a question of dimension may occur: in certain ways of understanding the figured space possible in an intaglio plate, not only an obvious concrete third dimension may arise, but through the ambiguity of position which we have seen to be characteristic of intaglio prints, more dimensions of idea may be implied. In the conflict, counterpoint, or reinforcement of figured space by the colour-space in certain prints—though many of the expressive qualities of drawing, painting, and sculpture may be present—further implications of a special character can arise which

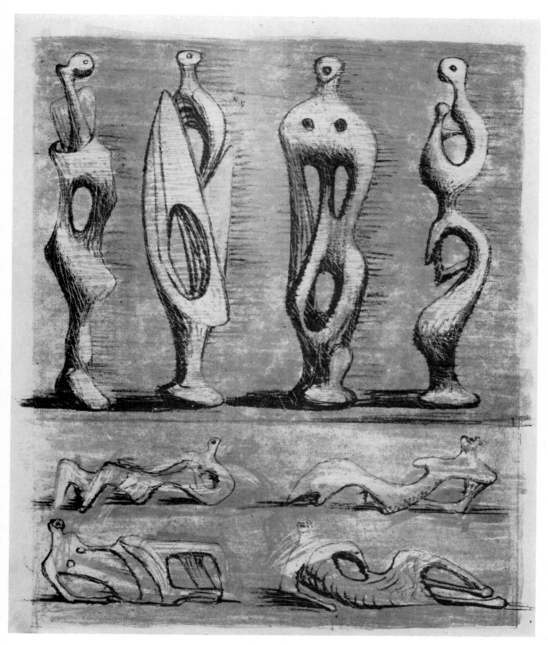

49. HENRY MOORE. Figures. 1950. Colour lithograph $11\frac{1}{2}'' \times 9\frac{1}{2}''$

50. GRAHAM SUTHERLAND. Predatory Figure. 1953. Colour lithograph $29\frac{1}{2}'' \times 20\frac{3}{4}''$

clearly determine this category. Some suggestions as to the means by which the layman can identify such qualities are made in Chapter 15.

However, the processes of print-making have since the sixteenth century been used exceptionally by artists whose major preoccupation was with a different means of expression. I say exceptionally because we must never forget that such instances as those of an original print-maker working for the sake of the print itself represent a minority against a background of many thousands of artisans who were translating into printable form the effects and ideas of works originated in another medium. It is reasonable to suppose that these latter works will be minor achievements, and in effect many artists of our time circulate sketches, notes for important paintings, and sometimes little more than specimens of their handwriting: all carried out upon stone, etched in metal or cut in wood so that many copies can be printed. This category, (B), which I should like to call 'the Autograph', appeals quite evidently to the collector of labels, and such works have a certain interest. Of course in these works it is most unlikely that the technique itself contributes in any way to a transposition of idea on the part of the artist. In so far as he has a sufficient freedom in the medium, the work may be no less than the drawing, but can hardly be more. Although they may be isolated from the rest of the artist's work, they often show *la Griffe*, the mannerism—frequently also an allusion to a subject or to a major work: in fact they serve to remind one that elsewhere and at another time this artist has done great things. They are so to speak 'By the author of . . .'. And why not? Nor is it surprising that more value attaches to the mere signature of Bernard Shaw than to a complete manuscript by Mr. X. However, it does seem of importance that whoever buys the one or the other should distinguish between the autograph and the work of art *per se*. I recall that in 1941 Ernst Kris in a seminar on the psychology of art at the New School for Social Research in New York suggested that prestige, considered as accumulative conditioning effected by all the previous works of the artist, was one of the essential factors in estimating the real value of a work—a suggestion which at that time I was not prepared to accept in view of my attitude

to the integral and independent functioning of the work of art as
a fetish possessing power in itself. If, however, we accept this view
of the prestige carried over from other works of the artist attaching
itself to the print of the second category, it could give a greater
value to such a work.

During the preparation of this book I have interviewed hundreds
of print experts, engravers, lithographers, dealers, and artists, and in
most cases have consulted them as to the means by which, in such
a book, the layman can be so informed that he may in some degree
become an expert himself. Of course in almost every case the reply
was that nothing serious could be done in this way: that only a direct
contact with the medium and the actual craft could confer this know-
ledge, some people often having this tendency to overestimate the
importance of special information they chance to possess. But such a
reply will not satisfy the general reader, so I am going to assume the
essential devotion and enthusiasm on the part of the print-lover and
try to give some definite indications to direct his study of the print.
How can one represent to an amateur what exactly is meant in our cate-
gory (A) by a major work? Of course it is not how big it is: among
print-makers in the United States recently a sense of scale seems to be
lacking and the prints are generally too big. This is not a question of
the function of the print—whether it is to be used as a mural decora-
tion or kept in a small portfolio—but is based on an absolute quality
which can be easily determined. I suggest that the amateur consider
whether the matter shown in a print would have lost in any way if
presented on a smaller scale; if not, it should have been smaller. I have
seen prints which when reproduced about the size of a postcard had
definitely greater effect than in the original about a yard across. It must
also be clear that this category is not determined by how elaborate
a print is; in fact I would suggest that if at first glance at a print
one is conscious of long and painstaking labour one of the qualities
that determines a major work, *celare artem*, has been neglected: the
force of the idea was insufficient to possess our imagination compared
with the means of expressing it, or possibly less cumbersome means
could have conveyed the idea more effectively. It seems to me that

where it is possible to separate readily the technique from the idea it expresses, one of these two conclusions must apply.

The artist himself generally knows what is a major work: he has, in the elaboration of a particular print or painting, been aware of something happening, difficult to describe but quite unmistakable, as if some force had intervened beyond his own effort. Not that I would suggest any metaphysical agency; to me this effect is no more than the liberation of an unsuspected resource of the imagination in moments of exceptional lucidity. Now of course this cannot be known to the observer, although perhaps there is something of this order which is knowable. Let us suppose that the amateur regards the print before him as simply as possible without assuming the completely 'innocent eye' which may be unrealizable to adults in our time, but with a mind as free from prejudice and superficial nonsense as possible. Strangely enough, what I am proposing is that the amateur try to put himself somewhat in the state in which an artist might begin a work; a state from which something of the same character, if not of the same order, as the original creation of the work of art can arise. I shall describe this preparatory state from my own experience. I attempt to empty my mind of nonsense and of superficial matters: in fact to make it 'a perfect blank'. This, although it may give people unaccustomed to the exercise that sensation, is not really to make oneself as stupid as possible. On the contrary it would seem to me that this sets free what Mallarmé calls *les sources pures*. By this he meant the exclusion of obvious associations: the emphasis on things present of themselves rather than the symbols of things elsewhere. Now I think in this state it will not only be possible but reasonably easy for the amateur to distinguish whether anything seems to happen to him or not, somewhat as the artist himself does; and I would suggest that if he decides that nothing has happened, he should at this moment reject that particular work. It is not impossible that at another time, having become more receptive to another order of idea, that same work may be moving to him, but for our experiment this is beside the point. Having registered the sensation of something happening, I should then suppose that any consideration of execution, of all the

separate factors contributing to the work, might broaden and deepen his appreciation; but always consequent upon the recognition of an event.

In this attempt to describe how one might identify a major work I have tried to put the experiment in its simplest terms: object/observer; and of course these terms are hard to isolate. It is not easy for the artist to withdraw his attention from superficial and temporary matters, and even less so for the observer who may well have far less experience of this sort of exercise. To speculate on the attitudes of the artist at the moment of making the work may well arise later, but I would suggest it to be unprofitable in this first stage. For the reaction that I have tried to describe in a vague fashion to occur, it is clear that the work itself must possess one quality, variously described as spontaneity, authority—in fact the ability to convince. It has always been my impression that to carry such conviction it is essential that the artist at the moment of creation should be himself convinced: that quite apart from his virtuosity of execution (the cumulative effect of a deep knowledge of the mechanics of his craft) and means of projection of his idea, his action, by which the work becomes visible, shall absolutely convince him at the time or it cannot convince an observer and hence is not a major work.

At this point some of the technical considerations mentioned in the opening chapters of this book may seem to have a direct application. Where the operations on the plate, block, or stone have been used to repeat or translate an image actually existing in another medium, as drawing, sculpture, or painting—or if not actually existing, readily conceivable as such—it is hardly possible that in the work we are seeing the idea itself coming into being: we are not in the presence of an original work. So I would suggest to the intelligent observer, who has found matter important enough to pursue in a print, to ask himself next if such a work could have arisen without the exercise of the particular operations whose result he is studying; if, furthermore, he can feel that in the artist's immersion in a succession of operations involving most print-making techniques—operations extremely remote from the final result—he has been able to realize some

character which was not apparent before the operation was undertaken. Thus if, in a pure line engraving, the situation of the artist in his progress at varying speeds through the convolutions of a burin cut compels the observer to retrace the path he has laid out, one at least of the conditions for a major work has been realized. If again the interference of textures, the web of space, the conflict or harmony between figured space and colour space, the ambiguity of convex/concave, tension, torsion, or flow: if all or any of these factors have involved the observer inevitably in their play, we have this condition. However, a corollary to this proposition ought to be mentioned here. One of the errors of certain of the 'space' groups is to imagine that, having demonstrated a certain order of space, a work has been achieved. It must be clear that unless in such space an event has occurred of real importance to both artist and observer, the effort is in vain. So that even when these qualities have been identified it is necessary for the observer to ask himself if any serious matter is involved beyond them, and of what order of importance. It is to be noted that in all this discussion of qualities in a print the reader has been invited to address himself to the artefact alone. Concentration on those books and articles intended to sell a product seems to me unlikely to bring the collector to any greater knowledge of the subject. This quality of conviction which I have proposed as a desideratum is that to which the result bears witness: it is impossible to fake, and its effect on the observer demonstrates it. A verbal or written profession of conviction, not evident in the result, has no bearing whatever on the issue.

To account for all the different varieties of proofs which will be offered from original etched and engraved plates, we shall have to describe in somewhat greater detail just what happens in the progressive development of a print. The very notion of a progressive development would indicate that we are here dealing with category (A); more generally with engraving and etching, though occasionally with lithography and even wood. Where the idea has come into being in the plate itself after a certain amount of work on it, the artist, however experienced, will decide that he does not quite know what he

has got. This is partly due to the fact that the inversion from right to left (as a mirror image) conceals his image from him, and partly to the very great difference between that appearance on the plate and the way it will appear on paper. Consequently the process of creation, instead of proceeding by continuous growth, will proceed by well-defined stages, at each of which one or more proofs will be made, and these are known as 'states'. These proofs are generally marked as 'State 1', &c., and numbered if there are more than one, and their very existence suggests continued work by the artist on the plate rather than the efficient translation of an idea by a skilled artisan, who will have no need to elaborate or develop an idea and is unlikely to make more than one or at the most two 'states' for arriving at his result. Such prints, though incomplete, are of course rarer than the proofs of the final edition and in many cases may be unique, since once the plate has been changed no more prints of the earlier state can be made. Where in a print made by an artisan one is unlikely to find more than one or two of these intermediate states, in some original engravings or etchings as many as ten might be made.

In the 'Battle' plate I made in 1936 there were actually ten states made over a period of six months. This plate was started in Paris, and except for two passages etched in soft-ground textures, was entirely engraved with a burin. I suppose that all the actual cutting with the burin into the copper could have been executed within a week, but as the idea had to grow and become clear like a long series of consequences on the plate, it was not complete for six months. During this time I was in the south of France, in Italy, and in Greece; travelling with one bag on the outside of which was strapped this large copper plate. The ten state-prints made, now in the collection of the Brooklyn Museum, together with the plate in the first sketch, were on paper, made when there was an opportunity to get to a press; there were in reality quite a number of others which were made without a press on plaster of Paris. This is done by inking the plate and wiping as for normal printing on paper; placing the plate face up on a flat surface, possibly with a rough frame around it, and pouring plaster to form a cast an inch or so thick. This permits the artist to see exactly what he has in

51. JURGEN VON KONOW. Blind Fish. 1954. Burin engraving $9\frac{3}{4}'' \times 13\frac{1}{2}''$

52. JULIAN TREVELYAN. During the Night 1932. Aquatint $4\frac{1}{8}'' \times 5\frac{7}{8}''$

the plate but is somewhat difficult to transport; in fact those plasters from the states of the 'Battle' were abandoned in various places in France, Italy, and Greece. It has been my experience that many collectors will buy a print of one of the incomplete states of a plate in preference to a print of the final edition and for a very much higher price. The justification for this is in part the greater rarity of the print, but also, I have found, to buy such a print ministers to the ego of the client, who is in a sense claiming that the plate would have been better left in this state than carried to what the artist calls completion. It seems to me only reasonable that the client should pay for this satisfaction, and I can hardly imagine that the artist would have any objection.

In classifying prints in order of their 'originality' we can find a third category, (c), in which the work is still executed on the plate or plates, blocks, screens, or whatever surface is being used, by the hand of the artist, but, as distinct from the first category (A) in which we have assumed the emergence of an image by the exercise of a technique in the medium, it is in reality a method of reproduction being employed by the artist himself. I want to make it clear that this is a very definite category and can be readily distinguished from category (A), and it is a category into which a large proportion of contemporary prints fall. Consider the case, which is a very common one today, of an artist who has achieved a certain renown but has up to this point acquired no knowledge of the techniques of etching, engraving, lithography, or such. He is strongly solicited by dealers to provide them with a print, often in colour, and by chance he is a person who is conscientious to a point that he is unwilling to sign proofs of prints entirely by another hand. He will apply to one of the excellent firms of artisans such as Lacourière and Mourlot in France where very competent advice will be offered in the techniques of reproduction by means of successive colour plates or lithographic stones. This advice he is going to accept uncritically because in his state of knowledge there is nothing else he can do.

As I may have mentioned elsewhere, the failure of engravers over a period of some centuries to free themselves from the mechanical

techniques used for the purposes of reproduction was due to very
simple causes. Thus when as little more than children Hogarth and
William Blake sought instruction in the craft of engraving there was
no one to whom they could turn but the practitioners of these tech-
niques, and that instruction began, like most instruction dispensed
by the ignorant, with a series of interdictions. It is more than one
could expect that at this early age these artists could have offered any
resistance to such instruction, or, if they had, have continued as
pupils—in fact apprentices—of the teachers on whom they were
dependent. Moreover, the artist intending to make a print is treated
with great respect, based on the price his works will command and
even on his very real achievement. However, confronted with the
long experience of these craftsmen, his ignorance of the mechanics
of print-making will hardly permit him, when told that a certain
thing cannot be done, to say 'Why not?' This can be so even when
the artist has had some experience in the medium: the craftsman will
have had very much more experience, which gives him an authority
the artist is unlikely to challenge. The result will be a work which is
original in so far as the plates or stones were actually executed by the
artist with his own hand, but which employs nothing beyond the
traditional methods of reproduction.

In defining these categories we must always remember that they
are not absolute: borderline cases exist in which the greater part of
the work has been carried out in terms of simple reproduction, but
one of the plates or stones, generally the key image, shows that such
liberties have been taken with the medium as to preserve the spon-
taneity of the artist's touch (as in category (B)); or that the contact
with the medium has so modified the artist's intention that some of
the qualities of category (A) may appear in the result.

The fourth category, (D), is that in which the artist has gone to a
competent firm of craftsmen with a gouache, drawing, water-colour,
or painting which he or his dealer would like to see in the form of a
print. An extremely careful analysis of the colour pattern is then made;
where the print is not to have the same scale as the 'original', photo-
graphic separations are frequently made and enlarged or reduced so

that they may be projected on to the plates or stones. In some cases the plates will even be etched in part or entirely by the heliogravure process described in Chapter 3. In other cases tracings are made, and the work of copying done by hand. The degree of skill that some of these lithographers and etchers develop, a layman would find almost unbelievable. When a considerable number of works have been made after the originals of an artist having a strongly marked mannerism, I have seen technicians who have developed the touch and hand-writing of the artist to such a degree that he would have difficulty in distinguishing the result from that of his own hand. All this results of course in a hand-made reproduction in which the exercise of the technique at its maximum perfection can almost equal the quality of the original, but under no circumstances could be expected to surpass it.

The apparent exceptions to this rule, in which the print is clearer or has greater interest than the original, can arise only when the practice of the method has simplified and imposed order upon a confused design (as in the case of the serigraph quoted in Chapter 6, p. 75) or where the action of the artisan has more real effect on the result than the original from which he started, in which case it seems to me he might well sign it together with the artist. But the result is a print with which the only contact of the artist's hand was at the moment he signed the finished sheets, and it has seemed to many authorities, as to collectors, that some means should be used to distinguish prints of this category from true originals. Traditionally, at a time when both engraver and artist were acknowledged on a print, this was done very simply by engraving the two names on the margin of the plate: the plates made by Jacques Villon after a great number of other artists' designs (38 plates in all made between 1921 and 1930) are distinguished in this way; they now belong to the Chalcographie of the Louvre and continue to be printed, the prints being sold at very reasonable prices (see Pl. 36). Now all these prints, reproductions though they may be, were done in the presence of the artist, who may even have been present when the first trial prints were made. He will have seen and corrected the progressive proofs and will to some extent have directed the work, which has quite clearly been done with his consent

and that of his dealer. As we shall see later, this is not always the case. Generally before the edition is printed a print is made which is marked '*bon à tirer*', signed by both engraver and artist, to which all subsequent prints should conform.

A last category, (E), is frankly a reproduction, frequently done by mechanical means, photographically or otherwise, even when in certain cases where a comparatively small number of proofs are made it is printed by hand. The heliogravure illustrations used in art books at the beginning of this century were printed by hand, almost as etchings and engravings are printed, although the wiping of the plate was done so rapidly and so mechanically as to resemble the methods of printing visiting-cards. Facsimile reproductions of engravings and etchings from plates made by electrotype, as described in Chapter 5, serve a useful purpose in disseminating copies in which practically all the qualities of the original are present. Photo-lithographs, in which each element to be printed in black or in colour is photographed on to a light-sensitive film on the surface of a stone or prepared metal plate, are often used for posters and reproductions which, on account of their fidelity to the original and in some cases of their rarity, become quite valuable collectors' items. The lithograph reproductions made by Mourlot after Picasso to serve as posters for certain exhibitions, sometimes printed in a smaller run without text, are of very great intrinsic value owing to the fidelity of the reproduction, due in many cases not only to the craft and cultivated sensitivity of the lithographer but also to hand work on the stones or plates to render effects that the camera could not reproduce. The silk screen has also been used to make such reproductions, which in the case of gouache and paintings with definite impasto can render to some extent the surface quality of the original. The simpler stencil method has been used in the same fashion; it can produce reproductions, particularly of water-colour and gouache, of astonishing fidelity to the original. The only distinction between this category and the previous category (D) depends on the degree of collaboration of the artist, which without other evidence can be determined only by the cultivated taste of the collector. Even typographic reproductions,

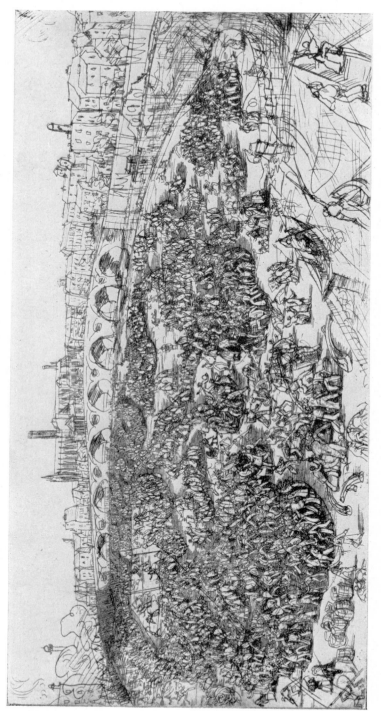

53. ANTHONY GROSS. La Foule — 12.30 a.m., Toulouse, Prairie des Filtres. 1920. Etching 6″ × 11⅞″

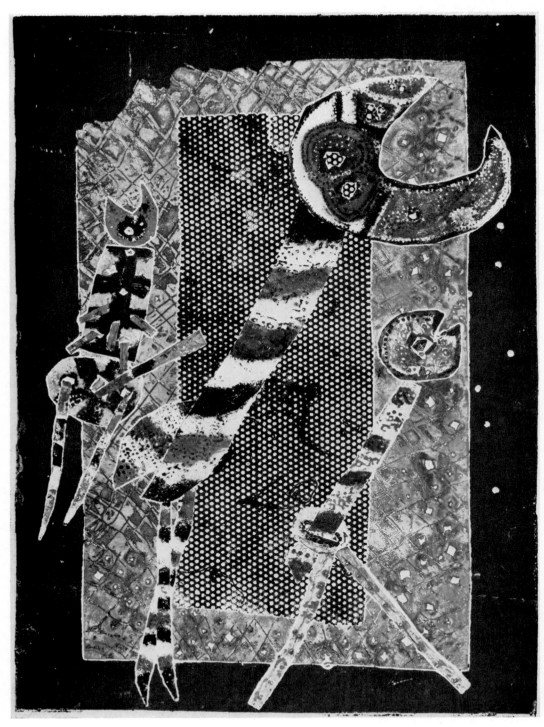

54. ROLF NESCH. Composition. 1955. Relief print 22½″ × 16″

like the Van Gogh 'Sunflowers' made by Hanfstangl of Munich many years ago, on account of their astonishing fidelity and ultimately of their rarity, can have considerable value. It may be of interest to know how these reproductions are made, in spite of the fact that they are really outside the category of fine prints and are practically never signed by an artist—though as we shall see such cases do exist. A very elaborate series of photographs, using different colour filters, are made of the original painting, from each of which a half-tone block is made for the particular colour that corresponds to the filter. In the case of the 'Sunflowers' I was told that there were twenty-one of these, eleven of them being yellows. Furthermore, as in many cases it will not be practicable to have the original painting in front of the printers when inks are being mixed and the first trial proofs made, a hand-painted copy which must be absolutely faithful in colour will be made by a competent artist to be used as a control at the time of printing. In the early summer of one year in the twenties it happened that I needed some money in order to spend the summer in the south of France. Consequently I was willing to paint several of these copies from paintings in the Louvre for Mr. Hanfstangl, devoting in no case more than five days to any one copy. Mr. Hanfstangl paid me for these works somewhat more than he was paying to other copyists at this time, partly on account of the celerity with which they were executed and partly, as he mentioned at the time, because he felt his family owed something to mine as they were still receiving income from the circulation of reproductions of regrettable works by one of my remote ancestors in the more backward parts of Germany.

12

HOW TO DISTINGUISH THE ORIGINAL
PRINT FROM A REPRODUCTION

ONE of the nightmares haunting even experienced connoisseurs of prints is the fear of being fooled by one of the methods of reproduction which so perfectly resembles the effect of original work that it is extremely difficult to distinguish. A print from a heliogravure plate which has been remade from a print is so exact a reproduction that at a short distance it appears absolutely identical. In this short treatise it is not possible to discuss in detail the methods by which these plates are made; some note, however, may permit the collector, in view of the effects of these methods, to identify with considerable probability a print in his hand. Heliogravure, described in Chapter 5, is a form of etching or aquatint, printed by hand by exactly the same method as an original engraved or hand-etched plate, but from plates made photographically: that is to say by the exposure of a sensitive resist to light. In this we have a point of distinction: made in almost every case from as perfect a print of the original as can be obtained, *everything* seen on this print is visible on the heliogravure plate and consequently on the final print. If the original is engraved, the incised lines are translated very faithfully by an etched trace: microscopic examination of the edges of the line, particularly if foreshortened in length, will show a slight serration due to the action of the acid, and this immediately betrays the facsimile reproduction. Then again, in the original some slight variation in value of the background left by the hand of the printer may appear, or the slight haloes of tone around a line. Similar changes of tone and haloes may be found on the reproduction, but together with them a dotted trace (actually from pits etched into the plate) will be detected with a microscope, which is

not present in an original. The presence of these dotted passages in a heliogravure plate is due to the fact that the method is too good: light passing through a negative before affecting a sensitive film does not of course distinguish between what was physically present in the original plate and those accidents of printing due to the hand of the printer. Thus when quanta of light are dispersed by tones or haloes on the print negative, the effect on the film is a fine dotting which one can learn to recognize. Of course if one has an authentic proof of the plate all this becomes very much easier, but even without it no expert can be mistaken. Where the original was etched or aquatinted it becomes much harder to recognize the facsimile, as there may be no perceptible difference in the serration of lines or borders under a microscope. The haloes, represented by fine dotting in the reproduction, may still appear. If one has special equipment, such as the Lessing Rosenwald Collection provides for visitors, other tests are possible. Examined with polarized light (vibrating in a plane almost parallel with the surface of the print), the relief of the line or texture above the paper is enormously exaggerated. In the case of a print from a heliogravure plate, two points are revealed under these conditions. Whereas in a hand-etched plate the depth of etch will generally vary widely, in a heliogravure plate most of the work will be at the same depth. Furthermore the total depth of etch in a heliogravure is generally less than in a hand-etched plate; bearing in mind that the print is a true cast in ink of the plate, these variations of depth will be exhibited as variations of relief of the ink above the paper, and are very clearly visible in polarized light.

An even more precise method of reconstituting a plate for intaglio printing is by means of electrotype (*galvanotypie*). Briefly this consists of preparing the surface of a suitably mounted print with graphite or other material to cause it to conduct an electric current. It is suspended in a copper bath opposite a copper plate which becomes the anode and the passage over a long period of a small direct current slowly builds up an electrolytic deposit of copper, which moulds with molecular accuracy the form of the plate. Removed from the matrix,

and possibly reinforced, the resulting plate can be printed, and again it is extremely difficult to distinguish such prints from the originals. Incidentally the method is used in a slightly different way for the falsification of metal objects, coins, and goldsmiths' work. Here the detection of a fake is really difficult; in fact the expert would base his verdict, if no other evidence were present, on the quality of the surface in parts where the original plate was unworked. The electrotype plate in these parts having been moulded on a surface of paper, it is not absolutely similar to the surface of the original plate which was arrived at by grinding and polishing. Methods as elaborate and expensive as these, as used for the unlicensed printing of banknotes, are unlikely to be undertaken except to falsify a rare and very valuable original. The electrotype facsimile, however, has been widely used for facsimile reproduction of valuable prints with no intention to deceive.

Thus in my village in the south of France a neighbour had a beautiful framed print of Dürer's 'Knight and Death'; deciding to sell it, he sent it to me in Paris to propose to a client. But a moment's inspection showed me that it was a facsimile print made, together with many other sixteenth-century prints, by a well-known house in Paris early in this century. However, in the case of this print and others of the same kind there is often a far easier and more certain method of detection. As we have seen in our discussion of the origins of printing, the papers made before the nineteenth century, by hand on wire mesh forms, are entirely characteristic. A little practice will enable a collector to distinguish with absolute certainty between papers of any century from the sixteenth to the eighteenth; and these from any contemporary paper, not excluding hand-made papers which in one case I know of are actually made on eighteenth-century wire mesh forms. In this case it is only by the quality of the pulp used and the skill of the individual paper-maker that any distinction can be made. But more certain evidence is provided by the watermarks (*filigrane*) in the papers, which are the traces left in the paper of a wire initial, crest, or motif which was part of the wire mesh form on which the sheet of paper was made. Thus a print offered as a Dürer which was not printed on a paper with his charac-

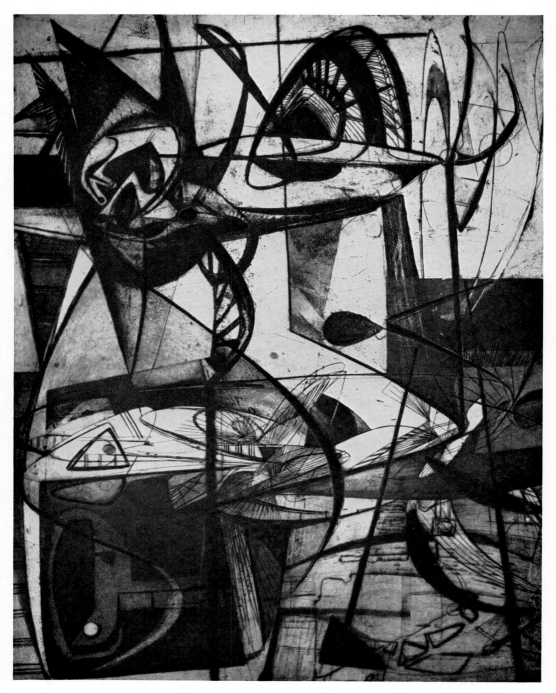

55. MAURICIO LASANSKY. Time in Space. 1945. Burin engraving and soft-ground etching 16″×24″

56. S. W. HAYTER. Cascade. 1959. Single plate, colour $19\frac{1}{2}'' \times 19\frac{1}{2}''$

teristic watermark or of the sixteenth century would almost certainly be a fake.

Some account of how paper is made by hand may be of interest to the collector, in so far as it enables him to identify with certainty a hand-made paper, whether so watermarked or not. Unless it is a deliberate falsification of a valuable print, it is rare for a reproduction to be printed on such paper; if it is on hand-made paper the presumption is that such a print is original and has value. The material from which paper is made by hand is some sort of fibre, generally cotton, linen, or the underbark of the paper mulberry (from Japan and Madagascar), although exceptionally hemp, papyrus, and certain fibrous grasses (as esparto) have been used. Wood pulp, which is the chief component of all cheap papers, is practically unusable; in fact its use for paper-making only became possible with the invention of machines in the nineteenth century. The usual source of the pulp is cotton or linen rag: for the best kinds of rag paper only white rag, not chemically bleached, is employed. (Where either rag or pulp has been bleached with sulphur dioxide or chlorine, the paper will slowly yellow with time.) Ever since the introduction of paper-making into Europe this material has been reduced to pulp by beating in water with hammer-mills, just as papyrus was flattened by beating with a paddle on a flat rock. The fibre in such pulp has a long strand which, if unbroken in the preparation, gives great toughness and resistance to the sheet. The later invention of the Hollander machine in which two rough steel rollers revolve against one another in the same direction, ground the material more rapidly but produced a pulp with a much shorter fibre. So to give the resultant paper enough strength various adhesive materials are added to the pulp, and in the machines the sheet often passes between heated rollers which harden and fix this material. Such papers have less permanence, and as they do not take moisture into the fibre are unsuitable for intaglio printing.

The operation of making paper by hand can still be witnessed in England at Maidstone in the ancient Hayle Mill of Barcham Green and at Whatman's near by; or in France at Vidalon or in the Auvergne. The

paper-maker stands in front of a bath containing the pulp suspended
in warm water. At arm's length he holds a sort of tray like a sieve
with a movable rim of hardwood, the bottom consisting of a grid of
crossed or woven brass wires (known as the form). This tray is dipped
into the bath, raised above the surface, and held perfectly level. As
the water is draining away through the sieve a slight jerk outwards
and then sideways causes the fibre to mat across the wires. As soon
as the water has drained off sufficiently the form is set diagonally on
edge in a rack beside the bath while another form is being dipped.
The rim of wood is then removed and the sheet of paper transferred
to a woollen blanket (similar to the blankets used in intaglio printing)
with a rolling motion. Another woollen blanket is laid over this,
then another sheet of paper, and so on until the stack is large enough,
when the whole pack is compressed (in a hydraulic press) to squeeze
out most of the remaining water and the sheets, now firm enough to
handle, stripped off and hung up to dry. It is difficult to estimate the
skill needed to do this unless one has attempted personally to make
paper; it is like holding a tea-tray full of water at arm's length with-
out spilling a drop. Then the slightest hesitation in the rolling motion
of transferring a sheet to the blankets will crumple or tear the paper.
Actually these men are not only trained from childhood for this
work but are frequently descendants of many generations of paper-
makers. The physical effort necessary to do all this in a steamy atmo-
sphere for an eight-hour day is also not to be despised; owing to the
heat the men often work stripped to the waist and one sees that the
exercise over years has developed enormous stomach and waist
muscles wider than the hip, similar to the form of certain fifth-
century Greek sculptures. All of which may seem remote from the
interest of the collector examining a sheet of paper against the light
when he may see the slight irregularity caused by a drop of water
fallen on the unformed sheet, the orderly laid pattern of thick and
thin wires, or the more uniform trace of 'wove' form in the hand-
made sheet. It is not always easy to distinguish between modern and
ancient hand-made papers, but in general the modern ones tend to
be rather too hand-made: that is to say, whereas the aim of the six-

teenth- to eighteenth-century paper-maker was to produce as fine, even, and perfect a sheet as he knew how, under the pressure of contemporary taste paper-makers are often expected to produce a sort of rustic-looking paper something like the health bread with twigs in it, sacramentally eaten by people with poor digestions. Another distinguishing characteristic can be verified by chewing a speck of the paper from an edge and examining the fibre: unfortunately many of the modern papers are made from ground pulp with short fibres of fairly equal length; hammer-mill pulp has longer and more varied lengths of fibre in it and can readily be distinguished.

With contemporary prints it is on the whole much easier to distinguish an original from a reproduction, as the means by which the reproduction is made are almost certainly completely different from those used to make the original. It becomes a little bit confusing when, as in the case quoted in Chapter 13, a reproduction is made by one means (serigraphy) of an 'original', which is itself a reproduction made by lithographic means. However, a moment's examination of the print surface with a glass shows the characteristic woven-silk texture of the screen; and consultation of the published records of Miró's prints shows that this work is a lithograph.

For the reader who might be disposed to go further into this print detective game, there are more elaborate means of obtaining information from an actual print by means of microscopic examination and chemical analysis of pigment and paper, X-ray, ultraviolet, and infra-red examination. This is of course getting into the curator's field, but the exceptional collector with a bent for this sort of thing might ask, Why leave such research entirely to professionals? An example of the use of X-rays to obtain information from a print arose when I was visiting the late Carl O. Schniewind at the Chicago Institute of Fine Arts. In his collection there is a print of the 'St. John' of Domenico Campagnola of such brilliance that it appears to show traces of the burr which would be left on the edges of the burin cut by the engraver, and which was not entirely removed at the time of making the very first prints. Now this can mean that we have here

one of the first prints taken by the artist himself, as further printing
would wear this burr away, and we were both very curious to find
some way of supporting or disproving this assumption. With his
new toy we examined together a recent print of mine: black ink
under X-rays is fairly transparent, seen on the fluorescent screen as
only a slight shadow. In one large mass of ink we detected a black
spot, completely opaque to the X-rays. With a scalpel we dug out
this speck and found it to be a grain of copper, probably part of a
burr removed from a burin line, and which consequently had been
caught in the ink when making this trial print. This could only occur
if the print was made in the actual place where it was engraved. It
is unlikely that grains of copper would be found in a printing-shop:
two or three printings would necessarily remove every trace of free
copper from the plate. So that the presence of a point like this gives
a strong presumption that we have here one of the first impressions.
When the Campagnola print was examined, a few of these points
were found; but as nobody is going to dig out grains of ink from such
a valuable print, this does not constitute absolute proof. The interest
of inspection by infra-red light (generally for the purpose of photo-
graphy, although viewers do exist for direct inspection) is chiefly to
detect alterations, erasures, or repairs to the work or to the paper. Even
if not visible in normal light, the difference of light-absorption in the
red end of the spectrum may be enough to distinguish them clearly.

In the case of an intaglio print in colour, criteria of value will be
determined by some of the considerations mentioned in Chapter 13,
such as size of edition, reputation of the artist, rarity of the particular
print, and, in general, demand. However, the first step is to determine
whether the print was printed by hand, from hand-etched and en-
graved plates. If, under a glass, it is possible to distinguish in a print
the mechanical grain of photo-reproduction, this is evidence against
the print being either directly from the hand of the artist or even
a fine reproduction made by an artisan. Again, the degree of relief of
the colour above the surface of the sheet is always greater in a hand-
printed copy than it is in a mechanical reproduction. Where a multiple-
plate process has been used examination of the margins will nearly

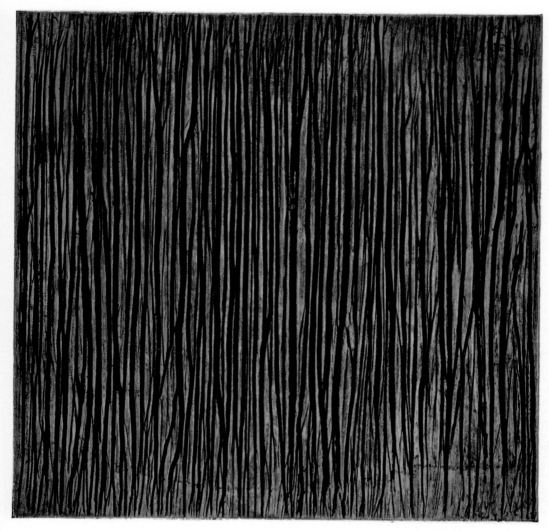

57. SERGIO GONZALEZ. Green and Mauve. 1959. Single plate, colour $15\frac{1}{8}'' \times 15\frac{1}{8}''$

always show errors of registration; and the characteristic pinholes used for placing the sheet in hand-printing can be seen on the back of a proof. The presence of these holes means definitely that the sheet was printed by hand, but their absence may mean two or three quite different things. For instance, there are no pinholes in the copy of the Masson print although this is in full colour, for the simple reason that all the colour was assembled on the plate and transferred in one impression to the sheet. A trial print in colour made by the artist from several plates might have been printed by the method described in Chapter 5 in which the damp sheet is held in the press while the plate is replaced by the second colour plate and so on, so that no pinholes were needed. In this case their absence shows that we have a trial print with a stronger presumption of originality than an edition print. But if we study carefully the surface of this print, which must have been printed wet on wet, some degree of mixing and even spreading of wet colour under pressure will be detected. These, however, are exceptional cases: a print which exhibits very little relief, although visibly printed by an intaglio method, and shows very slight or no indentation around the plate marks and no pinholes for registration, is most likely to be a reproduction.

In the description of lithograph workshops we saw that hand-printing from stones as well as machine-printing from either stones or zinc goes on in the same establishments. Here the absence of pinholes in a print suggests that a multiple colour image was printed rather by the machine than by hand, although the registration of colour is no less accurate on the machine than it is when done by hand. But to distinguish with certainty a hand-printed lithograph, let us say in black, without any of these indications, really calls for considerable study and discrimination. Certain qualities of texture obtained on a stone by very thin *tusche*, or subtle differences of texture in greys and in colours obtained by scraping or rubbing on the surface of the stone, can be perfectly well printed by hand but not by the machine; the quality of blacks or of deep colour in hand-printing is stronger and richer than that from the machine, and with sufficient practice one learns to distinguish the one from the other.

The same sort of difference, but very much more conspicuous, is found when the print was made by machine offset. The reader who has followed the description of offset printing will understand that a film of ink which has been transferred to a rubber blanket and re-transferred to a sheet of paper will inevitably be very much thinner than that transferred directly from the stone to the paper by pressure. Another interesting quality which can only be seen on paper with a wove or laid surface is the effect of this pressure, which crushes and flattens the paper grain on the printed part of the sheet. It is clear that in the case of a reproduction process such as lithography it becomes extremely difficult to distinguish between the different orders of originality, as no absolute originality exists at all, as it does in the case of sculpture compared with drawing. By this I mean that in the results of lithography, whether printed by hand from the touch of the artist, by machine, or by offset, we are not in presence of a complete transposition which took place in the elaboration of the work. Starting from a drawing, whether on paper or on stone, we end with a drawing printed in a large number of copies, and no greater change in idea is likely to have happened than if we had transferred the drawing to a different sort of paper. If, as we saw, a sculptor makes a drawing, and then starts to model with clay the forms suggested by the drawing, in the first moment of modelling something has appeared which could never have been demonstrated in any drawing, i.e. by the exercise of the medium new matter of idea has come into existence.

When a lithograph print has become very well known and is much sought after, it may be to the interest of a publisher to falsify the print. Not always with dishonest intentions, it is possible to lift a print from a stone which can no longer be printed effectively and lay it down on a new stone, on a zinc, &c., and continue to print what is practically a facsimile. Even when the stone no longer exists there are methods of doing this from one perfect print without having recourse to photography. The only sure method of distinguishing such a print that I know is by looking for a certain characteristic texture which can be seen under a microscope as the interference

58. ANDRÉ MASSON. Couple on a Leaf. 1954. Single plate, colour 12″ × 10″

59. TOULOUSE-LAUTREC. Loie Fuller. 1893. Lithograph $14\frac{1}{2}'' \times 10\frac{1}{4}''$

of two different grains; once this has been seen, I think the collector would find it easy to recognize. Such lithographs as the Toulouse-Lautrecs and certain of the more popular Daumiers which were in the first case printed in very large editions have frequently been re-imposed and some of them are still being printed. Again, as in the comparison of the orders of originality in prints, the least valuable may have as great an aesthetic interest as the most, but it is clearly in the interest of the collector to distinguish between them.

13

THE PUBLISHING, DISTRIBUTION, AND CLASSIFICATION OF PRINTS

LET us suppose a print is offered for sale in a gallery, print-shop, or bookshop: presumably one of a certain number of similar prints made from a plate, block, stone, or screen. It may be of some interest to follow not only, as in earlier chapters, how it got to be made, but how it came from the workshop, the artisan, the printer, or the hand of the artist, to where you find it. Here again there are quite a number of categories, sometimes indicating different degrees of originality or of authenticity in the print, some of which have already been indicated. In the particular case of prints from etched and engraved plates where, as we have seen, progressive proofs may be taken at different stages of development, the existence of either a signed (and possibly numbered) proof marked *état* (state) or an unnumbered signed proof which one knows to be an incomplete version of a plate known and published, are almost certain indications of authenticity and are generally considered to have greater value than the final prints. But for this to be true one must take into account whether the work of this artist and the particular plate is or is not in general demand. In the case of a lithograph, as the work is very seldom developed in stages (true also of woodcut or serigraph), state proofs of this type are practically never made at all.

What generally happens is that the artist (or his printer, or his dealer's printer) completes a stack of prints of a number previously decided upon, plus one or two extra ones intended to replace damaged or imperfect proofs. These he will number, either as a fraction, as $\frac{5}{100}$ (where the ordinate is above showing which one it is in the series, with the total number of the edition as the denominator), or some-

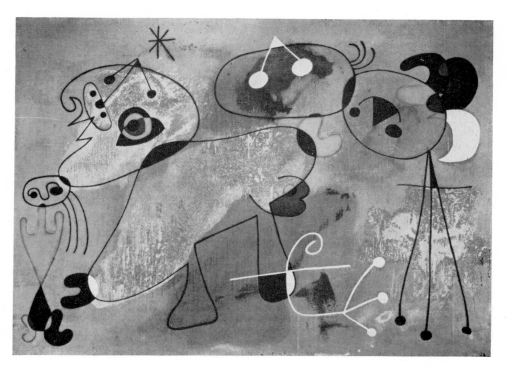

60. JOAN MIRÓ. Fond Vert. 1950–1. *Top:* Colour lithograph $13\frac{5}{8}'' \times 18\frac{3}{8}''$; *Below:* Serigraph (fake)

61. KURT SONDERBORG. Composition. 1954. Soft-ground etching $5\frac{7}{8}'' \times 11\frac{3}{8}''$

times as a ratio, as 5:100. As I can see no reason why the collector should not have the satisfaction of knowing that his number 3 really was printed before number 4, I personally arrange the proofs in order as they were printed and number them this way. I know many artists and printers who neglect this small detail. In some cases where the artist himself publishes the edition and is his own printer, the whole edition is not printed at one time: five, ten, or twenty prints are made and more printed as these are sold or as the artist gets around to it. Of course what can happen here is what has happened to me with scores of earlier plates: after five, ten, or so prints have been taken the plate is lost or destroyed or for some reason one is prevented from completing the edition. Thus the series of plates 'Proie Facile' with the poem of Paul Éluard, published by GLM, Paris, 1939, is numbered at 150 copies. As I printed this myself, only fifty were actually finished before I had to leave Paris and abandon the plates, which I understand were later sold when the occupying forces were buying up old copper. But in any case when prints are signed and numbered in this way the presumption is that no more copies than this were ever printed, and after printing them either the plate is destroyed (at one time by cutting across it, keeping a print of the cancelled plate; even by cutting in four parts, one being kept), the stone erased, the wood block planed down, or the design washed off the screen. My own practice is to cancel a plate after printing by engraving across part of the worked plate a signature in recto, which when printed will appear in verso. This effectively protects the buyers of the edition as this signature, if removed in view of later printing, would leave a white space which could not be disguised. At the same time this avoids the absurd destruction of the copper plate as a work of art, often a more beautiful work than any print from it. Indeed some ten of my most important plates, cancelled in this way, are to be found in museums, and I think it would be well if this practice became more general.

But in spite of this theoretical limitation to the number shown, there is a more or less generally accepted custom that the artist shall reserve five copies (lettered or numbered otherwise than the signed

and numbered edition) known as artist's proofs. The 'Société du
Droit des Auteurs' which regulates and protects the copyright of
artists and authors in France and some other countries, accepts this
practice. These prints may be marked Trial Prints, Artist's Proofs,
Épreuve d'Essai, Épreuve d'Artiste, Hors Commerce, H.C., &c., to
indicate what they are and that also, being 'outside of commerce',
they are not for sale, at least not on the same terms as the regular
edition. Of course this is a pious fraud: they are generally sold at
rather higher prices than the ordinary edition and the whole system of
artist's proofs has been somewhat abused. Against this the buyer is
really protected only by the personal integrity of printer, dealer, and
artist. In this category of prints, however, the real first trials of the
plate when practically complete often show that the manner of
printing had not then been entirely decided and slight variations
will distinguish these prints from one another and from the final
version. My own trial prints are marked with a capital sigma, the
number being shown as a fraction, as $\Sigma \frac{2}{5}$.

Let us suppose we have our stack of prints printed entirely by the
artist, or by a printer under the direction of the artist: how do they
get into circulation? Frequently the whole edition is sold outright to
publishers of the type of Berggruen, Maeght, La Hune, Lacourière
(in which case the printer is the publishing house), and others, in
Paris; Curt Valentin, Contemporaries, Associated American Artists,
The Seven Arts, International Graphic Arts Society, in America; St.
George's Gallery Prints, Folio Society, &c., in London; Guilde de la
Gravure, Geneva, Klipstein of Berne, L'Œuvre Gravée of Zurich,
all in Switzerland. Not all these are purely commercial houses, some
being tax-exempt institutions supported by donations. Since owing
to the way they are administered they offer no advantage to the artist
over houses run strictly for profit, I have made no distinction. Most
of these editions are between 50 copies and as many as 300, and are
consequently offered, particularly in the bigger editions, at compara-
tively low prices. The deal with the artist is generally based on the
rate of sale of the complete edition at an agreed price: the terms vary
widely according to whether the artist is free or tethered (belongs to

the stable of a dealer); whether costs of printing, paper, &c., are at the charge of the artist; and above all the estimated demand for the particular artist's work in relation to the supply. The sum may vary between less than one-third of the total price to as much as, but very rarely more than, one-half. In case this may seem to be unfair to the artist we must remember that the publisher may well take years to sell a complete edition; all the charges of presentation, distribution, and advertising are his responsibility; and the artist receives a considerable sum at once, whereas if he were to publish himself he would receive a number of small sums spread over a long period, and have all the bother of distributing the prints.

Now in some cases where the publisher has a gallery or direct outlet of his own, a certain proportion of the proofs will be sold directly to the public, and on these prints the margin of profit for the publisher is highest. Another device for the distribution of prints is the formation of more or less authentic clubs, to which members subscribe, having the right to purchase, generally at very low rates, any or all of the prints published by the club during the year. Some societies of artists such as the Jeune Gravure Contemporaine of Paris have closed lists of subscribing members who, for a fixed annual subscription, receive proofs of two or four plates made in turn by the artist members of the society; these plates being printed only for the membership. This idea for the distribution of prints has, with its obvious advantages, some very real disadvantages. Like the clubs it offers insufficient freedom of choice to the member, who is almost certainly going to find that he has to accept prints he would not have chosen. But the greater part of the production of those publishers who do not have direct outlets, and a very large proportion of the prints of those who do, will pass through other hands before they are sold. Thus small numbers of prints from a particular publisher are bought for a discount of 40 per cent. to 50 per cent. by small printshops and even bookshops; single prints at a slightly higher rate; some of the prints are even distributed to such shops for sale or return, in which case the publisher will receive no more than two-thirds of the full price. Where the work of the artist is in considerable demand

speculative buyers may attempt to buy numbers of an edition which are then held until the rest of the edition has been sold, when they can be sold at very much higher prices; most publishers try to discourage this, for the simple reason that if anybody is going to profit by this it should be themselves.

Among the galleries which exist chiefly for the exhibition and sale of painting and sculpture, but which have subsidiary activity in publishing prints, that of Aimé Maeght in Paris may be cited as typical, with some special features. These are due to the accident that the owner is himself a master printer, and is consequently able to direct the impression of his prints with knowledge. In view of the increasing commercialization of the printing houses for the reasons we have quoted, he has recently set up a workshop for the printing of his own editions in intaglio, lithography, and offset. The interest of a gallery with a stable of artists is to make available all the different categories of original, semi-original, or simple reproduction prints for circulation. Thus examples of the work of its artists will be in the hands of many thousands of people who otherwise would be unable to own them. In recent years it has become the policy of this house to issue original prints from the hand of the artist in numbered and signed editions of not more than 75; works made in part by artists (perhaps the black plate with colour plates made by an artisan), works of collaboration clearly marked as such in catalogues, 300 copies; handmade reproductions made by artisans, but also numbered and signed by the artist, in editions of 400 to 500 copies. To distinguish between these three categories, unless clearly defined by the dealer or salesmen, requires quite expert knowledge; some of the information given in Chapter 12 may help the reader to identify them.

However, this probity on the part of the publisher does not always lead to absolute control over those prints offered for sale: until copyright laws in various countries are stabilized it is still possible to falsify editions of prints. The print (Pl. 60) 'Composition Sur Fond Vert' of Miró of 1950–1 was made by artisans under Miró's own direction from a small painting (as the canvas-textured background reproduced by photo-lithography shows); it bears no signa-

62. ÉTIENNE COURNAULT. Judgement of Paris. 1930. Burin engraving $8\frac{1}{8}'' \times 6''$

63. MARINO MARINI. Horse. 1952. Lithograph $12\frac{1}{4}'' \times 8\frac{5}{8}''$

ture on the canvas or on the surface of the print. Some 400 copies were printed and put on sale. In 1952–3 there appeared in New York an unlimited edition of an unauthorized serigraph reproduction of this print: a signature of Miró, photographed from another work, had been added to the print. When informed of this the publisher consulted counsel as to his rights in the matter, and found that as the © did not appear on the face of each and every proof, he had no copyright under American law. However, representations made to a distributor who was advertising this pirated edition persuaded him to withdraw the announcement and the production of these prints soon ceased. I understand that the laws of copyright have since been amended, and that it would be very much harder to falsify an edition in this way at present: where the 'original' is, as in this case, itself more or less of a reproduction, it is all too easy for a further reproduction to be made.

It might be desirable if some distinction in the print itself, or in the manner of numbering and signing copies, were made to distinguish clearly in which category the print belongs. Unless the buyer has sufficient technical information, it is at present very easy for him to be deceived. As the size of the edition and category of the print are important factors in determining the value, such a distinguishing mark would be enormously to the interest of the artist, the honest publisher, and above all the collector. The Éditions 'Le Vent d'Arles' has published a print of Fernand Léger printed on paper with a watermark: 'Ceci est une réproduction de Fernand Léger': this clearly meets our requirements, but is perhaps more than we can demand of all publishers. A stamp of some sort on a margin might be sufficient for this purpose.

14

PUBLISHERS AND DEALERS IN PRINTS

France, England, Switzerland, America, and Germany

ONE of the most important galleries for painting and sculpture in Paris, and one of the oldest 'modern' galleries, is that founded by Daniel Kahnweiler in 1907, which became the Galerie Simon in 1920 and the Galerie Louise Leiris in 1941. Representing Picasso, Léger, Masson, and many other famous artists, this gallery has published prints by its artists since 1912 (Picasso and Braque). All the editions, both intaglio and lithograph, published by this house are, as the term is understood at present, originals; that is to say the works are from the hand of the artist. Printed by Lacourière, by Mourlot and Desjobert for the lithographs, the plates or stones were actually worked by the artist; where technical assistance may have been given in the preparation of plates or the succession of colours, in no case did the *chromiste* or artisan execute any of the plates. The editions vary from only 20 to 75 to, I think in one case only, 100 copies. But from the point of view of the new classification that we are trying to set up, even these prints can be seen to be in three of our categories. Works like the 'Danseuse au Tambourin' of Picasso or 'Un Couple sur une Feuille' of Masson (Pl. 58), the latter in full colour, are major works, of our category (A), existing for themselves, and would be valid in my opinion had we never seen another work of the artist or ever heard his name. Others are definitely works of lesser importance, having reference to the whole body of the artists' work, and could be perhaps seen as autographs, category (B). Again others, in full colour, in which prints the pinholes used by the printer to register successive colour plates are to be found, could belong to our third

category characterized by the use on the part of the artist himself of a reproduction technique. The Masson print is an example of the method evolved in the Atelier 17 of simultaneous printing from intaglio and surface: there are two intaglio colours, applied to a strongly bitten plate *à la poupée* with a surface colour laid on the same plate with a roller. The 'Danseuse', in which the stages of growth of the idea can be witnessed on the print, was begun in line, developed with aquatint, and completed with some very powerful work with scraper and burnisher which determines the liquid organic character of the modelling on the figure. Thus it is clearly a work evolved for itself in the medium and in no way transferred from an original drawing or painting.

Another important print centre in the Saint-Germain quarter of Paris is a bookshop filling the space between the two principal artistic and literary cafés, Les Deux Magots and Flore. Known as 'La Hune', it is a large international booksellers, publishers, and gallery for the exhibition of prints, drawings, water-colours, and small sculpture. On my return to Paris in 1950 from the United States it was this gallery, as it happened, that offered me the first graphic show that I had ever made in France. Until very recently this gallery acted as a repository for such editions as Lacourière's, Guilde de la Gravure, and L'Œuvre Gravée (see below), but for several years past the publishing of editions of engravings and lithographs in colour has been added to the publishing of interesting books. Its very active director, Gheerbrandt, is as passionately interested in contemporary graphic arts as he is in literature, and owing to this very wide field of activity his gallery lacks the atmosphere of galleries entirely devoted to furthering the interests of a 'stable'. In consequence, examples of contemporary graphic art from Brazil and Japan, primitive and archaeological documents, photographs frequently forming the illustration of books published by the house, and even documentary films are shown here. Owing to its situation at one of the main crossroads of the Latin Quarter, and its relaxed, even slightly amateur atmosphere, an exhibition in this gallery is probably seen by more people than in almost any other print gallery in Paris. The print of Georges Adam,

reproduced as Pl. 13, is published by this house. Many of the edi-
tions of Picasso's ceramics as well as his recent graphic work have
also been exhibited here. All the editions they publish are originals
within the definition of the first three categories given in Chapter 11;
that is to say they are major works originated in the medium, minor
works, or applications by the artist himself of reproduction tech-
niques. Although in this gallery straightforward reproductions are
also offered for sale, they are clearly described as such and no con-
fusion is possible.

Typical of the French publishers, though unique in audacity,
Ambroise Vollard produced in the first half of this century some of
the most magnificent examples of modern print-making. Bonnard,
Vuillard, Rouault, Picasso, Braque, and Chagall made editions with
him of such cost and elaboration that his colleagues were convinced
that they could never be sold, yet they have all justified the con-
fidence of their publisher. I met him first in 1932 when my 'Apoca-
lypse' had just been published by Jeanne Bucher, the kindest and
most far-sighted dealer in Paris in all matters except her own finan-
cial interests. He was delighted with the edition but horrified by the
price at which it was offered (which he found far too low), and we
started later on a scheme to do a series of plates for an edition of the
Numancia of Cervantes, which we never completed owing to his
death in 1939. No other dealer was ever found to undertake this
edition and those plates which had been completed were finally issued
as separate prints. His manner of publishing was simple enough:
everything he showed or produced belonged to him outright; he
fixed the price, dimensions, and size of edition without interference
from anyone.

In Germany from the twenties the house of Paul Cassirer produced
editions of prints, particularly of the Expressionists; Flechtheim and
J. B. Neumann (now in America) also published in Berlin until com-
pelled to abandon their enterprises by the régime in the thirties. The
two latter were incidentally the first two dealers that ever bought
prints from me in the late twenties. Several dealers who had been
assistants in their galleries later came to the United States where they

set up galleries, the most notable without doubt being Curt Valentin, of particular interest to us for his publication of prints. A man of great generosity and kindness, he had the European tradition of absolute loyalty to his artists. His career in New York reads like an American success story. Arriving with very little funds, with the intention of founding a branch of a Berlin gallery, he progressed from a desk in the corner of a colleague's gallery to the ownership of the most influential modern gallery in New York. His untimely death in 1954 has left a gap in international circles which no other dealer has been able to fill; and as one would expect no one was found capable of continuing his gallery. One must remember that the time over which he was operating extended from 1938, when it was almost impossible to give a modern print away in America, through the period when, by his own efforts, those of museums like the Museum of Modern Art in New York, who in 1944 put on and circulated for years a show of revolutionary prints, and those of our Atelier, an enormous market was created for such works, now being happily exploited by another generation of print-makers and dealers. I hope that they remember him with gratitude, as do the painters and sculptors whose works he showed so well.

Apart from those already mentioned, Peter Deitsch in New York does not as far as I know publish editions; his chief interest is in rare or even unique prints: the *épreuves d'état*, unique colour trials never repeated, as well as drawings of value. In Philadelphia the Print Club, ably directed by Miss Bertha von Moschzisker, acts as a centre in an area where many of the biggest collectors in America are to be found; the annual international exhibitions there are among the most important in the country. Although their function did not include publishing, their service to artists and to the print-collecting public cannot be overestimated. In Boston recently Robert Light has set up a gallery specializing in modern prints which has become an important centre; but again the activities of this gallery do not extend to publication.

In Switzerland there are a number of international publishers of prints who maintain contact with the whole of Europe as well as America. In Geneva the 'Guilde de la Gravure' was organized after

the war by Pierre Cailler and Nesto Jacometti to extend their pub-
lishing activities from books to editions of prints. A very large number
of etchings, engravings, lithographs, and a few woodcuts in black and
white and in colours have been issued from the better-known modern
artists of France, Switzerland, Germany, Italy, Holland, Belgium,
North and South America, England, &c. These editions were gener-
ally printed at 200 to 300 signed and numbered copies, were con-
sequently offered at very reasonable prices, and have had a wide
distribution in eight or ten different countries. The works them-
selves were produced in nearly all cases in one or other of the studios
described in earlier chapters and are again what are generally known as
originals. They fall into our first three categories, with a few excep-
tions where the skilled artisan has been responsible for completing
plates or stones for colour after the black was actually done by the
artist; to distinguish between these three categories it will be neces-
sary for the collector to call upon the trained discrimination he may
have acquired from the serious study of prints.

Since 1953 I understand this partnership has been dissolved and
while the Guilde de la Gravure still continues, Mr. Jacometti has set
up his own publishing house in Zurich, known as L'Œuvre Gravée.
With much the same distribution this editor has circulated the works
of rather more abstract or 'advanced' painters and sculptors in
somewhat smaller editions. The activities of these publishers, although
sometimes disapproved of by the older type of dealer in fine prints,
have had enormous value in putting prints by known as well as un-
known artists within the reach of a very much wider public. As one
would expect over ten years of operation, certain of these prints have
increased slightly in value while others are offered, if obtainable at all,
at five or ten times the publication price, regardless of the size of the
edition.

In a somewhat different field the ancient house of Gutekunst and
Klipstein (now Klipstein and Kornfeld) of Berne has dealt in drawings
and fine prints both of old and modern masters over a long period.
The periodic auctions held by this house constitute an international
barometer of prices for fine prints as well as other graphic works, and

64. SERGE BRIGNONI. Two Figures. 1951. Etching and burin engraving $13\frac{1}{2}'' \times 11''$

65. MAX ERNST. Masks. 1955. Aquatint and soft-ground etching $9\frac{1}{8}'' \times 6\frac{3}{4}''$

attract collectors and dealers from every country in the world. This house did for a time publish prints by a number of better-known contemporaries, but I understand that this activity, which was always subsidiary to their dealings in rare prints, has now been discontinued. The examination of the magnificent illustrated catalogues issued by this house, together with the estimated or reserved values on the lots and, when obtainable, the actual lists of prices bid, gives a great insight into the international market in contemporary prints. Yet it is perhaps necessary to point out that in England, let us say, there exists a certain market in which the quotations of different works correspond only to a local demand; another similar market in America; another in France. Certain of the prints quoted on all these markets will be found in the international sales. These are more or less concrete international values. But the great majority of the works quoted on local markets (and this is particularly true for the American market) have little or no value outside their country of origin.

In England the publishing of editions of modern prints was undertaken only exceptionally by book publishers (often, like the Golden Cockerel and Folio Society, for the illustration of fine books) and by some occasional art galleries, in which case it was rather to supplement the sales of sculpture and paintings by their own artists, but hardly ever did publishing houses specialize in such works. The publisher and art bookseller Zwemmer did in the thirties sometimes buy part of an edition of a well-known artist in Paris for sale through his London gallery. I recall a party with him in the company of Picasso just after he had bought the remainder of the edition of the 'Minotauromachie' plate, for what I imagine to have been a high price at that time. On this occasion he asked Picasso whether he could not also buy the copper plate (cancelled after printing). With malicious glee Picasso said of course he would not sell it: all that was necessary was to add a dozen lines and start printing another edition, and so on for the rest of his life. And forestalling the shocked calculation Mr. Zwemmer seemed to be making, he continued gleefully, 'and I am going to live an awful long time'. It is needless to say that he never did reprint.

The Zwemmer gallery exhibits groups of print-makers, notably an annual exhibition of the New Editions group in the summer, but I think the only gallery in England that specializes in the publication of contemporary prints is the St. George's Gallery, founded for this purpose in the fifties by the Hon. Robert Erskine. Abandoning a promising career in archaeology he devoted enormous energy and considerable funds to providing a centre for prints which was hitherto entirely lacking in England. (Perhaps this is why there is so far no serious public collection of modern prints in England, while there are at least thirty state or national collections in the United States.) His personal activity has stimulated print-making in England not merely by selling and circulating the results but by encouraging individual print-makers, organizing printing and working facilities in lithography and intaglio for them, and buying their editions outright for publication. With some assistance from the Arts Council and the British Council, but also on his own initiative, he has circulated groups of English prints in America, Scandinavia, and other parts of Europe and in Japan. The catalogues he produces with diapositives of colour prints, and the film *Artist's Proof*, made to familiarize the public with the operations of print-making, must have greatly widened public interest in this field.

Under the direction of Rex Nan Kivell, the Redfern Gallery has published and shown modern prints over a much longer period; many of the most important French and international figures must have been first seen in London in this gallery. But its chief activity was always the showing and selling of painting, to which the print-selling was subsidiary.

15

PRINT-COLLECTORS TODAY—
CONCLUSION

WE have already considered at some length those who make prints, the places in which they are made, and who distributes and sells them. But so far we have not given much attention to those who buy or collect prints. Without going so far as to attribute the greatest importance to this group, it is clear that without their interest and support very few prints in most of our categories would get made at all. Some would, I suppose, as the print-maker is a persistent type and not easily discouraged, but without active practical and moral support no great amount of work will be done; even the quality of what is done depends in some measure on the general popularity of the medium. As we have seen, the eclipse of the original print in favour of the reproduction made by hand was already determined in the sixteenth century by a change in popular taste; and over a long period it is not easy to criticize such taste. That is to say, though in our own time we might wish it were otherwise, this is quite futile; public taste in the end determines what will survive and the conditions in which works of art are produced, and it is useless to quarrel with it. By this I do not suggest that if the man in the street does not at that moment seize upon the newly made work, it should be destroyed; but I would suggest to the working artist that if over a certain time he continues to meet with indifference, or even with hostility (as one at least in every crowd has perception), he should consider the possibility that he could be wrong. If the public is bored with the subjects that have been seen, new ones have to be found. If academic means of presentation have become stale with use, new means must be found. In short, the artist's commitment is without

limit and without alibi; if his public is indifferent he must find the means to overcome their indifference, the ability to arrest their attention and to move them. As practically no artist really doubts the source of his ideas, this means that the language of expression he is using may be at fault; not merely obscure, although obscurity is often the result of such error, but inadequate, 'personal' to an undesirable degree, inappropriate to that which he has to say.

It must be apparent that I do not believe in Art For Art's Sake—if I understand what people mean by this. Anyone who declared a belief in talk for talk's sake and retired to a sound-proof room to put it in practice, would be considered in need of psychiatric care. Speech must be audible; a gesture must be perceptible; and the order of importance of the gesture must be such as to hold our attention. And to warrant the gesture reaching the permanence of a print, it must be a matter of significance and ultimately be recognized. At the risk of attempting a paradox I would suggest that originality, carried to its logical con-clusion, is undesirable; indeed absurd. The most original statement is in fact an idiosyncrasy; restricted to one individual, it is valid for him alone and communicable to no one else. In fact, as we have stated before, the artist is seeking what is, and not what is not. The pretension to create from nothing by a human instrument is impossible to defend, just as no phenomenon is knowable beyond the scope of the instru-ment that perceives it. That the expression 'originality' may be used in a loose sense by critics to describe matters of which the public is not generally aware, is fair enough; but unless this matter is latent in the minds of those to whom it is presented it cannot be recognized, and so has no practical existence.

Of the people who acquire images as prints, I have observed a number of different categories, distinguished by the motives, not always simple, that lead to this addiction. The collector of autographs, systematic sometimes to the point of becoming a graphologist, is clearly interested in the personality, the prestige, and frequently the simple human attributes of those whose handwriting he collects. Many print fans are of this order: for them the category of prints in which the trace has little intrinsic artistic worth may be as valid

as a work of greater significance. The collectors of postage stamps, beyond the obvious incentive of getting together all the sets and all the varieties, are I suppose seeking in an enormous quantity of similar objects the one exceptional, rare, or unusual case. Often this is an error in printing, in form, in colour, detail, or even perforation. There are print collectors of this variety. For them the doubled print, the error of registration of colours, or the unique trial print never repeated, constitutes the joy of discovery and triumph. Then together with these, though not necessarily an exclusive category as all and any of them may be combined in one individual, we have the gamblers. Here the overriding motive is to obtain by the exercise of knowledge and experience prints which have far greater value than the sum one has paid for them. Either by the exercise of the faculty used to pick winners on the racecourse, or by finding in an unlikely place a known print of great value, not known to its owner, the object is to obtain possession of a print which has, or with time will have, great value. The people (and this must include most of my friends) who prowl the flea market in Paris, the antique shops and junk yards of various countries, hunting for bargains, are clearly in this category. It is an error to suppose that such things are not possible to a man with some knowledge. The sculptor Jacques Lipchitz happened to notice, in the window of an establishment in New York which auctions old furniture, a Martin Schongauer print in a museum frame. As the sale was to be some days later he made use of the privilege that buyers have to leave a deposit in case no higher bid is made on a lot: he left five dollars. At the sale, owing to the absence of any person aware of the value of a fifteenth-century print, or needing the frame more than he needed five dollars, he acquired the print for four dollars. This almost constitutes another category: the browsers in printshops or along the quays of Paris, the patient souls who go through portfolios and stacks of papers in the street markets in the hope of finding a lost masterpiece, whether for venal or aesthetic satisfaction.

All of them, however, have one matter in common. They are happily exercising their own taste and discrimination: perhaps with very limited means, they may for the moment have escaped from the

compulsion of a job with no issue and little satisfaction; a situation in life offering small opportunity of ecstasy; and, in the case of the real devotee, having as much fun as Berenson spotting a million-dollar old master in a back-street bottega. But at this moment it may occur to the astute reader that we have so far made little reference to a serious aesthetic motive: no search for the work of art and its moving power on the human spirit. The collector so far referred to is a man with a hobby, a 'violon d'Ingres' (and why should Ingres not play the violin when he had had enough of painting for the moment?). Again another variety of collector is replacing, I think with advantage, the modest collector of reproductions of well-known works of art. Why I think this an advantage is that where a person buys a reproduction, almost invariably of a work widely acknowledged to be great, and often of an earlier time, he is not exercising his own judgement; he is merely subscribing to the opinion of art critics and experts and of the public, so far as it is interested in pictures and not only in how much money people are willing to pay for them—whereas the person who buys a print because he likes it, of an unknown contemporary, is exercising his own taste and judgement, even if he has no better purpose than to decorate a wall. The enormous increase in popularity of colour lithographs, woodcuts, serigraphs, and etchings in the last twenty years demonstrates the replacement of a part of the demand for fine reproductions of acknowledged works, by a demand for originals of lesser-known artists, and does I think mark an enormous extension of the popular interest in art of our time. It is of no importance that we see all the categories of prints we have defined bought and sold indiscriminately within much the same price limits. Nor even that what we may find to be the poorest holds its place beside the best.

I have heard some of my colleagues complain of this state of affairs and regret the day when collectors were discriminating, extremely expert, and incidentally very few. As we have seen, this world has almost disappeared and has been replaced by an entirely different public, willing to risk, to make mistakes, and to learn. It is of course for such a public that this book is intended. Poor and derivative work, having lesser content, is often more accessible to the

understanding of the budding collector than work that we might consider more important. But this does not matter; may he continue to take a chance, blunder, and learn; may he ignore the snobs who try to tell him what to like, and the books that explain modern art (not excluding this one). What I feel my colleagues do not appreciate is that a dying and exhausted interest is witnessed by the existence of a few very discriminating collectors: a young and expanding public by many, if sometimes ignorant, collectors. As I have personally witnessed in the United States (where of course everything happens a little more and faster), they do not stay ignorant: at some moment, confronting their poorer choices, they will suddenly realize that they are bored; will even violently object to being bored, and at this moment the education of the new collector has already begun. I cannot insist too strongly on the right he has to buy the wrong ones or, when they no longer satisfy him, to discard them. This process is somewhat accelerated in the New World by the generally accepted view that all property is expendable and replaceable—an attitude that has certain advantages over the Old World's conservatism.

We have seen that it is difficult to find a common measure between the value of a print as a work of art and its demand and sale at any given moment. I was once delighted with a remark of a bank manager who said to me how nice it must be to produce works which command a ready sale. It would have been quite useless, as well as untactful in the circumstances, to point out to him that works of art seldom command; they rather solicit with hat in hand until with time and use they become commodities. Among my colleagues it is hard to get a clear view on this matter: many of them are either hysterical on the question or else, when well enough protected by an efficient dealer with a solid claque or a well-paid position, altogether too impossibly complacent.

Remember we are still talking about the peculiar conditions of a sense of values in art and life which does not mix with the conditions of labour and reward in industry any more than oil mixes with water. But if you have to mix them oil can be emulsified into an

uneasy emulsion with water by beating it up with egg-white or gum, and perhaps the dealers fulfil this useful if sticky role as protective colloid. Of course, if the emulsion stands too long, like milk it will separate and the cream (or scum) will float to the top. Those works which seem to me to be the most potent, those that have the power to change our general concept of the terms of life in the world we live in, seem to be of difficult acceptance at any time. The work of competent followers of the ideas embodied in such works, necessarily diluted and weakened by derivation in a second version, possibly even better presented than in the first order—such works generally meet with wide and ready acceptance, often about a decade after the former.

The works of the third order, of artists who have no real motive but to present a palatable product aimed at or below the estimated taste of the public, do sometimes appear to succeed for the moment. However, such works can be seen to pass out of fashion (to which they are keyed) quite rapidly: in fact the order represents the vast mass of prints or other art-works which date hopelessly after a generation. They may sometimes recover a sort of antiquarian popularity at some future date with slightly precious people, as Victorian horsehair in the thirties and the Nabis of the turn of the century at the present time. Having witnessed about three cycles of this sort—discovery to popularity to neglect—I have begun to think that I can call this variety on sight. In the late twenties when a certain sort of etching was still very popular and 'commanded' a high price, I happened to be going round an exhibition in a well-known gallery in London with a dealer, a friend of my father. The margins of all the prints were liberally decorated with rows of red sales spots, and the show was a great success. I offered to bet the dealer in question that in five years' time he would be unable to give those prints away. He was far too kind to take my money at that time, and treated me with the tolerance one shows to brash young men. When some years later the prediction turned out to be true he conceived a respect for my dealer's 'flair' really quite unjustified by the event. My view was based on the simple proposition that, finding myself bored by these

works, if I was bored an enormous number of other people were going to share that boredom sooner or later, and among them some of the purchasers of these works. Whereupon their popularity would cease.

I should not like to give the reader the impression that this process is invariable or automatic: I can with no effort at all bring to mind some of my contemporaries whose popularity, supported by incessant activity in the fields of showmanship, prestidigitation, and publicity, has survived thirty years and is not yet exhausted. Its survival is explained to some extent by a shift to new circles of supporters as older ones fail, and I think the sensitive ear can already detect the breathlessness of approaching exhaustion. It might appear that I am trying to find a sort of morality in the functioning of the market for the arts, than which nothing could be more absurd. It may be true that so-called artists will attempt to recommend their product with every allusion to virtue, elegance, power, wit, virility, and snobbery, just like the intelligent salesmen of hair-lotion. It is a merciful dispensation of providence that such appeals provoke the fortunate reaction known in such circles as 'sales resistance'. But we have already seen when discussing print-makers that in my view artists should ideally separate their peddling mentality from their serious function in making works of art. In this function it seems to me there is only one unforgivable sin, which is for the artist at the time of creation, whether from worthy or unworthy motives, to do any less than he feels himself to be capable of doing.

So far we have considered only collectors as amateurs—those who buy prints for their own entertainment, pay for them with their own money. But we have neglected the most important collections of the national and public museums. Here the choice is made by professionals, that is to say men who are paid salaries to do this, apart from their other curatorial functions, and the prints they select are purchased with either public or private funds not normally their own. Frequently these choices are no more than suggestions, the results being filtered through a further selection of a board of trustees, giving rise to what is known in such circles as 'trustee trouble'. Generally it is the curator

who is held responsible by the public for the selection, whether it is really his opinion or the trustees' opinion that determines the choice. This is not always so: among the thirty or forty museums that I know in the United States, one at least has a director who is the most generous donor and virtual owner of the collection. As one might expect in a time when values in art and culture are relatively unimportant to a majority compared with the 'practical' things of life, the taste, knowledge, and competence of individual curators of print departments varies enormously. While, as in Europe, the heads of print departments may be recognized world authorities in their subject (like A. M. Hind, once at the British Museum, and Dr. Benesch at the Albertina in Vienna), and others may be men of courage and initiative like Gustave von Groschwitz at Cincinnati who has brought honour to his museum in promoting international exchanges of print shows, others may be officials with minds like filing cabinets or refugees from the stress of competitive industry. At best they may be expected to remain free from the commercial standards of the dealers, and at worst they obstruct the choice of their trustees by presenting only a restricted selection to them. Be this as it may, while America has at least thirty important print collections, while France, Belgium, Switzerland, Holland, Germany, Austria, and Italy have contemporary collections, in England there is not so far one adequate collection. To have maintained such a collection over the last fifty years would have cost relatively little; to remedy this situation today would cost very much more, and if the matter is neglected for another ten years the cost will be still greater. I understand that this matter is being very seriously considered at the moment. The importance of a national collection of prints would seem to be chiefly that these are works of a wider circulation and popularity than paintings and sculpture: both because they are less costly (there must be a hundred times as many people willing to spend £10 as there are willing to spend £100) and because they exist in a number of examples and are relatively easy to transport and exhibit.

We have seen by what divers means prints are being made, who makes them, for what reasons, and in what sort of place: we have

considered some of the means by which they are distributed, and even the people in whose hands they are ultimately found. In the attempt to define the five main categories of originality and significance in prints, with the enthusiastic support of print-makers, dealers, and experts, an underlying thesis is implied which might be stated more clearly. Briefly, this is that under certain circumstances which we have indicated, the making of prints is not a minor or subsidiary art; it is a major art; such works, which are at present lost in the confusion of the market, are to be distinguished as possessing an importance beyond the repetition of the results of drawing, of painting, or of sculpture, and are themselves major works of art and not minor works. It is to be expected that the intrinsic power of prints of this order will ultimately separate them from those of documentary or associated interest, and even that their value will continue to increase beyond the ceiling that fashion sets to the value of prints of the other orders.

Throughout this book I have attempted to cope honestly with the very serious problem involved in all literary descriptions of matters of graphic art; what we are trying to describe is of a species so completely different from the actual means of description that clear definition and statement become almost impossible. And this even if we write the simplest of words about things and avoid the words about words. If we believe that the import of graphic statement is perceived by a different mechanism—more primitive perhaps, more direct and certainly less specific—from the logical syntax of word and phrase, then it becomes clear that all words can do for us in such matters is to create the climate of understanding.

BIBLIOGRAPHY

WORKS DEALING WITH TECHNIQUE

GENERAL

GABOR PETERDI. *Printmaking*. New York, 1959.
JULES HELLER. *Printmaking Today*. New York, 1958.
JORGEN VON KONOW. *Om Grafik*. Malmö, 1956.

The above books describe the technique of all the graphic media: the relevant chapters for specific media are all useful, and should be understood in the sections that follow.

INTAGLIO

S. W. HAYTER. *A New Way of Gravure*. New York, 1949.
B. F. MORROW. *The Art of Aquatint*. New York, 1935.
E. S. LUMSDEN. *The Art of Etching*. Philadelphia, 1926.
MAXIME LALANNE. *A Treatise on Etching*. Boston, n.d.
JOHN BUCKLAND-WRIGHT. *Etching and Engraving*. London, 1953.

LITHOGRAPHY

DAVID CUMMING. *A Handbook of Lithography*. 3rd ed., London, 1948.

SILK-SCREEN

ALBERT KOSLOFF. *Screen Process Printing*. Cincinnati, 1950.

WOODCUT AND WOOD ENGRAVING

JOHN PLATT. *Colour Woodcut*. New York, 1938.
H. HUBBARD. *Colour Block Print Making*. Boston, 1937.
F. MORLEY FLETCHER. *Wood-Block Printing*. London, 1916.
E. W. WATSON and R. KENT. *Relief Prints*. New York, 1945.
JOHN R. BIGGS. *Woodcuts*, London, 1958.
JOHN BUCKLAND-WRIGHT. Op. cit. under 'Intaglio'.

CRITICAL AND HISTORICAL WORKS

FELIX MAN. *150 Years of Artists' Lithographs*. London, 1953.
CARL ZIGROSSER. *A Book of Fine Prints*. New York, 1948.
—— *The Expressionists*. London, 1957.
ALBERT REESE. *American Prints of the Twentieth Century*. New York, 1949.
IRVIN HAAS. *A Treasury of Great Prints*. New York, 1956.
WILLIAM IVINS. *Prints and Visual Communication*. Cambridge, U.S.A., 1953.

P. J. Sachs. *Modern Prints*. New York, 1951.

A. M. Hind. *An Introduction to the History of Woodcut*. London, 1935.

H. Fuerst. *Modern Woodcut*. New York, 1924.

D. P. Bliss. *History of Wood Engraving*. New York, 1928.

Bernard Sleight. *Wood Engraving since 1890*. London, 1932.

E. G. Craig. *Woodcuts*. London, 1923.

Una E. Johnson. *Ten Years of American Prints, 1947–56*. New York, 1956.

Philip Hofer (editor). *The Artist and the Book*. Boston, 1961.

L. G. Buchheim. *The Graphic Art of German Expressionism*. Feldafing, 1960.

Oliver Statler. *Modern Japanese Prints*. Rutland, Vermont, 1956.

Monroe Wheeler. *Modern Painters and Sculptors as Illustrators*. 3rd. ed., New York, 1946.

C. Roger-Marx (editor). *Anthologie du Livre illustré par les Peintres at Sculpteurs de l'École de Paris*. Geneva, 1946.

MONOGRAPHS ON INDIVIDUAL PRINT-MAKING ARTISTS

PICASSO

Bernhard Geiser. *Picasso peintre-graveur*. Paris, 1955.

Hans Bolliger. *Picasso's Vollard Suite*. London, 1956.

Fernand Mourlot. *Picasso lithographe*. 3 vols., Monte Carlo, 1949–56.

BONNARD

C. Roger-Marx. *Bonnard lithographe*. Monte Carlo, 1952.

VUILLARD

C. Roger-Marx. *L'Œuvre gravée de Vuillard*. Monte Carlo, 1948.

SEGONZAC

A. Llore and P. Cailler. *Catalogue de l'Œuvre gravée de Dunoyer de Segonzac*. Geneva, 1958 (only two out of 6 vols. so far published).

MIRÓ

M. Leiris. *The Prints of Joan Miró*. New York, 1947.

KLEE

J. T. Soby. *The Prints of Paul Klee*. New York, 1945.

MATISSE

William S. Lieberman. *Matisse: 50 Years of his Graphic Art*. London, 1957.

INDEX

PRINTED IN GREAT BRITAIN
AT THE UNIVERSITY PRESS, OXFORD
BY VIVIAN RIDLER
PRINTER TO THE UNIVERSITY